THE AUTHENTIC NELSON

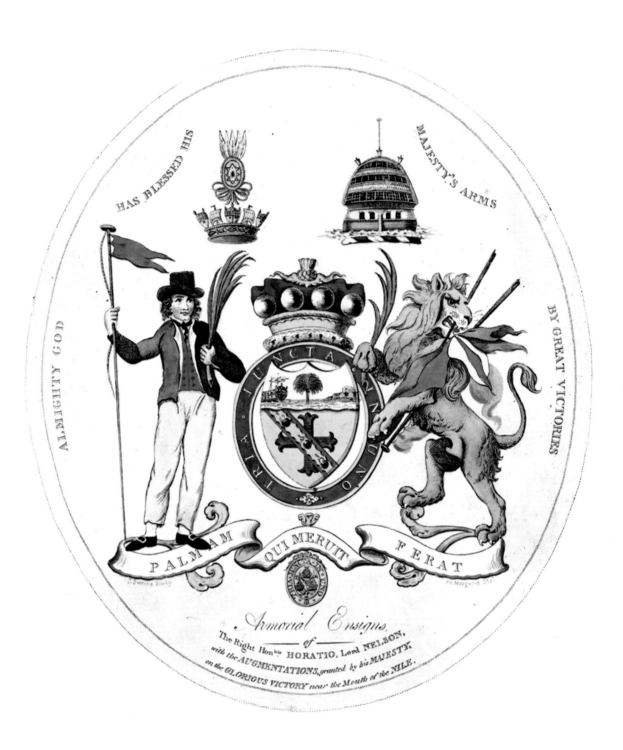

NELSON'S COAT OF ARMS AS A BARON, AFTER THE BATTLE OF THE NILE, ENGRAVED BY JOHN SWAINE.

THE AUTHENTIC
NELSON

Rina Prentice

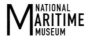
NATIONAL MARITIME MUSEUM

For Denis

THE AUTHENTIC NELSON

First published in 2005 by National Maritime Museum Publishing,
Greenwich, London, SE10 9NF

ISBN 0948065691

1 2 3 4 5 6 7 8 9

A CIP catalogue record for this book is available from the British Library.

Commissioned by Rachel Giles
Project managed by Lara Maiklem
Designed by Bernard Higton

Printed and bound in United Kingdom by Cambridge University Press.

www.nmm.ac.uk/publishing

CONTENTS

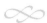

AUTHOR'S PREFACE

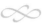

The purpose of this book is to describe and evaluate Vice-Admiral Horatio, Viscount Nelson's personal possessions and to explore how this material came to survive or, in some cases, has disappeared from sight over the two centuries since the Battle of Trafalgar in 1805.

An extraordinary number of objects associated with Nelson were treasured by his contemporaries and later became widely dispersed as they were passed down through families, salerooms and collectors. The various branches of the Nelson family were responsible for much of this accumulation and dispersal, and the story has become increasingly complex as the decades have passed. The Nelson 'relics' as they have often been called, have at various periods since 1805 been either revered or disparaged, but after two hundred years it is very clear that these material objects have lost none of their magnetic appeal for museum visitors and collectors. The reasons why people have been anxious to own or look at the things Nelson might once have touched, worn or used, have changed over time, but today those items remain just as desirable. As a result, as soon as demand for this material began to exceed supply, the fabrication of additional fake Nelson objects became a factor, so that searching for proof of authenticity has now become an essential part of the assessment process for curators, dealers and collectors.

This is not intended to be a biography of Nelson, although, of course, the objects described relate to every stage of his life and naval career. Many excellent lives of Nelson have already been written and others are being published in connection with the bicentennial commemoration of his death at Trafalgar. The present volume needs to be read alongside other works which cover the larger issues relating to Nelson's life and achievements. Important evidence for the Nelson story is to be found in his own writings and by examining the portraits, sculptures and other images produced in his lifetime, but these aspects are also the subjects of major modern studies. I do not, therefore, intend to deal in this survey with the magnificent collections of Nelson manuscripts and paintings to

be found in public and private collections all over the world. Nor am I attempting to include the purely commemorative material produced in the Admiral's honour in astonishing quantity ever since his own lifetime, up to the present day. I have included a number of 'funeral' items in the catalogue section as the only exception to the rule of 'owned by Nelson or those closest to him', because such objects provide a unique link between the personal and the commemorative, and raise many of the same problems of provenance and authenticity as the things he actually owned.

The Authentic Nelson tells the story of how the original Nelson possessions became scattered, how they were collected and grouped by museums and private enthusiasts, and how they have been shown to a wider public through special exhibitions and museum displays. Objects of all types are considered, including his silver, ceramics and household goods, his uniforms, orders and medals, weapons, furniture and other equipment, as well as some of the gifts he gave and received. Sometimes convincing relics have suddenly come to light in modern times, with little evidence of their previous history, but others can be traced through an unbroken line of ownership back to Nelson's possession. In the most satisfying cases, the provenance and documentation are further supplemented by entries in sale catalogues and old exhibition publications. Other chapters look at the way fakes, accidental or deliberate misattributions and legitimate copies have all added to the confusions, and examine some of the crimes which have been perpetrated as a result of the ever-increasing value and allure of these objects.

The core of the book is the catalogue section, which describes and illustrates some of the most important and interesting of surviving Nelson objects, ranging from the exquisite to the bizarre. It cannot claim to be completely comprehensive, as so many items are already known and new material is constantly being discovered or reassessed. However, I hope the book will provide some helpful comparisons and an idea of the research sources available to collectors and museum professionals who find themselves faced with a potential Nelson 'relic'. Nor can I claim to have solved all the many complex problems of identification and authenticity of the Nelson collections; in some cases I can only present the objects with their associated stories and claimed provenance, in the hope of assisting future researchers and curators to piece together the scattered evidence which will eventually complete the picture.

I have included as many contemporary references to these objects as possible, given the limitations of space, in some cases quoting Nelson's own words. Such sources do not always clarify matters, as various writers can sometimes describe the same object in terms so different that its identity is obscured.

However, the interest and immediacy of such early accounts enhances the history of these objects and makes future reassessments possible. For similar reasons I have included some old photographic images of objects, which may not be as dazzling as modern colour photography, but in some cases are beyond price, since they may provide the only record of objects long since stolen or lost.

I would like to acknowledge the help of many people in writing this book. I have taken as my starting point the accumulated records of generations of past curators and other colleagues at the National Maritime Museum, Greenwich, Royal Naval Museum, Portsmouth, Nelson Museum, Monmouth, Lloyd's of London and elsewhere. Without their conscientious compilation and preservation of documentary records, such a survey would have been impossible. I am indebted to a number of institutions, auction houses and private individuals for allowing me to include photographs and details of their Nelson material. Information about items in private hands or seen passing through salerooms has often illuminated the provenance of newly discovered material, even though these objects may never have been part of a public collection. It is sometimes possible to trace the same unique Nelson object by means of catalogue entries and press accounts through decades of being sold, resold and exhibited, and to make important links between related objects in different collections.

In particular, I would like to thank my many colleagues at the National Maritime Museum, including Colin White, Liza Verity, Barbara Tomlinson, Amy Miller, Geraldine Charles, Daphne Knott, Andrew Davies, Gloria Clifton, Pieter van der Merwe, Nicola Yates, Maria Woods, Laurence Birnie, Justin McMorrow, Jonathan Betts, John Graves, Sarah Laker, and many others. I am much indebted for the generous help received from curators in other institutions: Andrew Helme of the Nelson Museum, Monmouth; Matthew Sheldon and Richard Noyce at the Royal Naval Museum, Portsmouth; Laura Shears of the Nelson Collection at Lloyd's; Wendy Cook at the Museum of Worcester Porcelain; Kate Fielden of Bowood Estates; and Mary Robertson of the Huntington Library, California. Other most valuable and generous assistance, advice and support has been given unstintingly by Nelson specialists and descendants, collectors and friends: John Munday, Denis Stonham, Clive Richards, Anthony Cross, George and Jeanette Wilkins, Roger and Jane Knight, George and June Jeffreys, Ron Fiske and Maureen Girdlestone. My final thanks must go to those who made the vision of this book a reality: the designer, Bernard Higton; the whole publishing team including Rachel Giles, Lara Maiklem, picture researcher Sara Ayad, indexer Kathleen Gill and particularly photographers Tina Warner and Ben Gilbert.

ABBREVIATIONS

Beatty	Sir William Beatty, *The Authentic Narrative of the Death of Lord Nelson* (1807).
Beresford & Wilson	Lord Charles Beresford & H. W. Wilson, *Nelson and his Times* (1897-8)
BL	British Library
ILN	*The Illustrated London News*
Lloyds	The Nelson Collection at Lloyds of London
Monmouth	Nelson Museum, Monmouth
Morrison	Alfred Morrison, *Autograph Letters: Hamilton & Nelson Papers* (2 vols 1894)
NA	National Archives, Kew
Naish	G. P. B. Naish, ed., *Nelson's Letters to his Wife and other Documents 1785-1831* (1958)
Nelson Dispatch	*Journal of the Nelson Society*
Nicolas	Sir Nicholas Harris Nicolas, ed., *The Dispatches and Letters of Vice-Admiral Lord Viscount Nelson* (7 vols 1844-6)
NMM	National Maritime Museum, London
RNM Portsmouth	Royal Naval Museum, Portsmouth
RUSI/RUSM	Royal United Service Institution/ Royal United Service Museum
SNR	Society for Nautical Research
Trafalgar Chronicle	The Year Book of the 1805 Club
Walker	Richard Walker, *The Nelson Portraits* (1998)
White's *Companion*	Colin White, ed., *The Nelson Companion* (1995)

PART I

THE STORY OF NELSON'S POSSESSIONS

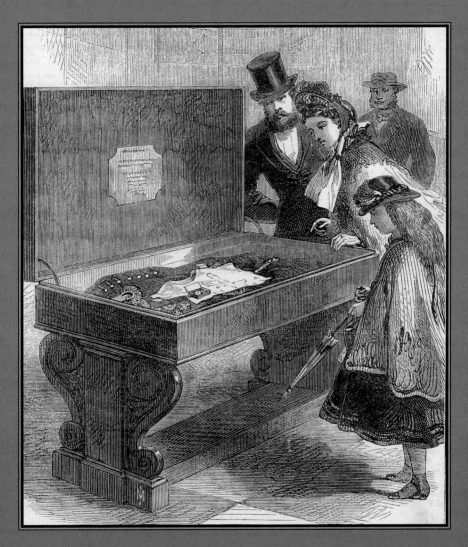

THE TRAFALGAR UNIFORM DISPLAYED IN THE PAINTED HALL,
THE ILLUSTRATED LONDON NEWS ENGRAVING OF 25 MARCH 1865.

Chapter One

NELSON'S POSSESSIONS

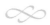

*I have just received from the Grand Signor a diamond star with a crescent in the centre which I wear above that of the Bath. (*Nelson to his wife Frances, 7 November 1799)

The starting point of any examination of Nelson relics has to be contemporary records of his possessions made during his lifetime, and who better than Nelson himself to contribute the evidence? Fortunately, he was an avid letter writer and recorder of details, and since so much of his correspondence has survived, there is no shortage of source material. In several letters written the same day he might announce the receipt of some precious presentation from a foreign ruler, or mention gifts he was dispatching to family and friends. At the same time he took an extraordinary interest in the most mundane details of his everyday shipboard belongings, which had to be conveyed from place to place to keep up with his naval movements. His letters often find him questioning the packing of his goods or the disappearance of some article of clothing or particular item of property.

From his lifetime there survive a number of useful lists and inventories of his household possessions, such as *'Mr Salter List of my plate to go afloat April 10th 1801', 'List of plate taken at Merton August 5th 1802 by John Salter of Strand',*[1] and another John Salter list of 7 May 1803 *'For Sea Service & packed in 3 cases'.*[2] Some of these inventories are detailed enough to be able to recognize particular pieces of silver such as the Turkey cup, Copenhagen ice pails, combined knife and fork and other items still in existence today. We have records of Nelson's accounts with John Salter of 35 Strand, his jeweller, silversmith and sword cutler, between December 1804 and 8 September 1805, which include references to a ring and a silver goblet made for his daughter Horatia. There are similar accounts for Rundell & Bridge, suppliers of the Nile and Copenhagen presentation silver for Lloyd's, as well as Barrett, Corney & Corney, lacemen and embroiderers, who made the embroidered versions of his orders and his sword knots, and Lock's of St James's, who made his hats.

REAR-ADMIRAL LORD NELSON KB PAINTED BY HEINRICH FÜGER IN VIENNA IN AUGUST 1800, WEARING THE INSIGNIA OF THE ORDER OF THE BATH, THE ORDER OF THE CRESCENT AND THE ORDER OF ST FERDINAND.

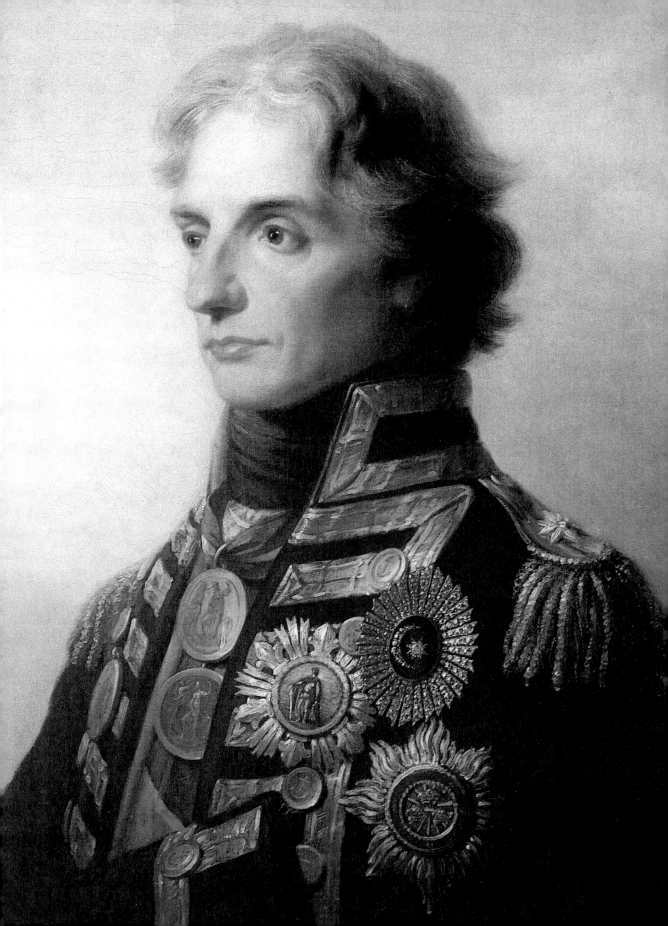

Nelson's accounts with his navy agents, Messrs Marsh & Creed, for the period September 1792 to August 1802 have been published[3] and can also be useful to verify particular purchases.

Nelson's ever-growing collection of valuable presentation pieces after the Battle of the Nile of 1798 was well publicized in the press of the day. In April 1800 the monthly *Naval Chronicle* published a list of '*Presents to Lord Nelson for his Services in the Mediterranean between October the First 1798 and October the First 1799*'.[4] This list also included his financial awards and new titles, but the items most relevant to this study are the specific precious objects he had been voted, several of which will feature in later chapters.

From his King, and Country... the Gold Medal.

... From the Turkey Company, a piece of plate of great value.

From Alexander Davidson [sic], Esq. a Gold Medal.

From the City of London, a Sword of great value... the Captains who served under his orders in the battle of the Nile, a Sword.

From the Grand Signior, a Diamond Aigrette, or Plume of Triumph, valued at £2,000

From the same, a rich pelice, valued at £1,000 [a sable pelisse or cloak]

From the Grand Signior's Mother, a Rose, set with diamonds, valued at £1,000

[the 'rose' appears in other versions of the list as 'box']

From the Emperor of Russia, a Box, set with diamonds, value £2,500

From the King of the Two Sicilies, a Sword richly ornamented with diamonds... £5,000

From the King of Sardinia, a Box set with diamonds... £1,200

From the Island of Zante, a Gold Headed Sword and Cane as an acknowledgment, that had it not been for the battle of the Nile, they could not have been liberated from French cruelty.

From the City of Palermo, a Gold Box and Chain, brought on a Silver Waiter.

In December 1800, Nelson displayed these trophies at Admiralty House, and Viscount Palmerston wrote to his wife: '*I have been this morning visiting Lady Spencer whom I found at home with quite a levée of people coming in and out. What I thought myself in luck was in meeting Lord Nelson with all his fine presents of every kind which he had brought there to show. It is melancholy to see him, himself so shrunk and mutilated. The worst is that his only eye is so weak as sometimes to give great alarm.*'[5]

Five years later the *Naval Chronicle* reported that in 1803, '*before he went out to take the command of the Mediterranean fleet, he was obliged to dispose of such of his jewels as were not of a nature to be left to his family, as trophies to illustrate the titles conferred on him by his King, and the Sovereigns in alliance with his country. He disposed of snuff-boxes, and other articles to Messrs Rundal and Bridges, but the chief presents, (including the chelengk and sword of the Grand Signior), he has left to descend with the title.*'[6]

Before he left England for the last time in 1805, Nelson visited the shops in

London's Strand, where, among other calls, he went to see John Salter, his sword cutler. Sir J. Theophilus Lee, a former naval officer who had served under Nelson, recalled in his memoirs, written in 1836, that Nelson had invited him '*to walk with him down the Strand as far as Salter's shop, which he was proud to do.... On arriving at Salter's shop, the door was closed, and his Lordship inspected all the Swords which had been presented at different periods, with the diamond aigrette, numerous snuff boxes, etc*'.[7]

Nelson also treasured less valuable mementos of his victories. Captain Benjamin Hallowell wrote to him from his ship the *Swiftsure* on 23 May 1799 about a trophy of the French flagship at the Battle of the Nile: '*Herewith I send you a Coffin made of part of L'Orient's Main mast, that when you are tired of this Life you may be buried in one of your own Trophies*.'[8] Nelson was delighted by the joke, and immediately lodged the coffin in his cabin. The coffin appears in a list of his property '*examined at the Customs House*' in October 1800[9] and in an inventory of his possessions made in March 1801.[10] After his death at Trafalgar, the *L'Orient* trophy was actually used for Nelson's funeral, inside other more elaborate outer coffins.

Evidently Nelson's cabin had become something of a museum in itself. In April 1800, Cornelia Knight sailed from Palermo with the Hamiltons on board Nelson's flagship *Foudroyant*, and reported in her autobiography that, among other things in the great cabin, '*a carving in wood of an immense three-coloured plume of feathers, which ornamented the cap of the figure of William Tell, when the ship so named struck to the Foudroyant; four muskets taken on board the San Josef by Nelson in the battle off Cape St Vincent, and the flag-staff of L'Orient, saved from the flames when that ship was blown up in the battle of the Nile, formed the chief ornaments of the cabin.*'[11]

Nelson is known, too, to have kept as mementos a writing slope and a snuff box both made of *L'Orient*'s timber, the French Admiral Brueys's silver fork from *L'Orient*, and a gold medal depicting Cardinal Borromeo, said to be cut from the neck of a Spanish sailor in one of his battles. A '*List of Sundries*' at James Dodds in Brewer Street, dated 5 March 1801,[12] includes among Nelson's furniture in store '*1 coffin; 1 piece of a ship's mast; 1 large piece of the wreck of a ship*', which we can assume are his *L'Orient* souvenirs.

Even in his own lifetime Nelson received such public adulation that he must have been aware that supporters were beginning to collect mementos of his victories. Joseph Allen of Greenwich Hospital wrote in his *Life of Nelson* of 1852: '*After the Battle of the Nile, scarcely a line – a note – a scrap of paper bearing Nelson's writing upon it was lost sight of. Everything relating to him was carefully treasured up.*' He evidently regarded personal items of clothing and equipment as suitable gifts for admirers who asked for a souvenir of his battles, and there are some relics that owe their survival entirely to such chance disposals. One of these is the coat he had worn at the Battle of the Nile, which he gave to the sculptress Anne Damer after he had sat to her for a bust depicting him wearing the uniform.

ᵗ

2	French Plated Sauce Pans — Sollee	1	Butter D: Gilt D:
6	very old Salts. — D:	1	Cheese d:
		2	Sugar Ladles

Plated Tea Service

		18	S: G: Tea Spoons
2	Oval Toast Trays — D:	1	D: Sugar Tongs
1	15 inch. Waiter — D:	18	D: Desert Spoons
1	Tea Kettle Lamp and Stand — D:	18	D: D: Forks
1	Egg boiler — D:	18	D: — D: Knives
1	D: frame blue Salt — D:	7	Oyster Forks
1	Old Coffee biggin Lamp and Stand D:	1	Punch Ladle 2 Toddie D:
1	Fluted round Sugar bason — D:	1	S: G: Toddie D:
1	D: Cream Ewer — D:	12	Lables
1	Muffin Plate and Cover — D:	8	Small Skewers
1	Toast Frame		
1	Old Sugar Stand blue Glass — D:		## China
1	Stand for Honey Glass — D:		### Horatia Set.
1	Small Cannister — D:	2	Tea Pots and 1 Stand

Knives & Forkes

		12	Breakfast Cups and 12 Saucers
		11	Tea Cups and 12 Saucers
11	Cap & ferrelled Table Forkes Sollee	12	Coffee Cups and 12 Saucers (1 broken)
9	D: — D: — Desert d: D:		2 Moss basons
1	D: — D: — Carver D:	2	Cream Ewers
18	Plated desert Knives D:	2	Sugar bason (1 broke) and 1 Stand.
1	D: Table D:	12	Breakfast Plates
2	Twisted Cap and ferrelled Carving Knives	4	Bread and butter d:
1	pair fluted Jt up Silver ferrells D:	2	Honey Hives and Covers
3	Fluted Jt up desert Knives D: — D: D:	1	Butter Cooler Cover and Stand
1	Beaded Carving Knife	6	Egg Cups
1	Desert Knife and fork D:	6	Punch Strainers
		6	Wine Cups Covers & Stands

Spoons & Forks.

			### Supper Set.
1	Fish Knife		
1	Asparagus D:	2	round Water dishes and Covers
2	Butter D: —		

Twelve inch Dish.
Ten inch Do

Nelson Set
Desert Service

Ice Pails with linings and covers
Plates
Sugar Tureens
Centre Dish
Dishes (Oval)
Do (round)

Tea Service

Cups and 13 Saucers
Slopbasons
Sugar bason & cover
Cream Ewer
Bread and butter Plates

Hamilton's Arms Service

12 /2 in. round dishes
11 — — Do
9 3/4 — — — Do
8 /2 deep — Do
Plates 4 broken
Plates India China
Do Turners Patent
Scollop Shells

Botanical Set
with Gold border

2 Ice Pails Covers & linings.

1 Centre Dish.
4 Corner Do
4 Shell dishes
2 Oval Do
2 Long Shap'd Do
2 Sugar dishes Covers and Stands
24 Plates

Botanical Set
with narrow brown borders

24 Plates
2 Baskets and Stands
4 Shell dishes
4 Square Do
2 Oval Do

White and Gold Desert

2 Ice Pails Covers and linings
4 Square dishes (One broken)
4 Long Shap'd Do
2 Long Shap'd Do
4 Shell — Do
2 Oval — Do
2 Do — Do smaller
1 Centre — Do
2 Sugar Tureens and Covers
One stand One Tureen broken
18 Soup Plates
59 Dinner Do
29 Desert Do
1 Oval dish.

3

approach from her husband to Alderman Smith on 22 March 1822 received the reply: *'In respect to unpacking the China it will be attended with very great inconvenience and danger I am fearfull after so many years laying in my Warehouse much will be damaged* [?] *and as it is my intention to sell it by Auction* [in] *the course of the spring I will inform you of the time and give you the opportunity of selecting out the Service you are anxious to possess with the Arms of Nelson which I shall be ready to part with under the advice and approbation of Mr Salter.'*[27]

It appears that the goods listed in the Bill of Sale of 1814 remained packed in crates at Alderman Smith's warehouse until 1831. A letter from Mrs Smith of 25 May that year indicates that the crates had been sent to John Kinsey in Southwark for safekeeping. Some items, such as the sabre and the sword, had already been disposed of, and the remainder were sold off by Mrs Smith after her husband's death in 1844, including the Trafalgar coat and waistcoat and a box of Nelson letters.

Horatia had nine children and did not die until 1881, twenty years after her husband. Her eldest son, Horatio, who became rector of Radstock, assumed the surname Nelson-Ward, and fulfilled his mother's wish to donate some of her most treasured heirlooms, including the pigtail, the velvet Trafalgar stock and a pearl-framed miniature of Nelson, to Greenwich Hospital.[28] Through this line many other Nelson relics were passed down, supplemented by other material later purchased by the family. In 1939 the large Nelson-Ward collection was presented to the National Maritime Museum in memory of their grandmother Horatia by the Reverend Hugh Nelson-Ward, on behalf of himself and his brother Admiral Philip Nelson-Ward CVO, who had died in 1937. The collection of sale catalogues of Nelson relics and papers which was also included in this acquisition now provides a most valuable resource.[29]

In 1957 the widow of Horatia's grandson Maurice Suckling Ward gave an important collection of Nelson relics to the Victory Museum, now the Royal Naval Museum, Portsmouth, in memory of her husband. Among these relics were the small silver-gilt cup bought by Nelson for Horatia before he left England in 1805, Emma's silver-gilt goblet, and the watercolour of Horatia by Edridge, which Nelson had displayed in his cabin, all described more fully in the catalogue section. The Nelson-Ward family was evidently widespread and more recently small collections of material have appeared from this source. Today, Mrs Anna Tribe, with her daughter, represents the Nelson line of descent through his daughter Horatia. She is rightly proud of her lineage, is a Vice-President of the Nelson Society and the 1805 Club, and can be seen supporting the various Nelsonian activities celebrating the bicentenary of Trafalgar.

Frances, Viscountess Nelson, being estranged from Nelson, was not left specific mementos in his 1803 will, although she received a financial bequest. She was to receive an income of £1000 a year, but there were complications which led to legal proceedings with Nelson's brother, William. Lady Nelson also retained some personal Nelson items already in her possession and from Lloyd's Patriotic Fund she received one of the large silver-gilt Trafalgar vases, which is now in the Royal Collection. On 29 January 1810 Lady Nelson wrote to William Marsh of Messrs Marsh & Creed: *'The vase the Patriotic Fund voted me is finished and I will thank you to direct Messrs. Rundle and Bridges to send it down to me taking care to have it insured if necessary.'*[30]

After Nelson's death at Trafalgar, his brother the Reverend William Nelson was created first Earl Nelson, with an estate annexed to the title; Standlynch, near Salisbury, was purchased by the government in 1814 for £120,000 and renamed Trafalgar House. He was also presented with one of the three large silver-gilt Patriotic Fund Trafalgar vases, which is now in the collection of the NMM. Under the terms of Nelson's will the Earl received his City of London gold freedom box and the Nile captains' sword, which were eventually stolen from display in the Painted Hall of Greenwich Hospital in 1900, as will be described in Chapter 4. He was also bequeathed *'the diamond-hilted Sword given to me by His said Sicilian Majesty, the diamond Aigrette presented to me by the Grand Signior, my Collar of the Order of the Bath, Medals of the Order of Saint Ferdinand and Insignia of other Orders'*, to be held in trust as heirlooms associated with the Dukedom of Bronte.

On the death of the first Earl Nelson in 1835, the Sicilian title, along with the items left in trust to the Dukedom of Bronte and other Nelson silver, porcelain and relics, went to his daughter Lady Charlotte, who in 1810 had married the Hon. Samuel Hood, later second Baron Bridport. She died in 1875 and her son General Alexander Nelson Hood, first Viscount Bridport, inherited the Nelson heirlooms. Photographs were taken of groups of the most important objects in *c.*1889, and in 1891 the General exhibited some of these relics at the Royal Naval Exhibition, Chelsea. The photographs provide us with very useful information on the collection before the major items were dispersed in a series of sales in July 1895. The detailed entries and illustrations in the Christie's sale catalogues are also invaluable as reference sources, and some copies of the catalogues have annotated prices and names of purchasers. Nelson's orders and medals were purchased for the nation, but most of these items were stolen from Greenwich Hospital in 1900. Of the other relics from the Bridport sales, some are now in the NMM and are described in the catalogue section of this book, and the remainder went to various private and public collections, including the Royal United Service Museum in Whitehall. Some items descended through the

Bridport family, and a number of these were on loan to the NMM between 1947 and 1978. At this time some were purchased by the NMM, a few sold at auction and the rest retained by the family.

Horatio, Viscount Trafalgar, son of William first Earl Nelson, predeceased him in 1808, so that when William died in 1835, aged 77, the earldom went to his nephew Thomas Bolton junior, son of his sister Susannah. The second Earl, however, died only ten months after his uncle, and was in turn succeeded by his son Horatio, a boy of twelve. The contents of Trafalgar House were sold off in a four-day sale on 6 to 10 July 1835 by Messrs E. Foster and Son at Salisbury Assembly Rooms. Later Horatio, third Earl Nelson, attempted to supplement

LEFT: NELSON'S ORDERS OF CHIVALRY, FREEDOM BOXES AND PRESENTATION SWORDS, PHOTOGRAPHED FOR GENERAL LORD BRIDPORT c.1889.

his remaining part of the family's Nelson collections, purchasing additional relics, paintings and documents, and accepting gifts from friends and admirers of the Admiral. The third Earl was himself extremely interested in the history of the Nelson relics and questions of their authenticity, although in his collecting he may not always have adhered strictly to his own guidelines. In 1904 he wrote in an article entitled 'Nelson Relics and Relic Hunters' in *The Windsor Magazine*.[31]

As a guide to a collector of Nelson relics, I would mention three authentic sources to which relics should be traced—

1. The things which were found in his cabin in the Victory at the time of his death. Some of the more private of these were returned to Lady Hamilton, and are now in the possession of Mr Nelson Ward, Horatia's son. Some were given as special mementos to friends or his servant; but the bulk of them were divided between William Earl Nelson and his sisters, Susannah (my grandmother) and Catherine (Mrs Matcham).

2. Anything that could be traced to the Viscountess before 1802.

3. Anything that can be traced to Merton and Lady Hamilton through Alderman Smith, who took charge of the things she left behind when he advanced money to enable her to get out of the King's Bench Prison and to go to France.

Of course, in addition to these, there were many presents given by the Admiral to friends in his lifetime and under his will...

From the first source mentioned I received a very paltry share, as the things sent to the Bolton family were divided among the members of the family in the certain hope that my father would inherit the family heirlooms; unhappily these were left by William Earl Nelson to his daughter, Lady Bridport, and were eventually sold at public auction by her son.

Earl Nelson also furnished a Nelson Room at Trafalgar House and allowed it to be photographed for publication. An article on the Nelson Room by W. H. Hosking appeared in *The Windsor Magazine* for October 1903,[32] and another by S. Bridge-Worth in *Pearson's Magazine* for 1905, in the special Trafalgar Centenary issue. Photographs of the Earl's and other relics were also repro-

duced in *Nelson & His Times*,[33] published in periodical parts, and other books. The third Earl Nelson died in 1913, aged 90.

In 1946, after World War II, the Trafalgar Estates Act ended the pension on the death of the fifth Earl, and the family was obliged to sell Trafalgar House and its Nelson collections. In 1948 the NMM at Greenwich, through the generosity of its major benefactor, the Scottish shipowner Sir James Caird Bt of Glenfarquhar, purchased a large collection of more than 140 items of Trafalgar House material, including the silver Turkey cup, which Nelson had bequeathed to his elder sister, Susannah Bolton. The present ninth Earl Nelson, Peter John Horatio Nelson, who succeeded to the title in 1981, takes an active interest in his illustrious forebear and is President of the Nelson Society.

Nelson had bequeathed to his younger sister, Catherine Matcham, his City of London sword. She evidently received a number of other Nelson relics, some of which are still with the Matcham descendants. At the end of January 1806, Nelson's young nephew George Matcham was summoned to London by Mr Bolton and returned to Bath with various presents and mementos, including *'a shirt, waistcoat and stock of our dear Lord's, and some medals'*.[34] In his diary for 27 June he wrote, *'My Father… had just come in the coach from Salisbury. After breakfast Mama came (from Hinton)…. My Father brought with him a sword given to Lord Nelson, which he left to my Mother.*

28th Assisted my Mother to unpack the plate chest, found it very handsome.'

In 1817 George Matcham married Miss Harriet Eyre of Newhouse, Wiltshire, a near neighbour of his uncle Earl Nelson. Many Nelson relics descended through his line, some of them now in public collections. One of Nelson's coats, now in the collection of the NMM, came through the Eyre Matchams, and his splendid City of London sword is in the Museum of London. Nelson's diamond *chelengk* was also purchased for Greenwich from the Matcham family in 1929, and the sad tale of subsequent events will be revealed in Chapter 4.

From 1965 to 1979 a large collection of silver, ceramics, table linen, clothing and other important Nelson items with irrefutable provenance was on loan to the NMM from descendants of the Matchams. The silver included four sauce tureens and covers with Nelson's coat of arms, four salt-cellars, a quantity of his spoons and forks, and two plated hot-water dishes and covers. There were glass decanters, rummers and wine glasses, and a tea service of the Baltic set. Among the other china was a service with small sepia landscape views on the border, which was said to have been painted by Catherine Matcham as a gift to her brother. Nelson's linen included tablecloths and napkins and a flannel under-shirt, and there was also his silver-gilt box for the Freedom of Oxford and Nelson's prized diamond-mounted cane from Zante. All these items were returned to the family in 1979.

In the 1930s a number of important relics came to the NMM through another family member, Miss Frances Girdlestone. Her father was the Revd Henry Girdlestone, who married Anne Bolton, the daughter of Nelson's eldest sister Susannah; Frances's uncle Thomas became the second Earl Nelson. In July 1935 the 95-year-old lady, *'full of fire, and spirit, and vivacity'*, visited Sir Geoffrey Callender, first Director of the National Maritime Museum, and showed him one of Nelson's coats in her possession, which had been given to her father by Nelson's servant Tom Allen. Then *'She packed it up and carried it away with her, vowing that she would not part with it under £500. "I can see that you do not want it," she said jestingly.'*[35] In 1937 a benefactor, Sir Percy Malcolm-Stewart Bt, purchased it from her for the NMM. From the same source came one of the Lloyd's silver sauce tureens from Nelson's Copenhagen service, a pair of crested decanter stands, a silver tea set and drinking glasses. When she died, Miss Girdlestone bequeathed to the Museum her treasured Nelson desk. Other members of the large Girdlestone family had moved to South Africa in 1872, taking with them more Nelson silver and furniture. Some items later appeared in the salerooms, but others, including a silver Nile covered dish, remain with the family in South Africa.

Nelson bequeathed to Alexander Davison a Turkish gun, scimitar and canteen, which his son William in turn bequeathed to Greenwich Hospital in 1873, although by this time the Turkish scimitar had apparently been switched for another weapon, and inscriptions added to all three items. Clearly Davison must have retained many other Nelson relics, including his guineas found after Trafalgar, which had been made into a reliquary. The Nelson cenotaph, as it became known, eventually became part of the Nelson Museum's collection at Monmouth, but following a robbery was vandalized and the guineas stolen.[36]

When Davison found himself in financial difficulties, he was obliged to sell off most of his important art collection, and this included some Nelson relics such as the cenotaph and the enamel miniature of Lady Hamilton by Bone.[37] Evidently not everything was sold, however, and in 2002 his descendants, now living overseas, were found to be still in possession of a number of Nelson-related objects, including porcelain and a purse which may have been used at Trafalgar. This intriguing discovery will be considered in more detail in the next chapter.

All Nelson's telescopes were bequeathed to another friend, Thomas Masterman Hardy, commanding the *Victory*, who served with him until his death. Evidently Hardy also retained some mementos of Nelson and Trafalgar, including another Nelson purse, now in the NMM. The telescopes became scattered, and one or two of them appeared later in naval exhibitions, or with various Hardy descendants, including MacGregor of MacGregor. Unfortunately, while these Hardy items are very credible, other more dubious material, said to have come through a descendant of Hardy's brother, appeared in the salerooms in the 1930s and has complicated matters, as we shall see later.

Over the years, the owners of Nelson material, which might otherwise have been lost or further dispersed, have approached the Nelson collections at Greenwich, Portsmouth, Monmouth and other museums to offer it for sale or as gifts. When there is a naval exhibition, or a special display to mark a particular anniversary, the publicity usually uncovers more objects. Such material always requires very close inspection, as there is an increasing likelihood of dubious items appearing, now that the commercial value of Nelson relics has become so inflated. The story of how the collections were formed at Greenwich Hospital, HMS *Victory*, Royal Naval Museum, Portsmouth and the Royal United Service Museum, as well as Lady Llangattock's collection bequeathed to Monmouth and the various naval exhibitions and Nelson displays, will be continued in another chapter.

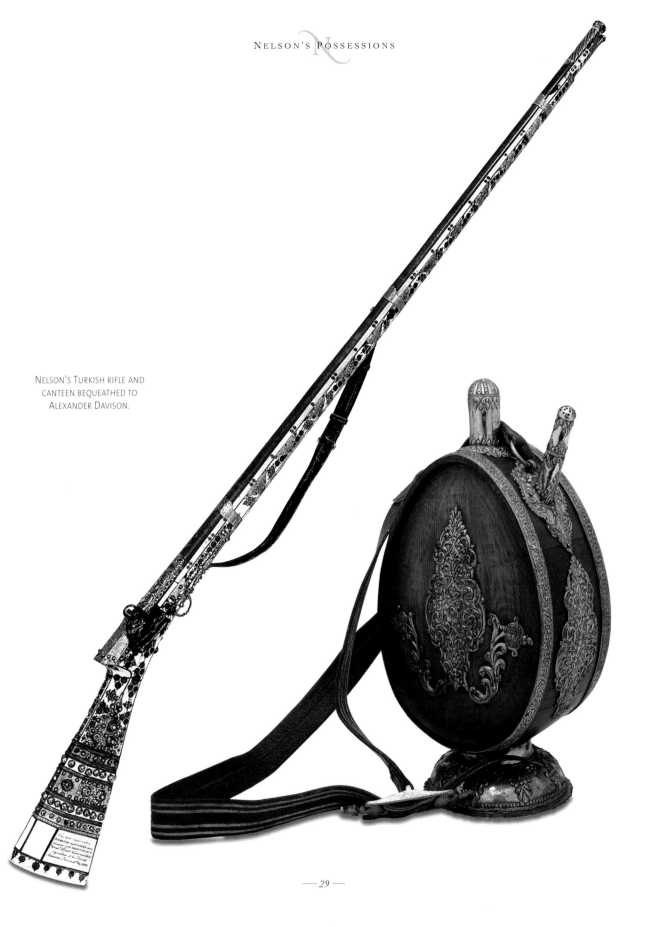

NELSON'S TURKISH RIFLE AND
CANTEEN BEQUEATHED TO
ALEXANDER DAVISON.

Chapter Two

NELSON IN THE SALEROOM

Salerooms and specialist dealers have always played an important part in the history of the Nelson relics, and the catalogues of Nelson sales provide valuable source material for researchers today.

The early sales

In 1809, Mr Christie at his Great Room, Pall Mall, held a three-day sale from 8 to 10 June of books, prints and sculpture, '*The property of the late Sir W Hamilton, KB and the Rt. Hon. Lord Viscount Nelson deceased: Removed from his Lordship's late Villa at Merton*'. Christie's still holds an annotated copy of the catalogue, but it is, of course, difficult to guess how many of the items were Nelson's own. However, at the end of the second day's sale was lot 138, a two-volume book, *Museum Worsleianum*, with a note that it was presented by Sir Richard Worsley to Lord Nelson. There were also many naval prints and engravings of Nelson and Lady Hamilton, and the last lot in the third day's sale was an antique marble figure of the Nile presented by Sir Richard Worsley '*soon after the glorious achievement of the late Illustrious Hero at Aboukir*'.

Mr James Abbott of 150 New Bond Street held an auction of Emma Hamilton's property on Thursday, 8 July 1813. An annotated copy of the sixpenny auction catalogue[1] at the NMM gives the prices fetched by each item. Most of the pieces sold were furniture, glass, porcelain and household linen, which we have no way of identifying as items personally used by Nelson, although, of course, doubtless some were objects he knew at Merton. Some lots were quite likely to be associated with the Admiral, such as lot 15, '*Two large trunks and 2 sea chests*', and others were indisputably his. Lot 88, '*The freedom of the city of Oxford, and gold box, as presented to Lord Nelson in the year 1802*', which fetched £20, was to find its way into the possession of Nelson's sister's family, the Matchams, and still exists. Lot 89 was '*A snuff box made from the mast of the L'Orient man of war*', which is likely to be the box of that description which later went to the Greenwich Hospital collection and thence to the NMM. Lot 94, '*A*

[gold box] *set with brilliants, with a portrait of His Majesty'*, might well have been a presentation to Nelson. Unfortunately, although the large porcelain dinner and dessert services are listed, the brief entries give no description of the patterns, so it is impossible to relate them to the services we know from the inventories to have been at Merton.

We have already seen that Nelson bequeathed to Alexander Davison his Turkish canteen, gun and sword, but it is known that Davison also acquired a considerable amount of other Nelson material for his extensive collection. Later he fell into financial difficulties. In 1808 he was tried for irregularities over commission on government contracts, for which he served a prison sentence, and in 1817 he was obliged to sell off most of his highly valuable art collection. The sale of the *'Entire Property of Alexander Davison'* by Mr Farebrother at St James's Square started on 21 April 1817 and lasted for fourteen days. The catalogue of the sale included a number of interesting Nelson items. Lot 418 on day four was the ormolu cenotaph or reliquary with Nelson's guineas, and lot 711 on day six the marble Nelson bust by Flaxman. There were examples of Davison's Nile porcelain mugs and medals and a huge statuary urn to Nelson's memory, which has recently come to light again. Some important miniatures were sold on 28 April, day seven. One was a large enamel of Emma as a Bacchante by Bone, to be sold again for 140 guineas in 1823, another *'a highly finished miniature of Emperor Paul from the hilt of a sword given to Lord Nelson'*. Most important of all was lot 830, *'An exquisite miniature of Lady Hamilton with her hair and initials at the back, worn by the Immortal Nelson at the time of his death'*, which is now displayed at the Royal Naval Museum, Portsmouth.

S. Leigh Sotheby & John Wilkinson of London sold at auction on 31 March 1853 a large collection of Nelson's Chamberlain's Worcester porcelain service, *'elaborately and beautifully painted with flowers and symbols, very richly gilded and ornamented in colours with his arms, coronets, motto etc.... As a few pieces have been presented to some of the Nobility as interesting souvenirs, Messrs L S and W have arranged the remainder in appropriate lots, for valuable ornaments or for use.'* The 119 pieces were sold in small lots of two to seven items, which explains why this service is now so widely scattered. They were the last lots in a sale of important Nelson manuscripts, which included the last, unfinished letter to Lady Hamilton. At this sale Pettigrew's[2] collection of Nelson letters was sold to Mr Joseph Mayer.

The Bridport sales

Perhaps the most important Nelson sales of the nineteenth century were the series of auctions held at Christie, Manson and Woods in 1895, when the relics owned by the Right Hon. Viscount Bridport were sold. The first of these was on 11 July 1895, and comprised mainly porcelain. Next day the

most significant items were Nelson's silver and other relics. A third sale included only prints.

The porcelain sale started with a number of pieces of oriental porcelain, with no obvious Nelson interest. Lot 41, however, was *'An old English white ware breakfast service, painted with key-pattern borders in red, and gilt bands, and with coronet, crest and arms of Admiral Lord Nelson in colours and gold, consisting of a large jug, cream-ewer, basin, six large tea-cups, five coffee-cups, twelve saucers and an egg-ring – the jug signed Absolon, Yarmth'*. Surviving pieces of this service, believed to have been owned by William, first Earl Nelson, actually have the Earl's coronet rather than the Admiral's, but no pieces marked *Absolon* are now known.

The next twenty-three lots are described as *'A Bristol tea and coffee-service, painted with wreaths of oak foliage and acorns in green and gold, and with Admiral Lord Nelson's coat of arms, with supporters'*. The items listed are a circular sucrier and cover, an oval sucrier and cover, and four oviform muffineers. There are also two milk jugs, two basins, and many teacups, saucers and beakers. The decoration is described as *'with inscriptions "Nelson, 2d April, Baltic", in medallion, with anchor, "Glorious 1st of August, San Josef, Aboukir, 14th of February", and festoons of drapery in blue'*. Each lot sold for between seventeen and thirty-six guineas.

Clearly these are part of the oak-leaf services comprising the Nelson and Baltic sets, which today can be found in various museums and private collections. However, we now believe the Nelson service to be by John Rose of Coalport, with additional French pieces, rather than from the Bristol factory, and the Baltic set is probably Paris porcelain. The Greenwich pieces have come through a variety of sources, from the Trafalgar House collection of the earls Nelson, the Nelson-Ward family and private collectors. Two pieces in the NMM can certainly be traced back to the Bridport sale, by the old paper labels still stuck on their bases. An oval sucrier and cover which came via the Nelson-Ward family in 1946 has a label *'Worcester, sucrier of the tea service made for Admiral Lord Nelson decorated by Baxter, Sold by Christie and Manson July 11 1895. Trapnell'*. The other piece is a saucer, which came through the collector Sir Henry Sutcliffe Smith, and is labelled *'Cup and saucer bought from Mortlocks who bought the service at Christies in 1895'*. A second label specifically mentions that it was sold at the Bridport sale of 11 July 1895, although strangely, this is not a piece from the original service but a copy. Mortlock & Son purchased much of the porcelain and sold it to collectors at its Oxford Street showrooms.

None of the other Bridport porcelain in this sale can definitely be associated with Admiral Nelson, although it is possible that other pieces may have been his. The sale concluded with two pieces of sculpture, a life-sized bust of Nelson by J. Flaxman and another of William Pitt by J. Nollekens, both sold by Viscount Bridport. The foregoing gives some idea of the complexity of tracking

CATALOGUE

OF

Old English Silver & Silver-gilt

PRESENTATION PLATE,

ENAMELLED GOLD BOXES,

GOLD SWORD HILTS, MEDALS, ORDERS,

And other Highly Interesting Objects,

FORMERLY IN THE POSSESSION OF

ADMIRAL VISCOUNT NELSON;

AND OTHER

Old English & Foreign Silver Plate,

THE PROPERTY OF

THE RIGHT HON.

VISCOUNT BRIDPORT:

WHICH

Will be Sold by Auction by

MESSRS. CHRISTIE, MANSON & WOODS,

AT THEIR GREAT ROOMS,

8 KING STREET, ST. JAMES'S SQUARE,

On FRIDAY, JULY 12, 1895,

AT ONE O'CLOCK PRECISELY.

May be viewed Two Days preceding, and Catalogues had,
at Messrs. CHRISTIE, MANSON and WOODS' Offices, 8 *King Street*,
St. James's Square, S.W.

particular objects through the salerooms, even when we can be sure that the provenance is good. Ceramics in particular are a problem, as unmarked pieces may be variously described over the years by different collectors and saleroom cataloguers as having been the work of quite different factories.

Christie's sale next day, 12 July 1895, was devoted to the Bridport silver, which included much of Admiral Nelson's, as well as other precious relics such as his City of London freedom box, orders and medals, and the *chelengk*. The catalogue is illustrated with three pages of photographs of Nelson objects, fourteen relics in all, including the freedom box, two sword hilts, a combined knife and fork, medals and orders. Since many of these items were stolen from

Greenwich Hospital just five years later, the Bridport catalogue provides a vital source for researchers. A copy of the catalogue at the NMM is annotated with the buyers and prices fetched in the sale, which makes it an even more valuable source.[3]

The catalogue includes brief descriptions, the weight of each piece and, in the case of the most important items, a transcription of the presentation inscription. The first section is devoted to silver services. Many pieces have no reference to Nelson, although it is possible that some of the items may have come from that source. The first specifically Nelson items are lots 120, 121 and 122. Lot 120 is the *chelengk*, described as '*An aigrette of rose diamonds. Presented to Lord Nelson by the Sultan of Turkey after the Battle of the Nile.*' This sold for £710 to Frazer and Haws, court jewellers, on behalf of Mrs Constance Eyre-Matcham. The next lot was '*A Brooch, formed of pastes, which formed the fastening to the "Cloak of Honour" presented to Lord Nelson by the Sultan of Turkey after the Battle of the Nile*'. The 'cloak' must refer to the sable pelisse. The brooch went for £260 to Sir W. Fraser.

Lot 122, '*A brilliant necklace, consisting of the stones removed from the Sword of Honour presented to Lord Nelson by the King of Naples*', sold to Mr Haws for the high price of £1250. The necklace was identified in 1952 as being in the possession of the Earl of Mexborough, and a photograph published in *Country Life*.[4] The remains of the sword itself, described as '*a gold sword hilt, chased and spirally fluted, and thickly studded with paste diamonds*', was sold as lot 171. It fetched only £170, a reflection of the fact that the original jewels had been replaced. We shall meet this relic again later in our story, at Monmouth.

Lots 123 to 165 comprise the Nelson silver '*engraved with the Arms and Coronets of Admiral Viscount and Earl Nelson*'. Here we can plainly recognize some pieces now in the collections of the NMM and Lloyd's. The fullest descriptions are for a pair of circular entrée dishes, part of Lloyd's Nile service, and two pairs of ice pails, covers and liners with Lloyd's Copenhagen presentation inscription, one pair of which is now at Greenwich. The entrée dishes sold to Spink's for £155 the pair, and the pairs of ice pails went for £400 and £370 to Mr J. A. Mullens of Battle and Mr Thomas J. Barratt.

The silver dinner plates with gadrooned borders and Nelson arms appear here as lots 140 to 143 (forty-four dinner and soup plates in all) and were bought by Spink's. Georgiana Marcia, Lady Llangattock, collector of Nelson relics, of whom we shall hear more later, purchased lot 150, a large oval tea tray. Most of the silver in the catalogue is not attributed to particular makers or exactly dated, so we cannot be absolutely sure that these are the same as pieces in present-day collections. However, lot 132, a jug and cover by Paul Storr with bands of basket pattern, on a tripod stand with lamp, purchased for £109 by S. J. Phillips, is the hot-water jug with Earl Nelson's arms which was

subsequently bought by Mr H. Panmure-Gordon for Greenwich Hospital. Also here are the boat-shaped sauce tureens from the Copenhagen service, circular salt-cellars, tea services, flatware and even a pair of table candlesticks and a toast rack, all marked with a coronet and initial 'N'.

The remainder of the sale catalogue lists '*Objects of art, medals, orders, and articles of personal use of Admiral Nelson*'. Lot 166 is an oval silver-gilt inkstand mounted on an oak stand, inscribed underneath '*William and Emma Hamilton to Nelson, Duke of Bronte, their dear friend*'. This was purchased by Lady Llangattock for £520 and is now at Monmouth. This is followed by a circular silver freedom box for Plymouth, conferred in January 1801, bought by Mr Wilson for £90, and an oblong oak and silver box with the Freedom of Thetford, conferred in 1798, which went to S. J. Phillips for £85 and was afterwards bought by Mr Panmure-Gordon (late of the 4th Hussars) for Greenwich Hospital and is now in the NMM.

One of the most important items in the sale was a gold and enamel freedom box from the City of London, presented to Nelson on 28 December 1797, and originally valued at 100 guineas. This box, lot 169, which we know to have been one of a series of superb boxes by James Morisset, fetched £1050 in the sale and went to Mr J. A. Mullens, who presented it to Greenwich Hospital. The enamel plaque on the lid was painted with a view of the Battle of Cape St Vincent, and Nelson's ship *Captain* was engraved on the base of the gold box. The full

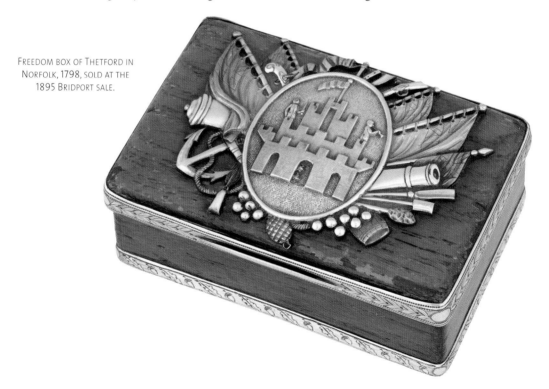

FREEDOM BOX OF THETFORD IN NORFOLK, 1798, SOLD AT THE 1895 BRIDPORT SALE.

presentation inscription is transcribed in the catalogue. From these details and the illustration in the catalogue we can see that this is a pair with Vice Admiral Charles Thompson's freedom box, also for Cape St Vincent, acquired recently for Greenwich. Unfortunately, the Nelson box was stolen in the 1900 robbery and this precious item was never recovered. The Bridport catalogue entry is an important source of information for this unique relic, which is also illustrated in third Earl Nelson's *The Nelson Whom Britons Love* (c.1900) and in Beresford & Wilson's *Nelson & His Times* (1897–8).

OPPOSITE, TOP: COMBINED KNIFE AND FORK, AND MEDALS FROM THE 1895 BRIDPORT SALE CATALOGUE. BOTTOM: NELSON'S ORDERS OF CHIVALRY FROM THE 1895 BRIDPORT SALE CATALOGUE.

The gold sword hilt shaped as a crocodile, presented by the captains of the fleet after the Battle of the Nile, came next. Nelson's arms were on the hilt, and a view of the battle was enamelled on the guard, with the names of the Nile captains. A photograph and the full presentation inscription are given in the catalogue, and we know that the hilt fetched £1080 and went to Mr Mullens. This too was stolen from the Painted Hall five years later.

Nelson's gold combined knife and fork was bought by Mr Mullens for £260, then a patch box with his hair went to Lady Llangattock, and two gold Davison Nile medals were bought by Glendining's and Spink's. These were followed by ten lots comprising the '*Medals and Orders, with their original ribands, worn by Lord Nelson at the time he was killed at Trafalgar*'. Here are listed the Naval Gold Medals

PRESENTATION SWORDS AND CITY OF LONDON FREEDOM BOX FROM THE 1895 BRIDPORT SALE CATALOGUE.

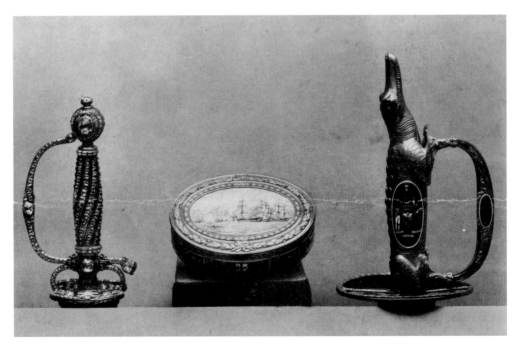

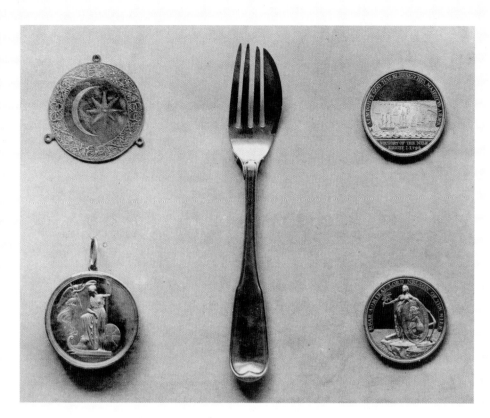

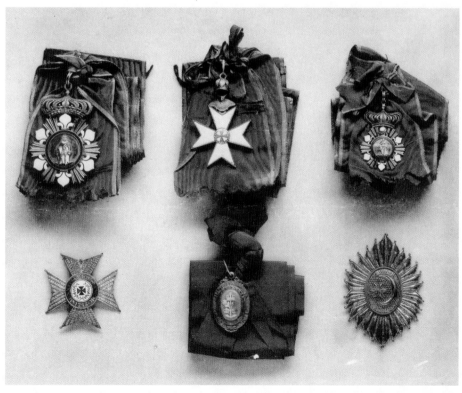

for St Vincent and the Nile, Jewels of the Order of the Bath with riband, St Joachim (the Jewel with riband and the Grand Cross), St Ferdinand (the Jewel and the Grand Cross, both with ribands), the Gold Star of the Turkish Order of the Crescent and two embroidered badges of the Order of the Crescent. The orders and medals, which are all illustrated, were withdrawn before the sale and purchased for £2500 by the nation.[5] They were mostly lost when the Nelson relics were stolen from the Painted Hall. The sale ended with a gold Trafalgar medal, named for Nelson but obviously awarded posthumously, and a few personal items, some small gold buckles, shoe buckles and three left-hand chamois-leather gloves worn by Nelson. The Bridport family must have retained similar items, as Greenwich later acquired some gold breeches buckles and two of Nelson's left-hand gloves from that source.

A few months later, a sale at Christie, Manson & Woods on 28 January 1896 included a few Nelson relics previously exhibited at the RUSI, which had formerly been the property of Lady Hamilton and were purchased with her house at Richmond by Alderman J. J. Smith, from whose son they passed to the vendor. These included the patent Morgan and Sanders folding bedstead from HMS *Victory*, which is now back on board the ship. There was also one of Nelson's table napkins with his crest and motto, and a supper service of Wilson creamware with the red key-pattern borders and coat of arms of the first Earl Nelson. The press reported, *'There is a very marked taste just now for Nelson relics, and the supply seems to keep pretty well up to the demand. Yesterday Messrs. Christie sold some seven articles which came in this category, and they all raised very high prices. For instance, Lord Nelson's mahogany bedstead from the Victory, a folding arrangement in three divisions, with dwarf turned legs, intrinsically worth "nuppence", brought 37 guineas, the purchaser being a lady who bore her treasure off in a "growler".'*

Twentieth-century sales

On 20 June 1905 a sale of Nelson and other naval relics was held at Foster's Gallery in Pall Mall. This was the collection made by Lieutenant William Rivers RN, Nelson's aide-de-camp at Trafalgar and subsequently appointed Lieutenant Adjutant of Greenwich Hospital. The catalogue gives the provenance: *'After his death, the Collection passed to his son, Horatio Elphinstone Rivers, Esqr., of HM Civil Department of Greenwich Hospital, afterwards Treasurer of Morden College, Blackheath. After his death in 1901, the Collection was held in the possession of his Widow, Mrs Sophia Rivers, who had a life interest in his property. Mrs Sophia Rivers died in October, 1904.'* The items included the figurehead of Nelson's funeral carriage, which sold for 20 guineas and was catalogued as: *'This, together with the stern lantern, was given by the Commissioners of Greenwich Hospital to Lieut. Wm. Rivers,*

after it had been kept some years in the Painted Hall, Greenwich 1850. Certified letter of Lieut. Rivers, and notes on its subsequent history.' There were also two gilt letters 'A' from the same funeral carriage and the white ensign hoisted at the stern, as well as the union flag that covered Nelson's coffin (74 guineas). There was a Davison gold Nile medal, said to be the one presented to Nelson (96 guineas), a silver shoe buckle (27 guineas) and two small wisps of Nelson's hair, one entwined with a fragment of bullion from the epaulette and given to Lieutenant Rivers by Captain Williams, which went to Mr Montagu for 125 and 70 guineas.[6]

Christie's sale of 17–18 July 1905 included items from the collection of Colonel Horatio Mends of Bishop's Waltham. These comprised the epaulette said to have been worn by Nelson when he lost his arm at Tenerife and a gold ring received from Ferdinand King of Naples after the Battle of the Nile, both of which had descended through Josiah Nisbet's widow to the Mends family. The sale also included twenty-five pieces of silver flatware with Nelson's crests. The next day Christie's sold the small-sword presented by Commodore Nelson to Captain George Cockburn (lot 26), now in the NMM, and the reliquary or cenotaph of Nelson guineas (lot 27), which was later stolen from Monmouth.

In Sotheby's sale of 22 December 1919 some of the Rivers collection items, including the funeral carriage figurehead, the letters 'A' and the lock of hair, appeared again. In the same sale was Nelson's bureau from the *Victory*, with the mark of a round shot on one of the drawers, from descendants of Admiral Sir George Augustus Westphal, and the piece of bullion from Nelson's Trafalgar coat which Westphal had saved.[7] The sale also included Nelson's uniform sword by Salter (lot 215), which was sold together with a number of documents and sworn affidavits stating that the sword was among the crates of Nelson's possessions with Alderman Joshua Jonathan Smith in 1830.

A group of Nelson silver items was included in a sale at Hurcomb's of Piccadilly on 17 May 1929. The illustration in the saleroom's advertisement is captioned, *'On Thursday last I motored 180 miles in Middlesex, Surrey, Sussex and Berks, making twelve calls. The most interesting one was on a descendant of Lord Nelson, who has entrusted me with the sale of a fine teapot, sugar basin, and cream jug – all same date and pattern – six boat-shaped salt cellars, sauceboats, gold snuffbox, and a ring (illustrated). Also miniature of Nelson when a midshipman…. All are crested with the stern of the St Joseph and the Nelson and Bronte crest and coronet. A very fine intaglio ring of Lady Hamilton by the most famous intaglio cameo carver of the day, which Lord Nelson had made at Naples.'* The sauce boat has the full Copenhagen inscription and the ring has now found its way to the collection of the NMM.

Glendining's of London held a sale of Nelson relics in its Oxford Street galleries on 5 June 1930. Many of the lots, *'the property of a collector'*, Mrs E. Nevill Jackson, a writer on antiques, were commemorative, but the sale also

included Nelson's embroidered Orders of the Crescent and St Ferdinand from the Bridport sale, now privately owned, and items of his crested silver flat-ware, as well as a Nelson memorial ring. Lot 32 was Nelson's seagoing dressing case, which was a mahogany three-tier fitted box, bought at the sale of effects of Admiral Fitzroy at Grafton Regis, where Nelson's code and other books had been sold. It evidently failed to impress, however, and was sold to a collector for £24.

In the early 1930s a series of London sales featured some rather unconvinc-ing Nelson relics, as well as other items associated with Hardy and naval figures of the time, and various mementos of the Battle of Trafalgar, all said to have been the property of one Pamela Hardy. These were mostly minor items, although they included a few pieces of furniture, but these will be dealt with in Chapter 5, as many of them are now thought to be from a dubious source.

However, on 17 July 1935, lot 91, a circular silver entrée dish and cover by Henry Chawner, 1794, with the arms of Lord Nelson, was the chief lot in a sale at Christie's in London. *The Times* report mentioned *'crests of the Victory and the Vanguard'*, which could be a mistake for *San Josef*. This is now in the collection of Lloyd's. On 30 April 1936 a collection of Nelson relics was purchased from

PAIR OF WINE COASTERS WITH
NELSON CRESTS, SOLD 1936.

Sotheby's, London, for the NMM by a benefactor, Sir Percy Malcolm-Stewart. The most important item was a silver sauce tureen and cover by Daniel Pontifex, 1801, part of the Lloyd's Copenhagen presentation, which fetched £500. He also purchased Nelson's silver teapot by John Emes, 1801, for £80, a matching sugar basin and cream jug by William Fountain, 1797, for £90, a pair of wine coasters engraved with Nelson's crests for £80, a small Sheffield-plate tray or teapot stand with the initials 'NB' for £13 and a set of four cut-glass rummers engraved with initial 'N', for £15. The tea set had previously been sold by Sotheby's on 13 December 1922, and all the pieces came with certificates of authenticity. The provenance was good, for they had been owned by Miss Frances Girdlestone, descended from Nelson's sister Susannah.[8] All these items were Nelson's own property and came off the *Victory*. The tea service is said to be the one he used when entertaining his captains in his cabin. *The Times* reported, '*In the same sale, from another source, came a silver goblet, the gift of Horatia, Nelson's daughter, to her friend and pastor, Mr Lancaster, and so inscribed, which was also acquired by Mr Stewart for £90.*' This goblet, by John Emes of London, was also purchased by Malcolm-Stewart for the NMM.

An inscribed silver vegetable dish with a domed cover and *chelengk* finial from the Lloyd's Copenhagen service, 1801,was sold at Sotheby's on 4 November 1937, lot 37, and illustrated in the catalogue. *The Times* reported, '*A remarkable price was paid… it was worth as old silver perhaps £50 to £60, but owing to its historic associations Sir Henry Lyons had to go to £840 to secure it…. Sir Henry Lyons advises us that in all probability he will present the piece to Lloyd's…. The dish formed part of the collection of the late Sir R Leicester Harmsworth, and two other Nelson pieces from the same collection went comparatively cheaply to Messrs Spink and Son. A tankard engraved with the monogram HN and the arms of Earl Nelson of the Nile made £55, and a small cup engraved with the initials N and B and the arms of Admiral Viscount Nelson, KB, went for £68.*'[9]

Another important piece of the Lloyd's Nile service was sold at Christie's in November 1965.[10] This was an oblong silver entrée dish and cover by Paul Storr, 1801, also with the full Nile inscription and *chelengk* crest handle. The dish, one of four in the original service, which had been the property of K. C. Johnson, was illustrated in the catalogue. During 1971 two of the Copenhagen service plates were sold, as well as candlesticks and flatware with Nelson's crests and coronets.

There always remains a possibility that genuine Nelson relics from the large ceramic and silver services, which became widely dispersed among collectors a very long time ago, might appear in the salerooms. A typical item was the instantly recognizable cup and saucer with Nelson's crests from his Chamberlain's Worcester service, which was sold by Sotheby's in January

1979.[11] This would have made a very desirable acquisition for any collector's cabinet. Nelson's other main heraldic porcelain service, that with the oak leaves and coat of arms, also occasionally appears in the salerooms, although the later copies are more usually encountered. A good authentic piece, a slop bowl from the original oak-leaf service, was sold at Sotheby's in February 1988.[12] The same bowl had been previously sold by Christie and Manson in the Bridport sale of 11 July 1895, and is known to have been formerly in the Trapnell porcelain collection. With such a good provenance, this small piece fetched five times the estimate.

It was in a general sale of English porcelain that a very fine example of a unique Nelson teapot from the Chamberlain's of Worcester service came to light in 2001. It is known that there were originally two teapots in this service, both of which, unlike most other items in the service, were painted with the complete Nelson coat of arms in full colour. The other teapot was known to be in the collection of the Museum of Worcester Porcelain, but this example was of a slightly different design. It was obvious that such a unique piece as lot 281 would be hotly contested in the Sotheby's sale of 12 June 2001, and this was indeed the case. While it would have made an ideal museum-piece, the hammer price of £28,000 was too high for public funding. However, the teapot remains in England, and is now part of one of the major private Nelson collections, so its importance is fully appreciated.

The Davison sale

It should never be assumed that all the extant Nelson relics have been accounted for. When such items become part of family collections, they sometimes get passed down through many generations. If they are not loaned to public exhibitions, but treasured in private or held on to for investment reasons, they may become lost to the public view for long periods. Sometimes families even lose track of the true significance of collections or individual important items, until they seek specialist advice from museums or dealers. The most important discovery of this type in recent years was that of the Alexander Davison collection. A major sale at Sotheby's in 2002, fittingly on 21 October, which featured this collection created huge media and public interest, and resulted in a follow-up publication in 2004, *Nelson's Purse* by Martyn Downer, Head of Jewellery at Sotheby's.

The 1817 sale of Davison's property described earlier in this chapter had appeared to be the end of the Nelson story for the Davisons. However, in 2002 Sotheby's was called to an overseas client to assess an anchor-shaped diamond brooch, among other items found in the proverbial attic. The brooch proved to be owned by descendants of Alexander Davison, who then revealed many other

related objects and manuscripts. The discovery resulted in a sale devoted to this one collection, which contained much material of interest to Nelson specialists. The manuscripts, including Davison's correspondence with Lady Nelson, have shed new light on Nelson's own life, but this is the province of other authors.

The sale also included a number of extremely interesting objects with possible Nelson associations, some of which still need further research and explanation. It is very tempting to jump to conclusions about the history of material from such a promising source, but the problem is that, good as the provenance is, the family did not inherit detailed notes or a catalogue of the collection. Perhaps in the future other evidence might come to light which will help to answer some of these intriguing questions. However, even though the collection is now widely dispersed, the catalogue of the sale, with its splendid photographs of all the objects, provides a valuable modern source for those interested in trying to decipher the complexities of the Nelson relics.

OVERLEAF: PAIR OF DERBY ICE PAILS FROM SOTHEBY'S 2002 DAVISON SALE.

Although many objects in the Davison collection, such as the Derby porcelain with shipping scenes by George Robertson, do not claim a Nelson association, there are other previously unknown pieces of Derby porcelain bearing Nelson's coat of arms, which are of the highest importance to our story, as they may once have been owned by Nelson himself. We shall look at these in the catalogue section. Of the other objects in the sale, the one that particularly caught the public imagination was the purse, which, it was claimed, was carried by Nelson at Trafalgar and was apparently stained with blood. In the sale the purse fetched four times its estimate, selling for an amazing £270,650. When recently found, it contained gold guineas and an incomplete paper note listing the coins in Nelson's possession after the battle. The problem is that there was already another purse at Greenwich, which had been in the Hardy family until 1880 and exhibited in 1891 as the purse that Hardy had taken from Nelson's body at Trafalgar. The provenance of both purses is reasonable and credible, and their claim to be Nelson's equally valid. The Hardy purse comes with a good long-term family story, and has no connection with the dubious Pamela Hardy relics, which only appeared in the 1930s; the Davison purse came to light as part of the Davison family collection some two hundred years after the event. The purse problem is symbolic of so many of the difficulties surrounding the authenticating of Nelson relics. In the absence of immediate proof we can only note the evidence and hope that future Nelson research will reveal further clues to the truth.

Other Davison items in the sale pose similar conundrums. A large diamond brooch, shaped as an anchor and with the letters 'HN', comes with no explanation at all. The catalogue suggests it was a gift from Nelson to Emma *c.*1801 and

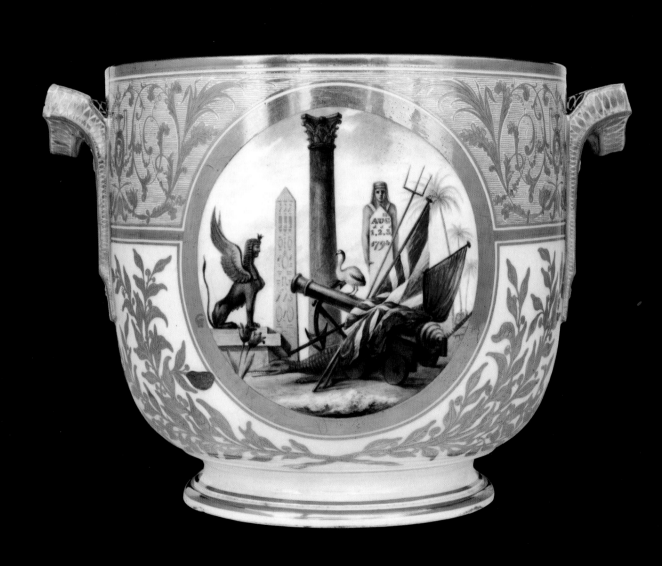

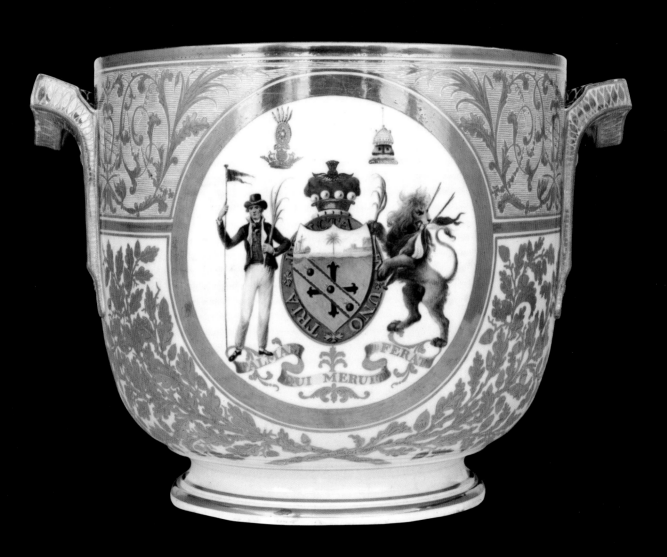

SILK PURSE AND GOLD GUINEAS FROM SOTHEBY'S 2002 DAVISON SALE.

was placed in Davison's custody after Nelson's death, but we have no concrete evidence to support that. In *Nelson's Purse*, Martyn Downer guesses that Emma might have arranged to convert Nelson's Turkish diamond star, which she had inherited, into this brooch in his memory. Again, we await the proof. Equally intriguing, if perplexing, relics in the Davison sale include the sword or 'scimitar' which is mentioned later, in the catalogue section of this book, and a gold Davison Nile medal, which Downer has suggested may be Nelson's own copy.

He quotes a Davison family inventory of 6 April 1866 in which a Davison Nile medal is listed as '*the Gold Nile medal worn by the immortal Nelson when he fell 21st October 1805 at Trafalgar*'.[13]. In fact no contemporary account of Nelson at Trafalgar mentions him wearing his gold medals in the battle, although the replica stars sewn to his undress coat always feature in the descriptions. There are other problems with identifying this Davison medal as Nelson's personal medal, as it is variously supposed to have been stolen from Greenwich Hospital in 1900 or sold through the salerooms to a private collector. It is likely that this particular problem can never be fully resolved, since none of the Davison gold medals bore individual names. We know that Nelson had more than one example of the medal, and Davison himself must almost certainly have retained specimen medals in gold and bronze-gilt.

The Davison sale catalogue illustrations include other items of particular interest and value to researchers of Nelson relics. Two manuscripts relate to Lord Nelson's business with Rundell & Bridge, the court silversmiths. Lot 24 is an '*Estimate of a service of dishes for the Right Honble Lord Nelson, Rundell & Bridge, Nov 20, 1800*', together with a sketch of the dishes laid out for two courses, with detailed annotations. Lot 25 is the bill for this plate purchased for Nelson by Lloyd's, and including the '*strong Iron bound Wainscot Chest partitioned & lined with green baize to contain the above*', which is now in the RNM Portsmouth. Another interesting lot, 23, includes '*A list of the Packages Examined at the Custom House belonging to Lord Nelson 10 Octr 1800*'. The items listed in the thirty-one packages include pictures, plate, glass, a hanger and gun, '*1 coffin*', and '*sundry articles of household furniture*'.

As a result of so many sales over the years, private collectors, as well as Nelson descendants, now own many interesting and important Nelson items. Some of these objects will be treasured for centuries as family heirlooms, but others will doubtless be sold again, it is to be hoped with their provenance details intact to assist the next generation in assessing their saleroom finds. We might leave the last word on collecting to Horatio, third Earl Nelson, describing in 1904 one buyer who had made generous donations to Greenwich Hospital and the Royal United Service Museum:

Mr T A Mullens is the best type, who, having spent £3,000 in saving Nelson relics at the Bridport sale, wrote, in repudiation of my letter of thanks; 'Purchase gave me possession of these treasures, but, in my opinion, a mere transfer of money gave me no right to treat them as my own private property, and in handing them over to the nation, I have only done what any Englishman in my place would have been eager to do. [14]

Chapter Three

NELSON DISPLAYED: MUSEUMS AND SPECIAL EXHIBITIONS

*S*oon after Nelson's funeral in January 1806, his funeral carriage was put on exhibition in the Painted Hall of Greenwich Hospital, where his lying-in-state had previously taken place. The elaborate carriage remained in the Hall, as popular prints show, until *c.*1826, by which time it had badly disintegrated. Eventually it was broken up, and a few remaining fragments were saved by individuals. Some of these pieces are now on public display in museums, and others appear from time to time in salerooms.

Meanwhile, in St Paul's Cathedral, where the funeral service had taken place, members of the public were able to visit his tomb in the crypt. Despite Nelson's declaration before the Battle of the Nile in 1798, *'Before this time tomorrow, I shall have gained a Peerage or Westminster Abbey,'* the Abbey had not been chosen for the honour of his interment. Now, in competition with St Paul's, Westminster Abbey added to the historic royal effigies already displayed in the crypt an effigy of Nelson, wearing some items of his own clothing. The wax head and left hand were modelled by Catherine Andras, wax modeller to Queen Charlotte, and the figure was originally exhibited in a gallery in Pall Mall. It was moved to the Abbey in the spring of 1806, and can still be viewed there today, displayed with Nelson's own hat by Lock's of St James's, complete with its green eyeshade.

Following the Battle of Trafalgar, *Victory* was refitted and remained in active service. After 1812, when she was paid off, she was extensively altered in appearance and laid up in harbour at Portsmouth, where by 1816 she had become a tourist attraction, with public visits by boat. In 1824 Trafalgar pensioners celebrated Trafalgar Day there, and in later years a special Trafalgar Dinner became an annual tradition on board, with Queen Victoria participating in 1844. The *Victory* was rammed and nearly sunk by the *Neptune*, ironclad, in 1903, and had to be docked for repair. After World War I the deteriorating condition of the ship made it necessary to move her permanently into dry-dock, and in 1922 she was moved to her present position in Portsmouth Dockyard in

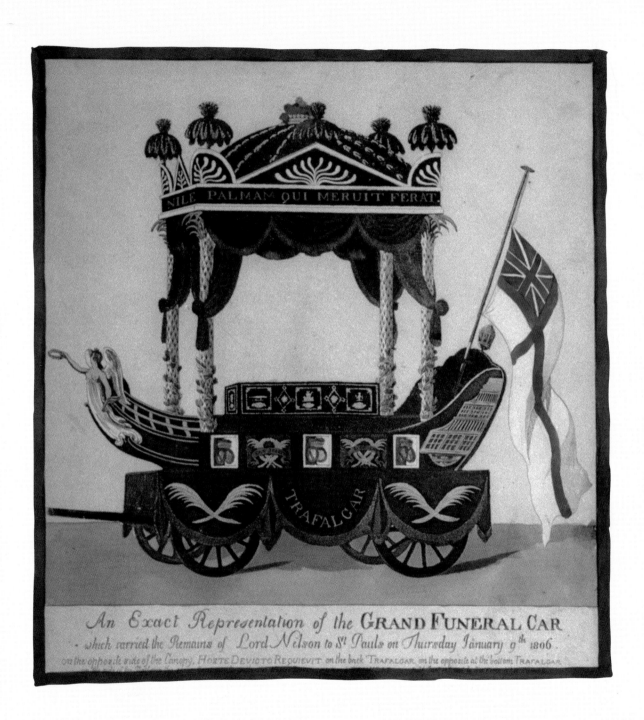

AQUATINT OF NELSON'S FUNERAL CARRIAGE, PUBLISHED BY S. W. FORES, 13 JANUARY 1806.

No. 2 Dock. A public appeal launched by the Society for Nautical Research, with the approval of the Admiralty, raised funds to preserve the ship and restore her to her Trafalgar appearance. Although she continued in commission as flag-ship of the Commander-in-Chief, Portsmouth, she had also become a national 'relic' of Trafalgar, with her cabins and gundecks being restored.

The quantity of Trafalgar-period furniture and Nelson-related objects and paintings which had been collected led to the setting up of the Victory Museum alongside to accommodate material not suitable for display on board. The museum, which was originally in the old Rigging House by the *Victory*'s dock, opened in 1930, and a new building was constructed on the site in 1937. The most striking exhibit in the museum was the state barge of Charles II, which had been used to convey Nelson's body from Greenwich to Whitehall Stairs in readiness for his funeral. Many mementos of Nelson and the *Victory* were added to the collection, as well as exhibits from the old Portsmouth Dockyard Museum, which had been founded early in the century. Today, HMS *Victory* and the present Royal Naval Museum in the dockyard continue to display a wealth of Nelson relics and commemoratives. Among these is a collection of objects from Maurice Suckling Ward, Horatia's youngest grandson. Other items once owned by Nelson include silver, porcelain and glassware; rings, seals and other jewellery; books; and his plate chest and shipboard furniture. Some intimate relics of Nelson and Emma have been loaned to the bicentennial exhibition at Greenwich. In 1972 Mrs Lily Lambert McCarthy OBE donated her life-long collection of Nelson memorabilia, which is now displayed in its own gallery in the Royal Naval Museum, Portsmouth.[1]

In 1823 Edward Hawke Locker carried out his father Lieutenant-Governor William Locker's suggestion of 1795 that the Painted Hall of Greenwich Hospital should become a National Gallery of Marine Paintings. In addition to the numerous naval portraits exhibited, the Greenwich Hospital Collection of Nelson relics was put on display in the Upper Hall. The growing collection of Nelson's possessions on view to the public there eventually included Nelson's coat and waistcoat worn at Trafalgar, his uniform worn at the Nile, his orders, medals and gold boxes, silver and many other priceless relics.[2] Sadly, some of the most precious items were stolen from the Painted Hall in December 1900 and have never been recovered,[3] but fortunately the uniforms and many other personal possessions survived. Later these became the core of the Nelson collections of the National Maritime Museum, established by Act of Parliament in 1934.

In 1838 Robert Browning referred to the Nile coat displayed in the Painted Hall at Greenwich in his poem 'Here's to Nelson's Memory', when he wrote:

He says at Greenwich they point the beholder
To Nelson's coat, 'still with tar on the shoulder'.
For he used to lean with one shoulder digging,
Jigging, as it were, and zig-zag-zigging
Up against the mizzen rigging.

Early guidebooks to Greenwich describe the Nelson exhibits, and popular prints enable us to get a very good idea of the appearance of the Nelson displays. The engraving which appeared in *The Illustrated London News* on 25 March 1865 shows visitors viewing Nelson's Trafalgar coat and waistcoat in a Victorian display case with a hinged wooden lid, which could evidently be closed down to protect and secure the garments.

In March 1926 Virginia Woolf, after a visit to Greenwich Hospital, recorded in her diary, *'behold if I didn't burst into tears over the coat Nelson wore at Trafalgar with the medals which he hid with his hand when they carried him down, dying, lest the sailors might see it was him. There was, too, his little fuzzy pigtail of golden, greyish hair tied in black; and his long white stockings, one much stained, and his white breeches with the gold buckles, and his stock – all of which I suppose they must have undone and taken off as he lay dying. Kiss me Hardy, etc., Anchor, anchor, – I read it all when I came in and I could swear I was on the Victory, – so the charm worked, in that case.'*

The other London repository of maritime relics at this period was the museum of the Royal United Service Institution.[4] This housed a unique collection of material relating to naval and military affairs and personnel, including ship models, uniforms, weapons, medals, pictures and personal relics. The museum was founded in 1831 as the Naval and Military Library and Museum, originally housed in Vanbrugh House in Whitehall Yard. In 1895 it was transferred to the Banqueting House of Old Whitehall Palace, where it remained until the collection was dispersed in the 1960s.

Among the trophies and relics that had gradually accumulated in the old museum were a substantial number of items with Nelson associations.[5] These included two of his cocked hats, one worn at the Battle of Copenhagen and a foul-weather hat with a waterproof crown, two combined knife and fork sets, silver ice pails from the Lloyd's Copenhagen service, his Trafalgar purse, watch, shoe buckles, cane, and even some of the spirit in which his body was preserved on board *Victory*. The *Official Catalogue of the Royal United Service Museum* was reprinted several times, and the 1932 edition lists 8506 items in total, with an index which allows the Nelson items to be found easily. After the museum was dispersed, some of the Nelson material went to the NMM and other museums, and some to descendants of the original donors, but the fate of some items has gone unrecorded.

While permanent museum displays enabled generations of visitors to view the nation's public Nelson collections, a number of temporary exhibitions commemorating British naval history collected together important objects from private and public sources for limited periods. The scope of such exhibitions ranged from small localized displays marking particular anniversaries to spectacular undertakings, the ambition of which could not fail to impress even today's public, accustomed as we are to the sophistication of the best shows that modern designers and display techniques can produce.

On 2 May 1891 a great Royal Naval Exhibition opened in the grounds of Chelsea Royal Hospital, on the site of the Royal Military Exhibition held the previous year. The suggestion of a naval exhibition was first mooted in the autumn of 1890, and amazingly, barely seven months later the display of 5354 historic maritime objects and paintings and state-of-the-art presentations of naval equipment was open to visitors. The exhibition was supported by an ambitious daily programme of band music, drills, field gun displays, balloon ascents, fireworks and other special events. In the grounds a replica of HMS *Victory* was built for visitors. A wide range of specially written and illustrated publications was for sale, including a detailed printed catalogue, an illustrated souvenir priced at one shilling, and the *Pall Mall Gazette Extra* illustrated handbook, for sixpence.

The introduction to the official souvenir stated: '*At Her Majesty's Dockyards, at the Royal Naval College at Greenwich, and in various other public places, as well as in the possession of private persons, there are many objects of public interest... which, if brought together, would admirably illustrate the Naval History of the Nation.*' But there was clearly more at stake in the success of the exhibition than a pleasing display of naval memorabilia, as the modern naval equipment features of the show made plain. Although it is outside the scope of the present book, the part played in naval propaganda at this period by the 1891 Royal Naval Exhibition and the 1905 Trafalgar centenary celebrations, and the consequent resurrection of Nelson as a heroic figure in the national mythology, should not be overlooked.[6]

The display was presented in four main sections: the Arts, Navigation, Models and Ordnance. It included galleries devoted to Arctic expeditions and naval heroes, and claimed to be '*probably the most interesting and valuable collection of Art treasures and Relics ever brought together*'.

The Nelson relics featured significantly in the exhibition, and it is reported that when the royal party toured the galleries after the opening ceremony, '*much interest was evinced in the various departments, the memorials of Nelson naturally eliciting special enthusiasm*'. These relics included Nelson's Trafalgar coat, his pigtail, the fatal musket ball, combined knife and fork, Copenhagen seal, Freedom boxes from London, Oxford, Thetford and Plymouth, and the eighty-four guineas

found in his possession after the Battle of Trafalgar, as well as his twelve orders and medals, lent by Viscount Bridport. The descriptions and illustrations in the catalogues and souvenirs provide us with valuable information about many of the Nelson relics still in public collections today. Each entry acknowledges the lender of the object, and an index of Arts Contributors even reveals addresses. Indeed, the only thing missing from the satisfyingly thick catalogue is a full index.[7]

Another loan exhibition was mounted at the Crystal Palace ten years later, in 1901. This was the Naval and Military Exhibition in aid of naval and military charities. Again a detailed catalogue was published, which included an extensive historic section. Thirty-three Nelson relics were lent by Lady Llangattock (items 1026–1056). These included a silver inkstand presented to Nelson by Captain Troubridge, two swords belonging to Nelson, a ring containing Nelson's hair taken off Lady Hamilton's finger after her death, various seals, buckles, gloves and silver boxes, and most amusingly, a *'seal always used by Lord Nelson, inscribed, "England expects every man to do his duty"'*.

The next year, in 1902, a Naval and Military Exhibition was held at Portsmouth. Although this largely consisted of prints and drawings, it also included some twenty Nelson items from private collections. Some were little more than mementos, such as souvenirs made from the wood of the cask in which Nelson's body had been brought back to England and from the *Victory's* rider against which he had died, but the catalogue compiler had taken some trouble to record in the descriptions the exact provenance of each item, which is of value to modern researchers. Less directly associated with Nelson, although significant as a part of the Trafalgar story, were the Lloyd's presentation sword and Trafalgar telescope used by Captain J. R. Lapenotiere, who had brought back the Trafalgar despatches in HM Schooner *Pickle*. These were lent by his descendant Miss Grace Lapenotiere, together with a lock of Nelson's hair cut off after his death by, it is said, Captain Lapenotiere.

Earl Nelson lent relics, including Nelson's seal as a Knight of the Bath and the silver and ivory Copenhagen seal with his full coat of arms. He also lent Nelson's Neapolitan cane, his Nile medal, three embroidered orders from one of his uniforms and examples of his Worcester porcelain service. James Griffin JP, the naval publisher of South Parade, Southsea, lent the cenotaph of eighty-four guineas previously mentioned, and the catalogue particularly advised that *'a history of the Nelson guineas in pamphlet form will be on sale in the exhibition, price 1d from the attendants'*.

The centenary of the Battle of Trafalgar in 1905 provided the most obvious opportunity to commemorate the event in the form of exhibitions and other festivities. A handsome illustrated catalogue was produced to accompany the Exhibition of Nelson Relics mounted at the RUSI in Whitehall. The exhibition

comprised two hundred objects, more than a quarter of them from the perma-
nent collections of the RUSI. Among these were Nelson's cocked hat worn at
the Battle of Copenhagen, his silver ice pails presented after the same battle, his
gold combined knife and fork, and the masthead and lightning conductor from
the French flagship *L'Orient*. Private individuals, including Nelson's descendant
William Eyre Matcham, loaned one of his uniform coats, his diamond-hilted
sword presented by the City of London, the Sultan's diamond *chelengk*, Nelson's
blue silk net purse and his cabin washstand.

Thirty objects were on loan from the Greenwich Collection by permission of
the Lords Commissioners of the Admiralty. These included the famous undress
uniform coat, waistcoat, breeches and stockings worn by Nelson at Trafalgar,
his pigtail, the Nile coat, and his Turkish gun, sabre and canteen. A special
Trafalgar Centenary Number of the *United Service Gazette* includes a useful illus-
trated supplement on the exhibition written by B. E. Sargeaunt, then Curator of
the RUSM. He explains, with one eye firmly on the recent Entente Cordiale of
1904, that the purpose of the exhibition was *'not so much to celebrate Lord Nelson's
victories, and thereby excite the feelings of foreign visitors to the Museum, as to demon-
strate his personal services, to value his fidelity to his country, and to appreciate his glorious
death. The Exhibition has been limited as far as possible to personal relics, and many
objects connected rather with his battles have been declined.'*

The other major London exhibition mounted to commemorate the Trafalgar
Centenary of 1905 was a huge Naval, Shipping and Fisheries Exhibition at
Earl's Court. According to the plan in the catalogue, two rooms in the Royal
Galleries, which surrounded the Imperial Court, were designated the Nelson
Rooms, and there was also a special *'centenary scenic spectacle'* commemorating
Trafalgar and the death of Nelson. Here the visitor could enter a separate build-
ing to view a circular painting of the battle by Professor Fleischer, which
measured 47 feet high and 370 feet in circumference.

The Historic, Art and Relic section of the exhibition included paintings,
trophies and not least the relics, described in a separate illustrated guide as *'a
collection of Naval relics which has never before been surpassed'*. Among the Nelsonic
treasures, in the words of the catalogue, *'the tourniquet that checked the bleeding
when his arm was sacrificed, his writing table from the Victory, and a host of unim-
peachable relics give rise to a flood of proud thought when inspected today…. These relics
give a personal touch of one, now long gone, but whose individuality saturates, with a
sense of glory, the minds of every generation of Britons…. These inarticulate mementos
illustrate and reflect with the convincing form of truth, the stern Admiral, the generous
friend, and the unswerving lover of his country…. All lovers of our sea power will have
an opportunity at the exhibition of inspecting a national collection under one roof that
will never be seen again.'*

SOUVENIR CATALOGUES FROM THE 1891 AND 1905 EXHIBITIONS.

The British Museum's Naval Exhibition for the Nelson Centenary in 1905 comprised manuscripts, printed books and medals commemorating not only Nelson but naval history in general, and that exhibition also had a published catalogue. There seemed to be no end to the availability of Nelson relics for display during the Trafalgar Centenary year. Although these London exhibitions must have swallowed up the majority of items, other special exhibitions were held at the Dorset County Museum in Dorchester, where Captain Hardy's relics were displayed with other Nelson material; in Norfolk, where a collector lent his Nelson memorabilia; and in other locations with strong Nelson associations.

Twenty-three years later, in 1928, an important Loan Exhibition of Nelson Relics was mounted at the London galleries of Spink & Son in King Street, St James's, opening on 11 May. The admission fee was two shillings and sixpence, and the entire profits were devoted to the 'Save the *Victory* Fund', which still required £10,000. Professor Geoffrey Callender, soon to be first Director of the National Maritime Museum, wrote the foreword to the exhibition catalogue. The greatest number of exhibits was loaned by the Revd Hugh Nelson-Ward, descendant of Nelson's daughter Horatia, and for this occasion they were reunited with three other Nelson relics, his pigtail or queue, the stock he was wearing at Trafalgar, and his miniature framed with pearls, which Horatia had earlier donated to Greenwich Hospital. Callender wrote: '*This benefaction of*

Nelson's only child may be recalled with singular appropriateness at the present hour when official sanction has been given for the establishment at Greenwich of a naval museum of national proportions and imperial significance. Is it too much to hope that the present generation will make it possible to carry still further Mrs Nelson Ward's desire, and, by a timely effort to reassemble what Merton once contained, will expiate the fault of the past?'

The exhibition catalogue listed an impressive display of objects, manuscript letters and books, and the entries for the sixty or more Nelson relics included interesting background notes and information on lenders. Apart from the Greenwich Hospital items mentioned above, *'no attempt has been made in the present exhibition to gather together Nelsoniana which may be seen at any time in public Galleries. The present exhibits derive their interest from the fact that (with one or two exceptions) they have hitherto been religiously guarded in private ownership and are now seen for the first time.'*[8]

Among these exhibits were the Sultan of Turkey's *chelengk* and Nelson's City of London sword with its enamelled hilt studded with diamonds, lent by the Eyre Matchams. Described by *The Times* as *'representing the hero from the baby-cap to the death mask'*, the exhibition also included many items such as his personal silver and porcelain table services, his naval commissions, books, shoe buckles, personal gold rings and seals and the miniature of Emma by Bone. Also on display was the figurehead and two letters from the funeral carriage, lent by the Revd Elphinstone Rivers, and a gold and enamel Nelson memorial ring. A letter from Professor Callender of 28 April 1928 reveals, *'The catalogue is now in print and for this reason we have omitted some interesting relics offered by the Duke of Bronte which came at the last hour. What I have suggested to the Duke is that the late arrivals should be included as soon as ever the first edition of the catalogue sells out – which I hope will be soon.'*

In more recent times there have been some more specialized small Nelson exhibitions, such as the display of 15 April 1967, 'Nelson and His Surgeons', mounted at the Royal Naval Hospital, Haslar on the occasion of a medical conference. Surgeon Captain P. D. Gordon Pugh compiled and edited a well-illustrated catalogue, which provides a useful reference source for Nelson researchers. Among the exhibits were the musket ball that killed Nelson, lent by Her Majesty the Queen, and the tourniquet used by the surgeon when amputating his arm and the medicine chest from his cabin, both lent by the Wellcome Historical Medical Museum. Nelson's razor was lent by the Victory Museum. The catalogue includes photographs of a number of other relevant Nelson relics, including his cocked hat with the green eyeshade.

In Autumn 2002 the Museum of Worcester Porcelain mounted a special exhibition, 'Nelson & Emma: Personal Pots and Lasting Mementos'. The

display included Nelson's Chamberlain's Worcester porcelain from the museum's own collection, the factory's ledger with Nelson's 1802 order for porcelain services,[9] and the bill for the completed pieces sent to Emma after his death, as well as many important items from the private Nelson collection of Clive Richards.

After the British victories at the Nile and Copenhagen, Lloyd's of London had voted Nelson considerable sums of money for the purchase of silver plate, in addition to distributing charitable donations to needy seamen and their dependants through Lloyd's Patriotic Fund. The silver is now to be found in various public and private collections, and seven of these pieces formed the nucleus of the Nelson collection at Lloyd's. From 1910 onwards, members of Lloyd's were acquiring pieces of the plate and other Nelson relics to present to the Committee. The original Nelson Room of the Lloyd's building in Leadenhall Street, specially designed for the display and security of the collection by the architect Sir Edwin Cooper RA, was inaugurated on Trafalgar Day 1931.

To accompany the display, Warren Dawson, the Honorary Librarian of the Corporation of Lloyd's, wrote *The Nelson Collection at Lloyd's*, a substantial history and catalogue of the plate and manuscript collections. After the publication of the book the collection continued to grow by gifts and purchases, and when Lloyd's moved into its new building in 1986 it was transferred into a specially designed modern display. Among the Nelson treasures which form part of the Lloyd's collection are his gold collar of the Order of the Bath, plates, dishes, sauce tureens and wine coolers from the Nile and Copenhagen services and other silver presentations, as well as precious boxes, jewellery and manuscripts. Over the years, items from the Lloyd's collection have been generously loaned for display in other Nelson exhibitions, including those at the NMM at Greenwich.

The collection in the Nelson Museum, Monmouth, was bequeathed to the Borough of Monmouth in 1923 by Georgiana, Lady Llangattock, mother of Charles Rolls of Rolls-Royce fame. Nelson had visited the town in 1802 with the Hamiltons. The museum was opened in 1924 and, among the important manuscript collections and Nelson commemoratives, there are many Nelson relics, including porcelain, silver, his service sword, a watch, the remains of the Nelson cenotaph, a prayer book and other items mentioned elsewhere in this book. There are also a number of less authentic items, such as other swords and silver, a compass and 'Nelson's glass eye', which certainly never had a genuine Nelson association. Lady Llangattock purchased enthusiastically in the salerooms and from dealers for many years, acquiring a wide miscellany of material, both genuine and bogus, and posing various problems of authenticity, which

recent curators have been at some pains to clarify. The Nelson Museum remains a popular local institution, and over the years it has loaned out its relics generously, despite having suffered a major burglary of Nelson material in 1953.[10] In 1952 it lent material to the Trafalgar Day exhibition held in Park Lane, London, as well as contributing to the exhibition at Nelson's birthplace in Norfolk commemorating the 150th anniversary of Trafalgar in 1955. In 1961 relics from the Monmouth collection travelled to Hereford and the United States, and in 1965 items were sent to Chatham for the bicentenary celebrations marking the launch of the *Victory*. The year 2005 sees Monmouth contributing to the bicentenary exhibition at Greenwich.

There are a number of small Nelson collections at other regional museums. The Castle Museum, Norwich, has the hat Nelson gave in 1801 when he sat for Sir William Beechey's portrait painted for the City of Norwich. There is also a penknife in a wooden sheath said to have belonged to Nelson as a boy. More interesting is a green-painted chair reputed to be from the *Victory*'s cabin, which gains credibility from the fact that it is an exact match for a chair at Greenwich, acquired with the same story.

The Maritime Museum at Buckler's Hard in Hampshire displays Nelson's baby clothes, consisting of caps and hoods, a shirt, breeches and socks, said to have been made in Burnham Thorpe and saved by his family. The story is that they passed into the hands of Earl Nelson, and ended up in the RUSM, being passed on to Buckler's Hard in 1963. There is also a lock of hair, an ironstone plate stand and an enamelled ring said to have come from Emma Hamilton.

Ever since the National Maritime Museum opened to the public in April 1937 with a splendid royal occasion, an important Nelson display has always been a prominent element in the permanent exhibition. The new museum assimilated important material from Greenwich Hospital and other collections, as well as from Nelson descendants and specialist collectors. Through the munificence of such benefactors as Sir James Caird Bt, it was also able to purchase many outstanding items. The original chronological display of the galleries, for which a printed catalogue was produced, culminated in a display on Trafalgar and the death of Nelson, although only the paintings were described in the printed guidebook. Alongside the permanent galleries, smaller special exhibitions on Nelson have given public exposure to the Nelson collections, as they have steadily been augmented by many generous gifts, loans and judicious purchases.

On 12 June 1948 the Museum opened an exhibition of the Trafalgar House collection of Nelson relics, recently purchased from Earl Nelson. The introduction to the slim catalogue states: '*It is a sad occurrence when old and famous families are forced to sell their treasures; it is particularly sad when the family name is Nelson and*

many Britons must have regretted the necessity of their so doing. But both the Nelson family and the nation must be pleased to learn that these sacred relics of our greatest Admiral have found a safe and lasting home at Greenwich, already the home of so many similar treasures.'

In July 1952 the Museum mounted a special exhibition on 'Nelson and the Nile', comprising mainly manuscripts and books. Then three years later, in June 1955, 'The Little Admiral: An Exhibition of Nelson & His Times' was mounted to commemorate the 150th anniversary of Nelson's death at the Battle of Trafalgar. The accompanying leaflet explained: *'The special exhibition is made up of material, some of it well-known but not usually seen by the public. There is, for example, a generous selection of manuscripts illustrating both Nelson's public and private life.'* As well as the manuscripts, which included examples of Nelson's commissions, honours and awards, there were displays of his plate, china, glass, linen, the figurehead of the funeral carriage and a fragment of the *Victory's* ensign. This was followed three years later by a booklet on Nelson and the exhibited relics, *Nelson & Bronte: An illustrated guide to his life and times*, published in 1958.

There have been constant redisplays and updates in the permanent Nelson exhibition at Greenwich, notably when the chronological displays were reinstalled in the new West Wing mezzanine galleries in 1978, and again in 1995, when a completely new Nelson gallery was designed for the first time by outside design consultants. For a few months the fatal musket ball was displayed alongside Nelson's Trafalgar coat with its damaged shoulder, as it has been to mark 2005. The ball, preserved by Surgeon Beatty after the autopsy, had been mounted in a locket with fragments of the bullion from Nelson's epaulette, and was lent by Her Majesty the Queen, in whose collection it remains.

Throughout its history, as well as displaying the Nelson collections at Greenwich, the NMM has improved public access to this unique material by making many loans to other museum exhibitions in the United Kingdom and overseas. The Nelson collections have always had a prominent place in the NMM's published guidebooks and souvenirs of the collection, but in 1995, to accompany the new display, the Museum produced a book, *Nelson: An Illustrated History*, which depicts in colour many of the most interesting Nelson objects in its collection. The year 2005 has been marked by a major Nelson loan exhibition, 'Nelson & Napoléon', accompanied by extensive published and online catalogues, to commemorate the bicentenary of the Battle of Trafalgar and Lord Nelson's death.

Chapter Four

A LOSS TO THE NATION

The historical and intrinsic importance of the Nelson collections has meant that, over the years, not only have questions of authenticity been a recurring problem, but Nelson's personal treasures have also been particularly marked out for theft. Material owned by his descendants and collectors only became well known to the public once it began to be publicized in exhibitions and illustrated magazines and books, and prices fetched in the salerooms made people all too aware of the financial value of such relics. In recent times museums and special exhibitions have protected Nelson objects with maximum security measures, but a century ago, in a more trusting age, these collections were very vulnerable. Displays of historically priceless objects were exhibited for the information of the public with what today would seem the naïve assumption that patriotic sentiment would protect them from criminal activity. Unfortunately this proved not to be the case.

Greenwich Hospital burglary

The turning point came in December 1900, when the Nelson relics which had been accumulated by the Admiralty and displayed publicly in the Painted Hall of Greenwich Hospital became the target of a burglary during the night of 8–9 December. Some of the most important of the Nelson relics were stolen at this time, most of them never to be recovered. Admiral Sir Robert Molyneux KCB, Admiral President of the Royal Naval College, reported to the Secretary of the Admiralty on 10 December 1900:

OPPOSITE: NELSON'S ORDERS OF CHIVALRY, PRESENTATION SWORDS AND OTHER POSSESSIONS, PHOTOGRAPHED C.1889.

When the Hall was opened by the Yeomen at 2pm yesterday they noticed that two glass cases containing the relics had been opened, the glass of one broken, and certain articles missing…. It appears likely that the theft was committed before dark and soon after the building was closed on Saturday afternoon at 4.00pm, for some of the articles had been taken to and left on a windowsill, presumably with the intention of examining them by such light as remained, only such articles being taken as could be easily carried in the pocket without attracting observation. If the theft was committed at that time, it seems

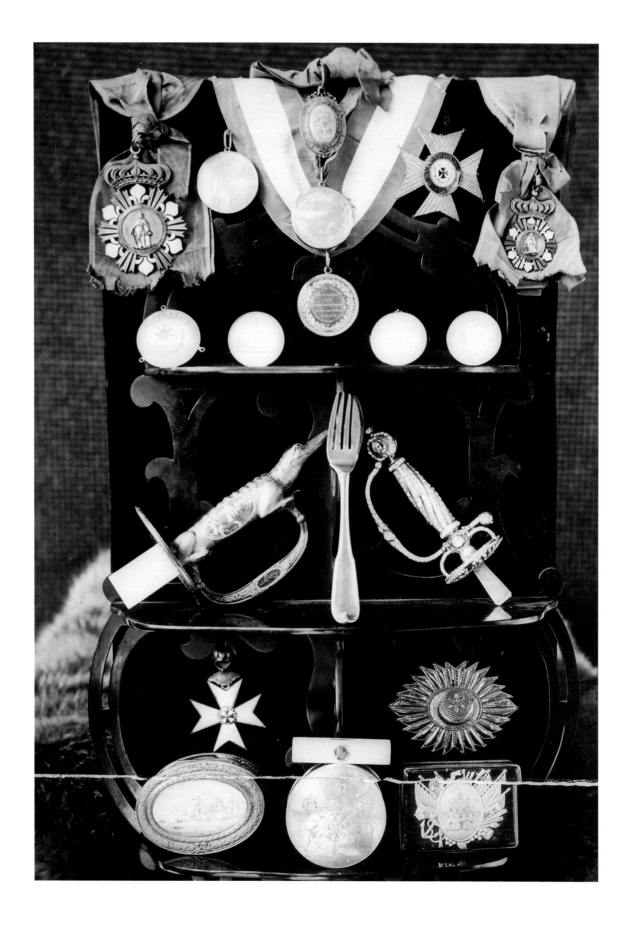

almost certain that the thief or thieves were concealed in the Hall when it was closed, and that the usual search before closing failed to detect them. [1]

A note following the report, evidently added after the detectives had examined the scene, mentioned that the broken case had been removed from the Hall and the remaining relics locked in the strong room so that *'No trace of the crime is therefore left to satisfy morbid curiosity'*. The stolen items listed in the report comprised thirteen medals, orders and valuable possessions of Nelson, and another five associated with Rear-Admiral Sir Thomas Louis. The police had apparently asked that the list of missing items should not be given to the press at that stage.

Next day *The Times* reported on page 11 under the headline 'Theft of Nelson Relics':

Between the hours of 4 o'clock on Saturday afternoon and 2 o'clock on Sunday afternoon almost all of the Nelson relics were stolen from the Painted Hall in the Royal Naval College, Greenwich. Although the robbery was discovered very soon after the relics were abstracted, none of them had been traced up to last evening. The relics were contained in cases set out in various parts of the hall, together with Nelson's uniform. The hall is open every day of the week to visitors, free of charge, and in a number of niches are large pieces of statuary. Behind these is ample room for anyone to conceal himself and it is generally accepted by the police that this was done in the present case. The hall was closed at the usual time on Saturday afternoon, and before closing the three keepers made the customary inspection of the place. Everything was then in order and safe. Shortly before 2 o'clock on Sunday afternoon the messengers came on duty to open the hall to Sunday visitors, and as soon as the door was opened it was seen that the cases containing Nelson's relics had been smashed and everything of value abstracted. Detective Inspector Gumner, of Scotland Yard, and Detective Inspector Felton of the R Division, were soon upon the scene, and a hasty examination showed that everything of value, except the uniform, had been taken. In the case of the swords, the hilts, which consisted of gold, had been wrenched off the blades, and the jewels taken from the scabbards. A number of people had arrived by this time to visit the hall, but they were informed that the place was closed. Prominent among the Nelson relics were the dress sword placed on Nelson's coffin when lying in state at Greenwich, an oval box presented together with the freedom of the City of London in 1797, jewels of the Order of the Bath, the Sicilian Order of San Joachim, the Neapolitan Order of San Ferdinando and Grand Cross of the same Order, Gold Star of the Turkish Order of the Crescent, Nelson's memorial bowl, a gold hilt presented by the captains of the fleet engaged in the battle of the Nile, a Turkish gun sent by the Sultan, Nelson's gold watch and seal, a medal commemorative of the battle of Trafalgar, and a medal commemorative of the restoration by Nelson of King Ferdinand IV to the throne of Naples. [2]

The presence of certain items on this list of stolen items which do not tally either with the Admiral President's list or with the later Metropolitan Police

reward poster suggests that *The Times* was making use of a current Painted Hall catalogue in the absence of an official list of missing items. Certainly the Turkish gun, the Grand Cross of the Order of St Ferdinand, the dress sword from Nelson's coffin and the memorial bowl were not stolen on that day. The newspaper report also claimed that the sword hilts had been '*wrenched from their blades*'. However, although the blade of Admiral Louis's gold-hilted Freedom of London sword had apparently been '*broken off and left behind*',[3] the blade of Nelson's crocodile-hilted sword had already been removed before it was sold in the Bridport sale of 1895 and added to the Painted Hall display.

Next day in its parliamentary column, *The Times* reported that Sir J. Colomb asked the First Lord of the Treasury for more information about the robbery of the Nelson relics '*and whether her Majesty's Government would consider the question of the removal of those that remain to the museum of the Royal United Service Institution, Whitehall, under conditions affording more adequate security for their safe custody*'. Mr Balfour replied that '*18 articles, of which 15 were Nelson relics, chiefly medals, were abstracted from cases in the Painted Hall at Greenwich Hospital. As the matter is now in the hands of the police I cannot give further details. A reward of £200 has been offered for the recovery of the articles, which I am informed, considerably exceeds their intrinsic value. The question of safe custody of the other articles is under consideration, and meanwhile they are locked up in the strong-room.*' Interestingly, in view of Mr Balfour's comment on the intrinsic value of the relics, the report concludes, '*Captain Norton (Newington W) was about to refer to the insufficient protection of these priceless national relics, but was ruled out of order.*'[4]

The £200 reward was duly announced in a Metropolitan Police poster dated 11 December 1900, which listed all eighteen of the missing items. The poster gives a very full description of two of the most precious objects, Nelson's City of London gold and enamel freedom box for the Battle of Cape St Vincent and the crocodile-hilt of his sword presented by the Nile captains. These had been part of the heirlooms which had passed to the Bridport family and had been sold at Sotheby's on 12 July 1895 (lots 169 and 170). They had been purchased by Mr J. A. Mullens of Battle and presented to Greenwich Hospital.[5] At the top of the list was the '*Watch (gold old-fashioned verge) and seal worn by Lord Nelson*', ultimately the only item to be recovered, and now in the collection of the NMM. Then came an enamel portrait of Lord Nelson in a gold case. Lower down the list were Nelson's medals and orders, and at the end came the sword hilt and medals of Admiral Louis, stolen at the same time from a second display case.

On 15 December 1900 *The Sphere* published an illustrated report of the theft, which the magazine described as '*a particularly despicable outrage on the nation*'. The account stated, '*By not taking the coat and waistcoat worn by the national hero at his death the robbers left what was of least value to them, and perhaps the dearest relic of all*

to the nation. At the time of writing there is no clue to the robber, but the police vouchsafe the suggestion that they are "hopeful".'

No more was heard until *The Times* of July 4 1904 reported in its Police Courts column: *'At Greenwich, on Saturday, William Alfred Carter, 22, a seaman, of Victoria Dock-road, Canning Town, was charged with being concerned in stealing and receiving, about December 9, 1900, from the Royal Naval College, Greenwich, a watch, seal, gold box, enamelled portrait, 29 (sic) old sword hilts, seven medals and other articles, value £5,000, the property of the Lords Commissioners of the Admiralty.'*

A lengthy explanation followed. It appears that in March 1904, Detective Inspector Charles Arrow had come by a letter dated 3 February that year, which began, *'Sir, I believe you were relieved some years ago of the custody of Lord Nelson's relics. Among the relics was Nelson's watch. I am led to believe I have the identical watch.'* The letter was addressed to the British Museum by a man in the Sailors' Home in Melbourne, Australia, who claimed he had obtained the watch from a drunken sailor. He described the watch as being bulky, of thick gold and decorated on the back with the stern of a man-of-war inscribed *San Josef*. Attached to it was a gold ring with a watch key and a red stone seal engraved with a woman holding out a snake in her right hand. A sketch of the watch and seal was sent with the letter, which requested a fair reward and threatened to destroy the watch if the police were called in. The writer, who signed himself 'Eucalyptus', suggested that *'Should you feel inclined to get it back without undue publicity and fuss, the best way is through the curator or head of the Melbourne Museum. By sending a full description of the relic and the promise not to prosecute, with £120, to the director of the museum, you will probably get it back.'*

A reply from the Director of Greenwich Hospital received no response, but a few months later, in July, a seaman, William Carter, came to Scotland Yard to enquire after the reward for information on the missing Nelson relics. He proved to have a record for petty theft, and had been released from prison a few days before the burglary, although he claimed to have gone to Australia in 1899. He admitted having written the 'Eucalyptus' letter himself and said he had the watch and seal in his luggage in the Victoria Dock Road, having only recently arrived in London from Hamburg. He also said he had seen a medal from the stolen Nelson relics in the possession of the sailor from whom he obtained the watch, as well as a gold snuff box in the hands of a Melbourne tobacconist who was also a receiver. Carter claimed never to have been to Greenwich Hospital and that he had thought the relics were stolen from the British Museum. His lodging room was searched, but the watch was not found. However, neither the story of how he came by the watch nor his alibi was believed, and he was remanded in custody for a week.[6]

OPPOSITE:
PAINTED HALL
ROBBERY REWARD
POSTER,
DECEMBER 1900.

METROPOLITAN POLICE

£200 REWARD.

The undermentioned articles were stolen between 4 p.m. 8th and 2 p.m. 9th December, 1900, from the PAINTED HALL, GREENWICH HOSPITAL:—

Watch (gold old-fashioned verge) and Seal worn by Lord Nelson.

Enamel portrait of Lord Nelson, in a gold case.

Oval Gold Box presented to Commodore Nelson with the Freedom of the City of London in 1797.

Inscribed :— "Watson—Mayor.

A Common Council holden in the Chamber of the Guildhall of the City of London on Friday the 10th day of March, 1797.

"Resolved unanimously

That the thanks of this Court be given to Vice-Admiral Thompson, Vice-Admiral the Hon. William Waldegrave, Rear-Admiral Parker, and Commodore Nelson, for their gallant behaviour on the 14th of February last in defeating the Spanish Fleet, and that they be presented severally with the Freedom of this City in a Gold Box.

NOTE.—Sir Robert Calder omitted by mistake afterwards rectified by a like vote.

Gold Sword Hilt, presented to Sir Horatio Nelson by the Captains of the Fleet present at the Battle of the Nile, 1798.

Inscribed :— The Captains of the

Squadron under the Orders of

Rear-Admiral Sir Horatio Nelson, K.B.,

desirous of testifying the high sense they

entertain of his prompt Decision & Intrepid Conduct

in the Attack of the French Fleet in Bequier Road off the Nile

The 1st of August 1798

request his Accept- ance of a sword

& as a farther Proof of thier (sic)

Esteem & Regard hope that he will

permit his Por- trait to be taken

& hung up in the Room belonging

to the Egyptian Club now established

IN COMMEMORATION OF THAT GLORIOUS DAY

Dated on Board of His Maj'ys Ship Orion this 3rd of Aug. 1798

Jas. Saumarez	Alexr. Jno. Ball	R. Willett Miller
T. Troubridge	Saml. Hood	Ben Hallowell
H. D. Darby	D. Gould	E. Berry
Thos. Louis	Th. Foley	T. M. Hardy
I. Peyton		

There is also inscribed on the guard :—

R. Adml. LORD NELSON	Capt. Thos. Louis MINOTAUR	Capt. Sr. Jas Saumarez ORION
Capt. Sr. E. Berry VANGUARD	Capt. Sr. T. B. Thompson LEANDER	Capt. Thos. Foley GOLIATH
Capt. T. Troubridge CULLODEN	Capt. B. Hallowell SWIFTSURE	Capt. G. B. Westcott MAJESTIC
Capt. R. W. Miller THESEUS	Capt. Davidge Gould AUDACIOUS	Capt. H. D. E. Darby BELLEROPHON
Capt. Alexr. J. Ball ALEXANDER	Capt. John Peyton DEFENCE	Capt. T. M. Hardy MUTINE
	Capt. Saml. Hood ZEALOUS	

Medals and Orders belonging to Lord Nelson, viz.—

Medal of the Victory of St. Vincent, 1797, inscribed "Horatio Nelson, Esquire, Commodore, and fifth in command, on the 14th of Feb., 1797.—The Spanish Fleet defeated."

Medal of the Victory of the Nile, 1798, inscribed "Sir Horatio Nelson, K.B., Rear-Admiral and Commanding Officer, on the 1st of August 1798.—The French Fleet defeated."

Jewel of the Order of the Bath. | Jewel of the Sardinian Order of San Joachim. | Grand Cross of the Order of San Joachim.

Jewel of the Neapolitan Order of San Ferdinando. | Gold Star of the Turkish Order of the Crescent.

Medal of the Victory of Trafalgar, 1805, inscribed "Horatio, Viscount Nelson, Vice-Admiral and Commander-in-Chief, on the 21st October, 1805.—The combined fleets of France and Spain defeated."

Medal commemorating the Restoration, by the aid of Lord Nelson, of King Ferdinand IV. to the Throne of Naples.

The Medal for the Battle of the Nile, at which Captain Louis commanded the "Minotaur."

A Medal The Victory of the Nile, a tribute of regard from Alexander Davison.

The Medal for the Battle of St. Domingo, at which Admiral Louis was third in command

A gold sword-hilt, presented to Admiral Louis with the Freedom of the City of London, in recognition of his services at the Battle of St. Domingo.

The Order of Ferdinand, presented to Sir Thomas Louis by the King of Naples.

The above Reward will be paid to any person (other than a Police Officer) by JAMES GRAY, Esq., 5, NEW COURT, CAREY STREET, LONDON, W.C., for such information as shall lead to the conviction of the thief or thieves and the recovery of the property or in proportion to the amount of property recovered in the condition in which it was taken.

Information to the Assistant Commissioner, Criminal Investigation Department, New Scotland Yard, or to any Metropolitan Police Station.

METROPOLITAN POLICE OFFICE,
NEW SCOTLAND YARD,
11th December, 1900.

E. R. C. BRADFORD,
COMMISSIONER OF POLICE OF THE METROPOLIS

Printed by the Receiver for the Metropolitan Police District, New Scotland Yard, London, S.W. 19000—12-00

On 6 July *The Times* reported under the headline 'Recovery of Nelson Relics':

Two of the Nelson relics stolen from Greenwich Hospital have been recovered. On June 27 two packages were left by a man in the cloakroom of Customs House Railway Station and they have not since been called for. Suspicion was aroused, and on Monday the luggage was handed over to Detective-inspector Arrow, who on examining one of the packages – a portmanteau – found among its contents a concertina. On seeing a mark at the side of a screw in the instrument, as if a screw-driver had slipped, the inspector took the concertina to pieces, and found inside, carefully packed, the missing gold watch and gold sword hilt which formed part of the missing Nelson relics.[7]

The account given in *The Times* does not tally in every detail with that in Inspector Arrow's memoirs. The sword-hilt was evidently not in the concertina and has never been recovered. Arrow recalls how, after an initial search of the Gladstone bag had only produced some old clothes and a concertina, his wife that evening had asked, *'Did you look inside the concertina? I dropped my knife and fork as I said "No, what an ass I am!"… I hurried back to the railway station and got the station-master to produce the bag once more. We took out the concertina, he found a screw-driver, and we unscrewed one end of it. There, snugly deposited in the woodwork was Nelson's watch, while in the other end we found the seal.'*

On 11 July *The Times* reported William Alfred Carter's next appearance in court at Greenwich. Thomas Joliffe, a Greenwich road sweeper, who had been an attendant in the Painted Hall for ten years, identified the recovered watch and seal as Nelson's, although he could not swear that it was the one that had been in the display case. Inspector Thomas Evans, in charge of the Royal Naval College Police, said he believed the watch and seal formed part of the Nelson relics, but *'he had not had an opportunity of handling the watch and had only judged by appearance'*. The printed list of stolen items simply referred to the watch as *'a gold verge with seal'*. The prisoner remarked, *'It strikes me they hardly know the watch themselves. There is no inscription on the watch.'*[8] Carter was remanded for a further week, and at his next court appearance at Greenwich, evidence was given that the prisoner had left for New Zealand under the name of William McCarty on 21 December 1900. *'The watch and seal were identified as Nelson's, and as the property of the Admiralty worth anything between £500 and £1,000. The prisoner, who made no reply to the charge, was committed for trial at the Central Criminal Court.'*[9]

At the hearing on 16 September 1904 Carter was indicted for stealing a watch, seal and other articles to the value of £5000, the property of the Lords of the Admiralty. Important evidence in identifying the watch as the one stolen had been provided by Mr Francis Ellis of Streatham, who had photographed it in 1898 for the publication *Nelson and his Times*, and by the storeman, Mr William Bartlett, who had kept a wax impression of the seal. *The Times* reported:

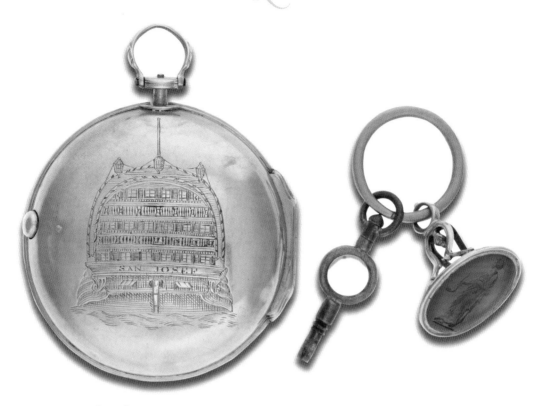

NELSON'S WATCH AND SEAL, THE ONLY ITEM RECOVERED AFTER THE PAINTED HALL ROBBERY.

'The jury, after deliberating for about half an hour, found the prisoner Guilty of receiving the property in the United Kingdom and of being concerned in the robbery…. The offence was an offence against the nation. It would have been thought that any criminal, however hardened, would have some reverence for the relics of a man who laid down his life for his country. No such sentiment, however, seemed to have affected the prisoner in the slightest degree. He was sorry to say that a large quantity of relics were still no one knew where. No information had been given by the prisoner as to them. He sentenced the prisoner to seven years penal servitude.'[10]

Until at least July 1910, the case was pursued by the Director of Greenwich Hospital and Inspector Arrow, in the hope of discovering what had become of the rest of the stolen items. Carter served his time at Chelmsford, Portland and Pentonville Prisons, being released on licence in January 1910. In further interviews in prison and after his release, when he lived under the assumed name W. Garton, he gave statements in which he overturned his previous story of the relics being in Australia, and named Alfred Sutton, a sweet-shop owner of Lever Street, Islington, *'who was both the instigator of the theft and the receiver of the articles'*.[11] Carter described how he had planned and carried out the burglary, and claimed he had sold all the relics except the watch and seal to Sutton for £105. He had got the impression from Sutton's attitude that the items might be

preserved rather than melted down, so perhaps there still remains a small hope that something may one day come to light.[12] In 1966 reports of a sighting of some of the missing relics in Chicago proved to be a red herring.[13]

In a chapter on the Nelson theft in his memoirs, published in 1926, Chief Inspector Arrow wrote: '*The thief has been convicted, but the reward remains unappropriated, for his conviction and the recovery of the watch and seal were brought about entirely by the police, whose office precludes them from participating in such a reward. It is still open to some person to earn the gratitude of the nation and this reward by giving the information that is required…. Some people say that the other relics have gone into the melting-pot, but I do not believe it. I believe that the man who stole them had a market for them, maybe in England, but more likely in America. It is just possible that they are in the hands of some collector of antiques, who knows nothing of their value to the nation or of their true character. If so, I sincerely hope that chance may put this chapter into his hands.*'[14]

The *chelengk*

In 1831, some seventy years before the Painted Hall theft, another robbery had occurred which may explain the disappearance of other Nelson jewels. On 16 May 1831 *The Times* reported a burglary at Earl Nelson's house, No. 23 Portman Square, while the Earl was out of town. Jewellery had been taken from a dressing table and a bureau had been forced open and diamonds and precious stones, gold chains and collars and bottles with silver tops in the form of coronets engraved 'HN' had been stolen. There is no way of knowing if most of these stolen items had ever been owned by Admiral Nelson, but strangely, on this occasion a most precious Nelson object had a very narrow escape. *The Times* reported:[15]

OPPOSITE: DIAMOND *CHELENGK* PRESENTED BY THE SULTAN OF TURKEY.

There was one article in particular which had escaped the thieves, although they might readily have laid their hands upon it, and it was loosely wrapped in a piece of brown paper, and carelessly thrown into the bureau. This article was the diamond aigrette presented by the Grand Seignor to Admiral Lord Nelson, who was in the habit, on state occasions, of wearing it in his hat. One of the same description but of a smaller size, had been also presented to Sir Sidney Smith, who subsequently sold it for 13,000l, so that the value of that which had escaped the thieves could not have been less than 20,000l; in fact that sum had been refused for it. Mr Halls [the Magistrate] observed that it might be injudicious to give publicity to these facts, as it would hold out a temptation of which others might take advantage. The applicant observed that Lady Nelson had provided against that by sending her diamonds to her banker's, and her alarm was so great that she dreaded a second visit from the thieves, and gave him the key of her plate chest, as she was fearful of keeping it herself.

The diamond aigrette or *chelengk*, a plume of honour, had been presented to Admiral Nelson by Selim III, Sultan of Turkey, in gratitude after the Battle of the Nile in 1798.[16] Later, Nelson was granted the *chelengk* crest as an

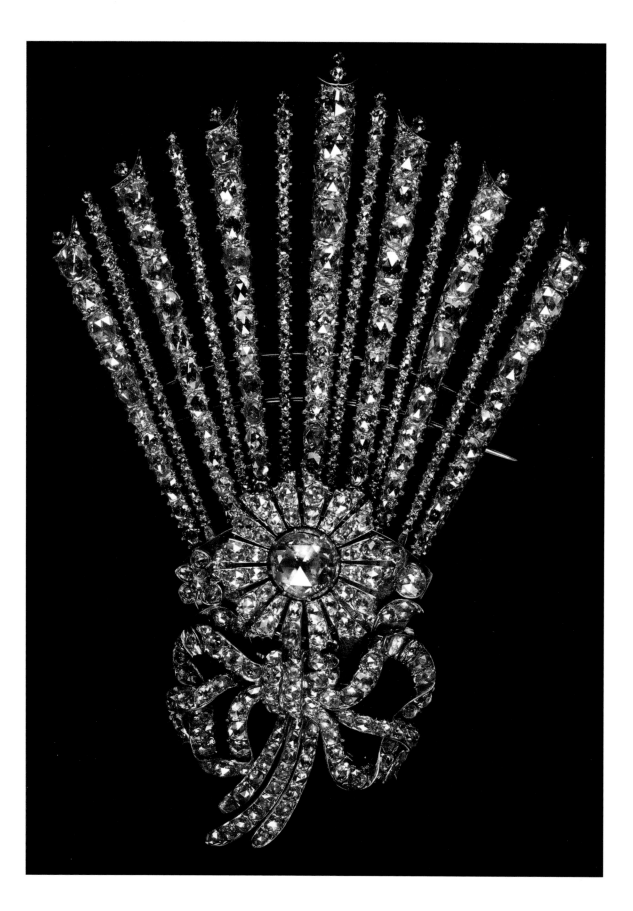

augmentation to his coat of arms. The *chelengk* was the highest Mohammedan honour, and Nelson was the first Western recipient, although the Sultan gave similar honours to Sir Sidney Smith and Lord Keith, as well as a more elaborate version to King George III, in 1801. Lord Keith's *chelengk*, smaller than Nelson's, but of a similar design, was stolen in April 1988 from the family home at Bowood, Calne in Wiltshire, together with his Order of the Crescent. Replicas are now displayed in their place.

Nelson's diamond *chelengk*, which is said to have been taken by the Sultan from his imperial turban, consisted of a central flower of sixteen petals with leaves and buds. Below the flower, the spray was bound by a diamond bow, and above it seven diamond rays were mounted so that they trembled as the wearer moved. The Sultan ordered that the central rose should be made to revolve with a clockwork mechanism, and also that six additional rays should be added to represent the thirteen enemy ships taken, burnt or destroyed at the Nile.

On 1 November 1799 Nelson wrote from Palermo to Sir Isaac Heard, Garter King of Arms: '*As the Pelises given to me and Sir Sidney Smith are novel, I must beg you will turn in your mind how I am to wear it when I first go to the King; and, as the Aigrette is directed to be worn, where am I to put it? In my hat, having only one arm, is impossible, as I must have my arm at liberty; therefore, I think, on my outward garment. I shall have much pleasure in putting myself into your management.*'[17]

In England, people had only the haziest idea of the appearance of this jewel. Even the artists were mainly working from written descriptions, or incorrect sketches, so most portraits showed a *chelengk* which bore very little relationship to the real thing.[18] One popular version, reproduced in *The Lady's Monthly Magazine*,[19] suggests '*In all probability, after the gallant Admiral has appeared at Court, it will become a fashionable article with the ladies, — The large star in the centre, by means of some mechanism behind it, is kept continually turning round, which produces a most brilliant effect.*'

Nelson evidently enjoyed wearing the Sultan's gift, although it became a subject for ridicule with the caricaturists, and he appears to have taken good care of it. The obituary for Thomas Coutts Esq., the banker, in Longman's *Annual Biography and Obituary* for the year 1823, mentions, '*It is remarkable that on the first day of opening these improvements* [to Coutts's premises], *Lord Nelson, then Sir Horatio, sent to Mr Coutts for security the valuable diamond aigrette which the Grand Seignior took from his turban, and placed in the noble admiral's hat, as a token of his respect and gratitude.*'

Nelson made special provision in his will for the *chelengk*, requesting that it should remain associated with the Dukedom of Bronte. After his death the jewel was inherited by his brother William, first Earl Nelson, and it was during his lifetime that the jewel narrowly escaped being stolen in the 1831 burglary at

Portman Square. In 1835 it passed to William's daughter Charlotte, who had married Samuel Hood, later Baron Bridport, so the jewel passed into the Bridport peerage. Here it remained until 1895, when it was disposed of with many other precious Nelson relics at a series of sales of Lord Bridport's effects. It was purchased at that time for £750 by the Hon. Mrs Constance Eyre-Matcham, a Nelson descendant through the Catherine Matcham line, and lent by her to the 1905 centenary exhibition of Nelson relics at the RUSI. A photograph of the *chelengk* appeared in the catalogue of that exhibition.[20] In 1928 she lent the *chelengk* to the exhibition of Nelson relics at Spink's galleries in aid of the Save the *Victory* Fund.[21] With it she loaned a letter sent on 3 October 1798 from the Embassy at Constantinople to the Foreign Office which referred to the presentation by the Sultan:

A Superb Aigrette (of which the Marginal Sketch gives but an imperfect idea) called a Chelengk, or Plume of Triumph such as has been upon very famous and memorable successes of the Ottoman Arms conferred upon Victorious Seraskers (I believe never before upon a disbeliever) as the ne plus ultra of personal honor, as separate from official dignity. The one in question is indeed rich of its kind; being a blaze of brilliants crowned with a vibrating plumage; and a radiant star in the middle, turning upon its centre by means of Watch Work which winds up behind. This badge was absolutely taken from one of the imperial Turbans and can hardly, according to the ideas annexed to such insignia here be considered as less than equivalent to the first order of Chivalry in Christendom.'

In 1929 there was a public appeal to save the *chelengk* for the nation, through the Society for Nautical Research, as Mrs Constance Eyre-Matcham was compelled to sell the jewel and had offered it for sale in the United States.[22] Most of the money was contributed by Lady Barclay, in memory of her husband, the Right Hon. Sir Colville Barclay, British Ambassador to Portugal, and it was eventually purchased for the nation through the National Art-Collections Fund in November 1929 for £1500 and presented to the Royal Naval Museum at Greenwich. It then moved to the National Maritime Museum, where it was displayed until 1951.

On 11 June 1951 a break-in at Greenwich targeted this Nelson relic soon after it had appeared in a television programme. During the night the diamond *chelengk* was stolen from a display in the Nelson Gallery and has never been recovered. *The Times* reported next day:

A relic of Nelson, containing 300 diamonds, was stolen early yesterday from the National Maritime Museum, Greenwich. Thieves, using two small ladders, forced a window nearest to where the relic was kept in the Nelson gallery, on the ground floor of the museum. They smashed the glass showcase in which the relic was kept, but made no attempt to take other valuable objects.... Though Nelson's chelengk is of the very greatest sentimental and historical value, its value as a collection of diamonds is small. The

THE NELSON RELICS SHOWCASE AFTER THE THEFT OF THE *CHELENGK*.

stones are cut very shallow, and before the last war the valuation of them as diamonds was less than £150. [23]

There has been much discussion about the possibility that the *chelengk* was altered after Nelson's lifetime, or the diamonds replaced by stones of inferior quality. On 3 May 1913 Alexander Nelson Hood, Duke of Bronte, had written to Mrs Eyre-Matcham, *'As far as I am aware the Aigrette – it was thus we always spoke of it – remains in the identical condition to which it was given to Lord Nelson,'* and was still contained in its original case. However, the clockwork mechanism does seem to have been removed at some stage, presumably to lessen the weight when ladies wore it as a hair ornament. In 1951 Viscount Bridport wrote to *Country Life*, saying, *'In the modern form there was no watchwork. I believe that the Chelengk may have been altered by order of my great-grandmother (the then owner) at the same time as she had the diamonds removed from the sword of honour given to Nelson by the King of Naples and made into a necklace.'* [24]

In the week of the burglary the *Illustrated London News* published a photograph of the stolen *chelengk* and claimed, *'This trophy, which is a priceless relic, is said to have a break-up value of about £2000.'* The next week's edition included a photo-

graph showing the *chelengk* as it had been displayed at Greenwich with other Nelson relics. Alongside was a photograph of the museum display soon after the robbery, showing the broken glass of the case which had held the *chelengk*.[25] In the centre of the showcase on a shelf stands the empty glass display case which had held the jewel. Above it the Turkish rifle, pigtail and sword are untouched, while the Turkish canteen, Nelson's purse, watch and other small objects stand undisturbed on the base of the case. Only the *chelengk* had been stolen.

The thieves escaped into Greenwich Park, leaving two ladders behind. Although the police arrived with dogs within four minutes of the alarms sounding, nothing was seen of the intruders. Several newspapers reported, '*Detectives investigating the theft of the diamond plume – the Nelson relic – from the National Maritime Museum at Greenwich yesterday were today keeping a special watch at ports and aerodromes. One theory being examined is that the theft was the work of a gang specialising in stealing articles of historic interest for sale to private collectors on the Continent and America.*'

A reward of £250 was offered for information leading to the arrest of the thief or thieves and the recovery of the stolen property. The robbery was debated in the House of Lords, and Lord Pakenham, First Lord of the Admiralty, said: '*His Majesty's Government and all concerned greatly deplore this shocking theft of the most treasured possession of one of our greatest national heroes – indeed our greatest sailor – and the whole nation must hope that the reward offered and the measures now being taken may result in its return.*'[26] Nothing more was heard.

Forty-six years later, in June 1997, a notorious London rogue and cat burglar, George 'Taters' Chatham, died, taking the mystery of Nelson's *chelengk* with him to the grave. Chatham claimed to have broken into as many as twenty-six art galleries during his long life of crime, and his specialities appear to have been climbing and targeting art objects. He laid claim not only to stealing two of the Duke of Wellington's jewelled ceremonial swords from the Victoria and Albert Museum, but also to the theft of the *chelengk* from Greenwich.[27] Of the swords he said: '*I was sort of besotted by them. And not only that, it was, shall we say, a test. I had no respect for the police whatsoever, and if I could outwit them, I would do my best to do it. I knew there'd be a hell of a rumpus, and as long as I was successful I was very, very satisfied.*' He visited the displays many times and planned meticulously for his raids, the success of which then depended on speed. In the case of the *chelengk*, he claimed that it was broken up for the diamonds after he had received '*a good few thousand*'. In 1994, when Chatham was aged 81, he had been interviewed for a BBC television series on the criminal underworld.[28] His criminal activities had only been interrupted at the age of 79, when he fell from a building during a burglary and broke his ankle. He remained proud of his career of crime, stealing jewels and cash from victims in high society, a well as national treasures. A

major post-office van robbery, safe-breaking and daredevil roof climbs had
made him an underworld legend, but he earned himself a total of thirty years
imprisonment and gambled away all his ill-gotten wealth. Sadly, we may never
know the truth of his claim to have stolen Nelson's jewel.[29]

The Nelson cenotaph and Monmouth burglary
In 1865 *The Times* reprinted an article from the *Waterford Mail* entitled 'Relics
of Nelson':

*One of the most costly and interesting relics of Nelson is still extant in the possession
of a gentleman residing at Cheam, Surrey. It consists of a small golden pyramid,
composed of the identical 84 guineas which were found in the Admiral's escritoire, when he
so gloriously fell in the arms of victory at the memorable battle of Trafalgar, on 21st
October, 1805. After Nelson's death these coins fell into the hands of Mr Alexander
Davison, of St James's Square, London, the intimate friend and navy agent of the hero of
the Nile, and who, as a mark of lasting respect to his gallant friend, caused this pyramid
to be constructed out of the coins in a quadrilateral form, each side containing the comple-
ment of 21 guineas. Upon the occasion of Mr Davison becoming insolvent some years
afterwards, the relic under consideration was, among other property forming a portion of
that unfortunate gentleman's estate, sold under the hammer by the auctioneers of the day,
the Messrs Farebrother, and the pyramid adverted to was at that period purchased at the
sale by a relative of its present possessor.*[30]

The 'or-molu cenotaph' was sold to William Joy of Cheam as lot 418 on the
fourth day of the Davison sale at Farebrother's on 24 April 1817. The catalogue
entry claimed that *'the guineas were in his Lordship's pocket when he was killed at the
Battle of Trafalgar'*.

The cenotaph was later displayed on Messrs Hancock's stand at the Great
Exhibition of 1851, and also lent to the Fisheries Exhibition in 1883 and the
1891 Royal Naval Exhibition. The sixpenny illustrated handbook and souvenir
of 1891 includes a photograph of Davison's pyramid of guineas, now described
as 'the Nelson cenotaph'. It was lent to the exhibition by James Griffin of 41
South Parade, Southsea, a naval publisher, who had purchased it at Christie's in
1877. By now it was described in the catalogue as *'made of the 84 guineas which
were found in Lord Nelson's purse at the time he was mortally wounded at Trafalgar, 21st
October 1805.... The handles of the sarcophagus are modelled from the stern and prow of
the barge that conveyed Nelson's body from Greenwich to Whitehall previous to the funeral.
This barge is now preserved on board the Victory in Portsmouth Harbour.'*[31] Although
variously described as being found in his purse or his pocket, this number of
guineas is most unlikely to have been carried on his person during the battle.

In 1902, James Griffin lent the Nelson cenotaph to another exhibition, the
Naval and Military exhibition at Portsmouth. A pamphlet explaining the

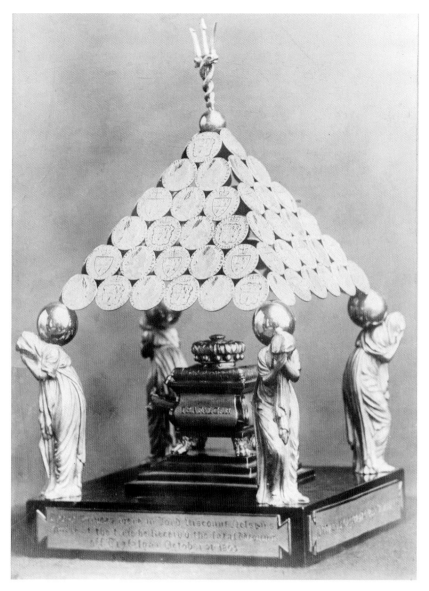

CENOTAPH OF NELSON GUINEAS BEFORE THE MONMOUTH ROBBERY.

Nelson guineas was for sale in the exhibition, price 1d.[32] Three years later at a Christie's sale of 19 July 1905, the executors of James Griffin sold the item as lot 27, '*A reliquary containing a lock of Lord Nelson's hair, known as the Nelson Cenotaph*'. The coronet on the sarcophagus unscrews to reveal the phial containing the hair.

The cenotaph was bought by Lady Llangattock, who bequeathed it in 1923 to Monmouth. On Trafalgar Day 1953 the Nelson collection at Monmouth was

the subject of a Richard Dimbleby television broadcast. Usually the museum closed for the winter at the end of October, but because of increased interest in the collection it remained open for another month. On the night of 9 November, intruders, who were believed to have hidden in the basement of the museum, stole jewellery, watches and other Nelson relics from the museum. Next day *The Times* reported:

Articles were stolen from three display cases. They included 84 spade guineas found in Admiral Lord Nelson's purse when he died and made into a canopy to cover a replica of his tomb in St Paul's; the jewelled hilt of a sword presented to Lord Nelson by the King of Naples; about 75 brooches, rings, and seals, and several gold medals and watches. Articles belonging to Lady Hamilton are also missing.

The Nelson relics stolen include a gold ring with three intaglios given to Lord Nelson by the King of Naples on board the Vanguard after the Battle of the Nile and given by Lady Nelson to her son Josiah Nisbet, in 1798; a small silver-mounted telescope inscribed 'From Lord Nelson to Dalrymple, 1805', a gold ring set with jet, inscribed 'In memory of dear Horatio'; an emerald and diamond pendant inscribed 'N.B. to Emma'; a gold anchor brooch inscribed 'Trafalgar'; a gold and black brooch inscribed 'N.B.'; a gold anchor brooch inscribed 'Earl Howe, June 1st 1794'; and a pendant with miniature inscribed 'E.H'.[33]

After the Battle of the Nile the King of Naples had presented to Nelson a small-sword with a gold hilt thickly studded with diamonds.[34] While wearing the sword at a fete arranged in his honour by the English merchants at Hamburg in 1800, Nelson lost a large diamond from the hilt worth £800, which could not be recovered.[35] The sword was bequeathed to his brother William, in trust, with other heirlooms to remain with the Dukedom of Bronte. In 1891 Viscount Bridport exhibited it at the Royal Naval Exhibition (cat. no. 2648)[36]. At some point the diamonds in the sword hilt were made into a necklace, which still exists, and replaced by pastes. Both the hilt and the necklace were sold at Christie's in the Bridport sale on 12 July 1895 (lots 122 and 171); Lady Llangattock subsequently bequeathed the sword hilt to Monmouth.

Clearly some of the stolen jewellery was commemorative rather than owned by Nelson personally, and some of the items may not have been entirely authentic, but the theft was a major blow to the town of Monmouth. The Town Clerk played down the loss to the press, saying that the most important historical items had not been taken, and explained that the jewels in the Neapolitan sword had been replaced by pastes some time previously. The value of the items stolen was said to be about £2500. Three weeks later a parcel was sent anonymously by post to Scotland Yard. It contained a gold enamelled box inscribed *'To dear Lady Hamilton for your birthday from Nelson & Bronte'* .This was one of the items stolen from Monmouth, and was subsequently returned there.[37]

The next year, in March 1954, police searched a house in Romford, Essex,

and recovered many of the stolen relics, including Nelson's telescope, several gold watches which Nelson had presented to others, and seals used by Nelson and Lady Hamilton.[38] The crime might never have been solved had not the thief, *'emboldened by the success of his Monmouth crime, tried to break into a museum in South Kensington, but was disturbed, and during a chase he fell, broke his arm, and was caught. When his home was searched by Essex police, some of the relics were found.'*[39] Essex market trader Ronald E. Walker was found to be in possession of sixty of the ninety-one missing Monmouth items. Thirty-three were still intact, but the remaining twenty-seven had been vandalized and broken up for their valuable parts which, unfortunately, were never recovered.[40] Walker was sent for trial in Monmouth, charged with breaking out of the Nelson Museum after stealing property valued at £2500. He pleaded guilty and was sentenced to three years' imprisonment. At his trial in April the broken items were described by the prosecution as having been *'savagely mutilated'*.[41] Among these was the Nelson cenotaph, which had for ever lost its pyramid of gold guineas. The remains are still displayed in Monmouth alongside a photograph of the original cenotaph.

The Matcham silver

More recently, Nelson relics have continued to be targeted for burglaries. In 1989 a collection of authentic Nelson material, which had come down through the descendants of Nelson's sister Catherine Matcham, was stolen from a private house, after it had been put on view to the public. Fortunately, much of the collection was eventually recovered, but not everything of importance. Some of the Nelson silver, and in particular one of four silver tureens, which had remained in the family's possession for so long, was never found, and we can only hope that one day in the future these pieces will reappear and can be reunited with the rest of the set.

Chapter Five

CAVEAT EMPTOR: FAKES, COPIES & MYTHS

∞

he catalogue of the 1891 Royal Naval Exhibition at Chelsea described many relics of naval heroes including Nelson, which had been lent by descendants and collectors. Writing in 1904, Earl Nelson claimed: *'The Committee... rashly undertook to give an authoritative pedigree to the things there exhibited, as they proposed to admit nothing without a clear pedigree.'* The official catalogue, however, listed all the exhibits without making judgements on the authenticity of the pieces shown. The additional illustrated souvenir of the show was far less circumspect. In the introduction to the Blake and Nelson Galleries, the souvenir guide warns visitors:

Returning from the Benbow Gallery into 'the Blake' and 'the Nelson', we will next examine the relics and miscellaneous objects of art which are placed in these two Galleries. These objects are very numerous, and of very different degrees of interest. In the case of the relics, we fear we must add 'and of doubtful authenticity'. Let the visitor judge for himself. He will go over the Victory presently, and be able to form an idea of what the Admiral's cabin was like. It is simply a physical impossibility that it should have contained all the 'favourite chairs', 'arm-chairs', 'chairs and beds combined', and 'folding bedsteads' here exhibited as having been used by Nelson at sea. There is a similar difficulty with regard to 'Nelson's' watches, seals, and medals. There are, however, enough well-authenticated relics of Nelson and other great commanders to make this part of the Exhibition very interesting.[1]

A long review of the exhibition in *The Times* agreed with these doubts: *'Among the relics there are none to which the visitor more eagerly turns than those which are alleged to be connected with the career of Lord Nelson. Many of these are of undoubted genuineness. They are contributed by descendants or connexions of the great admiral, and the history of them is perfectly well authenticated. Concerning others there is, unfortunately, much less certainty, and of several it may unhesitatingly be said that they are not what they pretend to be.'*[2]

Evidently more than a century ago, reviewers were already well aware that there was a growing industry associated with 'relics' of the famous. Today, when there is huge profit to be made from the sale of any objects associated

with people like Nelson, Bligh, Scott and Shackleton, or ships like the *Victory*, *Discovery*, *Bounty* and *Titanic*, it is necessary for museum curators and private collectors to look extremely closely at the provenance of every supposed relic and doubt everything until it can be categorically proved.

Initially, however, there was probably a limited financial aspect to the collecting of relics. At the time of his death, Nelson had already become such a legend that people had other motives for clinging to any object that appeared convincing. They may well have felt little need at that time to possess documentary proof of authenticity of a cherished item, and such pieces would be passed down through families accompanied only by an oral tradition. Unless the item was regarded as valuable enough to be mentioned in a will, this means that often there is no documentary evidence left to trace. Family traditions are notorious for losing sight of the original facts, and today in many cases it is almost impossible to unpick the truth. The 'Chinese whispers' effect can so easily change a genuine claim that an item was owned by an ancestor who was 'a naval officer in Nelson's time' into the wishful thinking that he was 'a naval officer who served with Nelson' and thence into 'owned by Nelson'. This does not necessarily imply any deliberate act of deception, but can cause just as much confusion to anyone now trying to establish a reliable provenance.

As the years passed, the number of genuine Nelson objects proved insufficient to supply the public demand, and with the increase in saleroom prices, the temptation arose to manufacture additional 'relics' to supply the more gullible collectors. We need to support the oral traditions with more concrete evidence. Where an object has been lent by the owner to a museum or exhibition, and published in an illustrated catalogue with a detailed description, a useful trail is created which may help to verify a story. Many of the Nelson relics in museums today have acquired such exhibition trails, as demonstrated in Chapter 3. When authenticating Nelson relics, we rely to a considerable extent on establishing a good provenance which links the material indisputably to Nelson or at least to his family or friends. Unfortunately such provenance often stops short of making an actual link right back to Nelson's possession, but at least it may help to exclude the possibility of recent deception. An added problem is the fact that even Nelson's descendants sometimes bought from salerooms and accepted gifts to add to material the family already owned. This means that, even where we can trace an object back through the Nelson family, there still remains the possibility that it may not have come down in an unbroken line from the Admiral.

Similarly, material owned by museums cannot be assumed to be genuine in every case. Most old museum collections have a complicated history, not always with continuous acquisition records. Sometimes large private donations of objects have included some dubious material among the authentic. However,

such objects have a number of museum uses today, particularly since we need to remain aware of all the various categories of fakes, copies and 'embroidered' stories, in order to help us assess the objects which are still constantly coming to light. The story of the Nelson fake and copy industry remains an interesting and important part of the Nelson legend, telling us as much about public attitudes to his reputation as the myths that have grown up about his life story and the monuments that have been erected in his honour.

Legitimate copies

Sometimes, however, copies of original items are manufactured for perfectly legitimate reasons. A porcelain or silver dinner service might well have additional pieces specially made to match at a later date to replace breakages or increase the number of place settings. There are other instances where copies of unique items have been made so that more than one branch of the family can have a particular memento, for instance Horatia's silver-gilt knife, which was copied in the 1930s. Some of the Nelson porcelain, such as the Baltic service, was copied in creamware, presumably to provide an affordable alternative for modest collectors.

Souvenir manufacturers and museums also make legitimate copies of antique items for display or sale. Today, museums which commission such copies normally insist that there is some indication printed or inscribed on the object to make its origins clear to all, but this hasn't always been the case in the past. As the years pass and such objects come on to the market again, these copies can create further confusions and may be purchased by people who are unaware that they are not buying an original.

Museum replicas include Nelson's uniforms, which have been copied at various periods for display in Westminster Abbey, and at Portsmouth and Monmouth. A replica of Nelson's stolen *chelengk*, based on photographs of the original jewel, which was made for the film *Bequest to the Nation* (1973), was presented to the NMM by the film company Hal Wallis Productions. Other smaller copies have been produced in both real and non-precious stones to wear as commemorative jewellery. The gold *fede* rings which Nelson and Emma exchanged have been reproduced for sale, as have his uniform buttons. The Trafalgar bicentenary will be marked by the reproduction of various Nelson relics, including porcelain, Horatia's christening cup and Nelson memorial rings.

Family traditions, misattributions and confusions

Family traditions cannot always be relied on for proof of the provenance of a long-treasured relic, and there are many instances of mistakes being perpetuated through generations, without any deliberate attempt to deceive.

Miscellaneous collections tended not to be catalogued in any detail until they eventually came to be disposed of, so there have been two centuries in which confusions could have occurred and myths kept alive.

The Trafalgar House cellaret at the NMM (AAA3557) is one of the best examples of a well-known Nelson relic with a good provenance being later discredited. The circular cellaret is veneered in amboyna, burr mahogany and Cuban mahogany, and inlaid with ebony. There is tulip-wood banding, a hinged lid, gilt wood lion's feet and silver-gilt lion's mask and ring handles. Inside there are fittings to take the cut-glass wine and liqueur glasses and four matching decanters. The cellaret has been much displayed and published,[3] appearing in reference works as a typical fine example of a cellaret of *c.*1800, and has firmly

LATER COPIES OF NELSON'S PORCELAIN AND AN ICE PAIL WITH EARL NELSON'S CORONET.

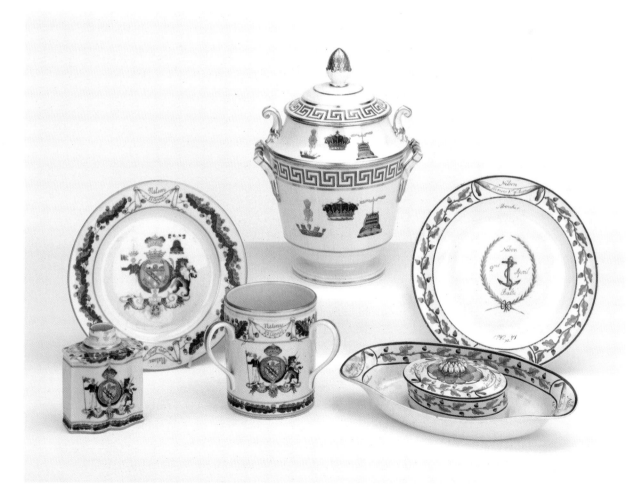

entered the established canon of Nelson relics. It has come down through the Nelson family, as part of Earl Nelson's Trafalgar House collection, so the provenance should be good. However, detailed cataloguing of the piece during conservation in 1977 showed the silver-gilt handles to bear the hall-marks of William Burwash and Richard Sibley of London, with the date letter for 1807. Clearly the Admiral Nelson association cannot stand without expla-nation. Could it be that after Nelson's death the cellaret was specially ordered to hold Nelson's set of decanters and glasses, also well-established Nelson relics in the collection of the Museum, and so became known as the Nelson cellaret? Or was it simply a question of a mistaken family tradition? The piece of

furniture appears never to have passed through the salerooms, so the matter of commercial value does not seem to be a factor. The other possibility is that the present hallmarked handles are later replacements. This is not at all unlikely, as the handle fixings have certainly been disturbed at some time in the cellaret's history.

Another problematical Nelson piece at Greenwich is a small pocket tele-scope marked 'Warris Patent'. William Warris, optical instrument maker of Burgen Street, Sheffield, took out a patent for mounting opera glasses in 1804, so the date is possible, and it is part of the Nelson-Ward collection, so the provenance is good. However, the telescope is not a marine piece but a very small decorative brass telescope with ten draws, which collapses to a flat disc housed in a silk-lined morocco case. The instrument has very low magnification and is clearly designed for use as a gentleman's opera glass. The family story is that it was used by Nelson after the loss of his arm and is supposed to have been put to his blind eye at the Battle of Copenhagen. We do not know whether confusion may have arisen because the Nelson-Ward family once owned Nelson's Copenhagen telescope. Another possibility is that this is the *'opera glass'* listed in the Huntington Library manuscript cited in Chapter 1, which perhaps Nelson used in his cabin as a magnifying glass to aid his poor vision.

A third example of such confusions, from the many, is a Spanish mahogany cylindrical writing desk, said to have been the property of Lord Nelson and to have come from the sale at Merton Place. It is an elaborate piece of furniture, which opens out at the front of the cylinder to reveal a cabinet escritoire with mirrors, drawers and other fittings, including several secret drawers on the inside of the opening wings of the cabinet. This was given in good faith to the RUSM by a previous chairman of Lloyd's and transferred to the NMM in 1963, where it was displayed for a period as a Nelson item. It is now known to date from *c.*1815, so is of too late a period to have been Nelson's property, although it may have been at Merton later.

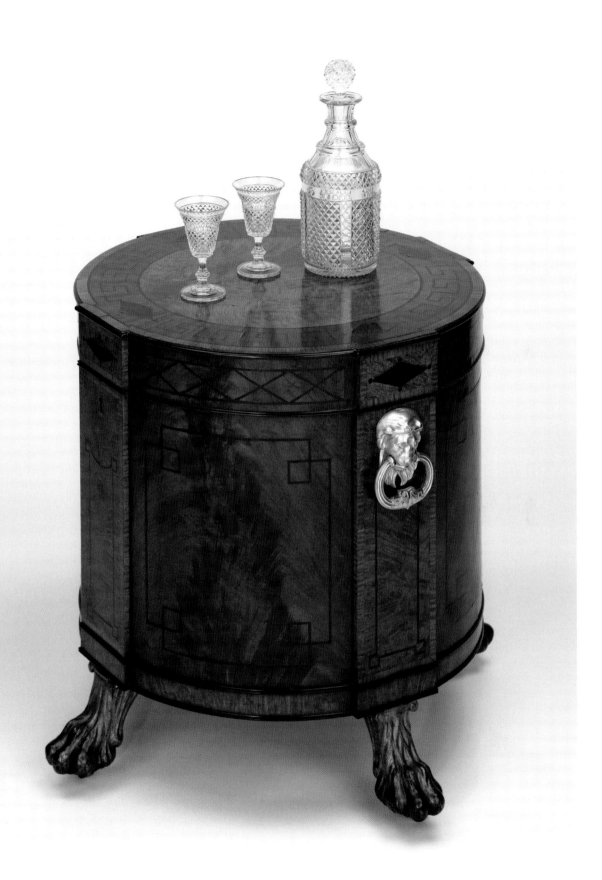

Many Nelson collections have silver and porcelain engraved with Nelson's arms with the Trafalgar augmentation and an earl's coronet. These clearly cannot have belonged to the Admiral, so are attributable to a descendant. Some typical examples are described in the catalogue section.

Deliberate fakes

Sir Nicholas Harris Nicolas wrote to *The Times* about a Nelson sword on the market in 1846: '*The manufacture of Nelsonian relics, swords, buckles etc seems so profitable a speculation to certain curiosity dealers, and the folly of persons who can be imposed upon by such things is so glaring, that I should not interfere; but when it is attempted to foist one of these spurious articles on a national institution, it becomes the duty of every Englishman to prevent, if possible, such an imposition.*'

Nelson fakes are indeed to be found in major public collections. By the end of the nineteenth century, Nelson relics were already becoming valuable, and even minor items had their price. Objects were coming on to the market which had been deliberately altered and given later inscriptions to add to their associations in an attempt to increase their interest and intrinsic value. Greenwich Hospital acquired a large collection of bogus Nelson silver through the somewhat misdirected generosity of the Corbett family. The industrialist John Corbett, MP for Droitwich, whose interest in Nelson appears to have grown out of a hatred of Napoleon and France, collected Nelson silver and other memorabilia. He died in 1901, and his brother Dr Thomas Corbett gave his whole Nelson collection to Greenwich Hospital in February 1905.[4] Two months later the naval historian Sir John Knox Laughton wrote to the Director of Greenwich Hospital, '*It seems to me in the highest degree improper that anything should be so exhibited unless there is absolute certainty that it is genuine, and... I have no hesitation in saying that some (at least) of them are fakes.*'[5] Other similar opinions were received, and two items were returned, but the majority of pieces went on exhibition in a specially built showcase.

At the same period Lady Llangattock was collecting Nelson silver, swords and personal relics through dealers and salerooms, including some important genuine pieces. The Corbett and Llangattock collections include silver items which appear to be by the same hand. Some are good antique silver items, later 'enhanced' with Nelson's coat of arms and spurious inscriptions, crudely engraved in comparison with genuine examples. Other pieces have been altered or virtually remade to deceive. Evidently someone in the late nineteenth to early twentieth century was making a good living by supplying material to Nelson admirers whose generosity and love of Nelson were greater than their collecting expertise. Some of the silver items condemn themselves, by having hallmarks of a later date than the inscription. For instance, at Greenwich there is a silver

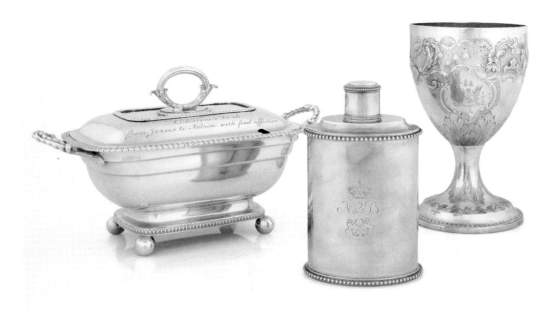

SILVER TUREEN HALLMARKED 1809, FRENCH TEA CADDY AND A POST-1807 DUBLIN GOBLET, ALL WITH
SPURIOUS NELSON INSCRIPTIONS.

sauce tureen and cover by Crespin Fuller, hallmarked London 1809, with the
ludicrous inscription '*Lobscouse dish from Jervis to Nelson with fond affection*'.

Among the Llangattock relics are some amusing instances of dated objects
with inscriptions which do not match, and other anachronistic uses of heraldry
and titles. A silver three-handled loving cup supposedly presented by Nelson's
Monmouth admirers in 1802 includes the Trafalgar augmentation on the arms
(ref. C5). A silver mug has the monogram 'HN' and an inscription '*From Horatio
Nelson to his loved daughter Horatio* [sic] *on her 4th birthday, 1798*', although Horatia
was not born until 1801 (ref. C2). A snuff box inscribed as a presentation to
Nelson by the Society of Steelworkers of Birmingham in 1792 is engraved with
the viscount's coronet only attained by Nelson in 1801.

After taking specialist advice, in 1969–70 the Nelson Museum at Monmouth
sold many of these fake silver items and a few swords by auction, the false
inscriptions having first been removed, to prevent their reappearing on the
market as Nelson relics. However, they retained a number of the bogus pieces
in the collection to provide an instructive display representing the different
types of fakes and illustrating the measure of Nelson's fame, which caused them
to be made.

Some bogus relics have been created by marrying genuine parts with non-matching additions. One sword of this type is the hanger at the NMM (WPN1063), which is said to have been given to Nelson by his uncle Maurice Suckling, with whom he first went to sea. The guard is engraved '*Capt. Suckling Comg. HMS Triumph*' and a gilt band around the grip has '*To Horatio Nelson Midn*'. Nelson is said to have been wearing this sword on 25 July 1797 during the boat attack on Santa Cruz.[6] However, the inscriptions both appear to be later, the term HMS in the inscription is wrong for the alleged date, the hilt and blade fit together badly and their decoration does not match. The blade might well be an infantry hanger of the second half of the eighteenth century, while the hilt is later. There is no evidence that either Nelson or Suckling ever owned the sword. Also at Greenwich is a stirrup-hilted sword (WPN1075) which is faintly engraved on the top locket of the scabbard '*Horatio Nelson*'. But the royal arms on the blade date it to post-1816, and the scabbard mounts are a mix of military, rather than naval, types, in use in 1816 and 1822. A pair of flintlock pistols at the NMM by Wogdon, London, are hallmarked on the trigger guard 1788, but inscribed '*Horatio Nelson 1780*' (AAA2430).

As well as the authentic Nelson uniform sword, and the trophy swords surrendered at Trafalgar, Monmouth acquired a number of bogus Nelson and Trafalgar swords with the Llangattock bequest. All Monmouth's swords were catalogued in considerable detail in 1949 by Captain Henry T. A. Bosanquet RN, and for those interested in this subject, the best reference is Bosanquet's illustrated typescript.[7] They include a flag officer's dress sword of the 1842–56 pattern, engraved with Nelson's initials, crest and coronet and Queen Victoria's cipher, and marked with the number 5386, which dates it as being made by Messrs Wilkinson in October 1854. Another dress sword of *c.*1825 has a crude leather label attached saying that Nelson used it when a mate, which means it should date from before 1777.

Sometimes fakers went to great trouble to forge provenance documents to accompany an object. A Nelson epaulette with a crown-and-anchor device, which was not introduced until 1812, was said to have come from his servant Tom Allen. Lady Llangattock was provided with convincing legal documents making the claim, supposed to have been signed with his mark by Allen, which can only be a forgery.

By the early 1930s the interest in Nelson relics and increasing rise in the value of even the most mundane objects associated with his life were resulting in the appearance of many spurious objects in the London auction houses, some of which resurface from time to time. Clearly someone was taking considerable pains to add inscriptions to antique pieces to enhance their value and fabricate false provenance for objects. They were sold through reputable salerooms, and

many collectors and museums were duped. It is always easy to be wise after the event, and now that these productions can be viewed as a whole, the false relics and inscriptions seem obvious. Mostly the stories were too good to be true, and items were regularly appearing with inscriptions associated with everyone who had played a part in Nelson's life, his ships and his naval actions. The more dubious relics tended to be inscribed with a superfluity of initials, names, dates and other details, often in a most inappropriate and unlikely way.

A typical provenance for one of these spurious relics is this, from a sale of 10 May 1932, in which Nelson's purported sword and dirk were sold: '*The following relics of Admiral Lord Nelson originally belonged to Captain Thomas Masterman Hardy R.N., Lord Nelson's great friend. They were bequeathed by him to John Hardy, Esq., who left them to his great-grand-daughter Miss Pamela Hardy, of Eastbourne, and were purchased from her by the present owner.*' The present owner was an Eastbourne dealer, but the Pamela Hardy provenance does not hold water. Although some of the catalogue entries claim letters of authenticity from the lady, she has not yet been identified, and certainly cannot claim descent from Sir T. M. Hardy's younger brother John, who died unmarried, leaving all his property to his sisters. In any case, John Hardy, who died in 1822, predeceased Sir Thomas, who did not die until 1839, so could not have received a bequest from him.[8]

It is essential to be extremely careful when assessing the authenticity of any Nelson relics which claim a similar provenance, because, although some of the dubious items are safely confined in museums as an interesting sidelight on the Nelson story, there must be many still on the loose, waiting to trap the unwary. Other types of relics with the false Pamela Hardy provenance also appeared in the salerooms in the early 1930s, including 'Captain Kidd's sea chest', one of a series of chests complete with secret compartments and treasure maps. The elusive Miss Hardy is said to have died in Spain in 1931, and her pirate relics were eagerly bought by Mr Hubert Palmer for his pirate collection.[9]

The Pamela Hardy Nelson items included watches, telescopes and other instruments, snuff boxes, buckles, swords, jewellery and furniture. Three watches which came to the NMM through various sources were also said to have come through Miss Pamela Hardy. One silver watch, sold on 5 December 1932, inscribed '*HN from CC 1800*' and supposed to have been presented to Nelson by Admiral Collingwood in 1800, is unfortunately hallmarked 1807. Another watch in a tortoiseshell case is inscribed '*Horatio Nelson 1779*'. Although it was not sold through a saleroom, the Eastbourne dealer's receipt claimed the same provenance for this watch: '*Pinchbeck watch in tortoiseshell outer case once owned by Horatio Nelson RN and given to him by Cuthbert Collingwood. This watch was bought from Miss Pamela Hardy of Lushington Rd, Eastbourne, Grandniece of Capn. Hardy RN.*' It was accompanied by a letter of authenticity signed by Pamela Hardy.

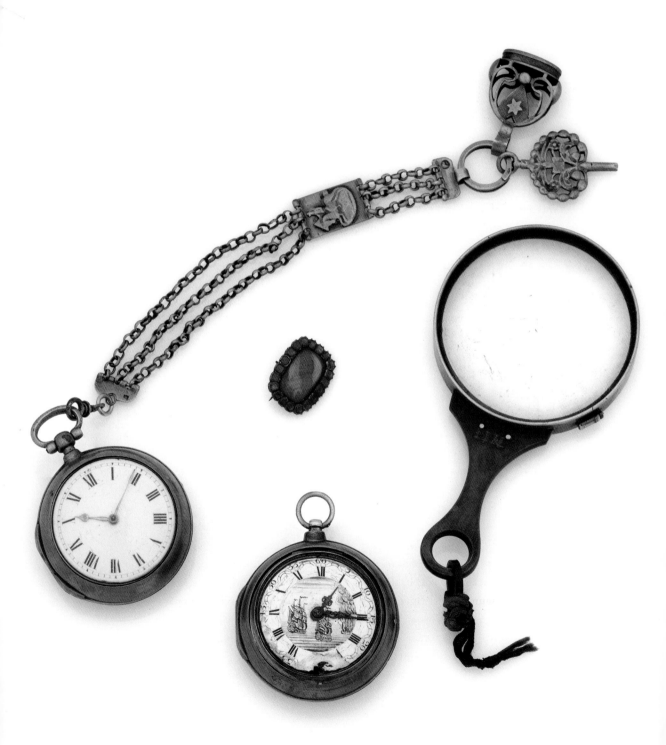

Yet another watch, which appeared at the same period, also with a Pamela Hardy provenance and again purchased through an Eastbourne dealer, is hallmarked 1750 and inscribed on the front rim of the case *'For strict attention to duty with HMS Racehorse North Pole Expedition 1772'*. On the back of the case is inscribed *'From Hon. Capt. C J Phipps RN to Horatio Nelson, Midsn.'* Nelson was a midshipman in the *Carcass* on the 1773 expedition, and the bomb vessel sailed from Sheerness on 30 May 1773 to join the *Racehorse* at the Little Nore. Even if the provenance of these watches was less dubious, and the inscriptions and hallmarks were more convincing, it would be extraordinary that so many presentation pieces should survive from an early period before Nelson had become famous.

The sales also included some larger items, such as pieces of furniture. It appears that even items associated with Nelson's relations had commercial value by the 1930s. On 5 December 1932 a large mahogany breakfront sideboard, standing on two cupboards, with lion's-paw feet and lion's-mask handles on the drawers, was sold in a London saleroom. An inscription reads *'Formerly the property of Lord Nelson's father, the Revd. Edmund Nelson of the Parsonage, Burnham Thorpe, Norfolk'*. Again, Pamela Hardy was given as the source for the piece. Another item with a supposed Pamela Hardy provenance was bequeathed to the NMM in 1961. This is a mahogany bureau which has a secret drawer in a pigeonhole and a hidden brass plaque inscribed *'Rev. Edmund Nelson, the Parsonage House, Burnham Thorpe, Norfolk, 1759'*.

Unfortunately, new Nelson fakes are still appearing, which perhaps is not surprising given the value today of even the most minor item associated with the Admiral. On 8 September 1998 a number of 'Nelson relics' were sold in a West Country saleroom. The items comprised a collection of relics associated with Nelson's death and funeral, including a piece of the *Victory*'s flag torn by the sailors at his funeral, a piece of the deck where he fell, and other items said to have been once exhibited in the Royal United Service Museum, complete with the old museum labels. Buyers received a complex and convincing provenance with their purchases. It turned out, however, to be the latest in a series of sales of fake Nelson memorabilia uncovered by a Dorset Trading Standards investigation, which led eventually to prison for the Kent man responsible. On closer analysis, dyes in the flag fragments were proved to be modern, wood was the wrong type for the *Victory*, and the old museum labels had been produced by modern techniques. It proves that one should never assume that a faker is unlikely to go to the trouble of fabricating a complicated background for a minor relic; in this case the criminal had done his homework.[10]

MYTHS

Amputation

When Nelson's arm was amputated on board the *Theseus* on 25 July 1797, following his injury at Santa Cruz, the details of the operation were well documented,[11] and the surgeon's journal can be consulted at the National Archives.[12] The surgeon who performed the amputation is known to be Thomas Eshelby, assisted by Louis Remonier, who had transferred from the *Captain* to the *Theseus* on the same day as the Admiral. The second surgeon's mate, George Henderson, had already died in the attack. Some early Nelson biographers, such as Harrison and Robert Southey, suggested that it was the Frenchman Remonier who was responsible for trapping a nerve in one of the ligatures, which afterwards caused Nelson great pain. A letter from Nelson to Lord Keith on 6 April 1800 makes it clear that Remonier had only assisted in the amputation.[13]

However, a myth created by another claimant to have been the surgeon responsible has often been quoted, and there is even a 'relic' of the operation to be found in the NMM. *The Gentleman's Magazine* for 1845 includes a brief obituary notice of Surgeon Auchmuty, who died on 6 February 1845: '*At Kilmore, Roscommon, Surgeon Auchmuty, who amputated Lord Nelson's arm at Santa Cruz. He received a gold medal from the distinguished naval hero.*' A century later a descendant of Auchmuty wrote to Carola Oman to complain that in her biography of Nelson, first published in 1947, she had given the honour to Eshelby and Remonier. He referred, as further proof, to an exhibit in the RUSM: '*7139: Saw with which Dr Auchmuty RN amputated Lord Nelson's arm in 1795* [sic]. *The saw was given to Field-Marshal Lord Wolseley in Dublin in 1893, by Mr Thomas Dillon, godson of Dr Auchmuty. Given by the late Dowager Viscountess Wolseley.*'

When the collections of the RUSM were dispersed in the 1960s, the supposed amputation saw was sent to the NMM (TOA0123). The saw has a steel blade reinforced with copper, a wooden handle and a silver label attached which gives the provenance. Unfortunately, the myth does not stand up to close scrutiny. Although a ship's surgeon named Arthur Ahmuty or Akmuty (but not Auchmuty) was serving in the Royal Navy at the time that Nelson's arm was amputated, on 25 July 1797, he was on board the *Harpy*, a brig sloop, moored in the Downs, so clearly could not have been at Santa Cruz.

Nelson's blind eye

There is a popular misconception that when Nelson was blinded in his right eye, he actually lost the eye and was obliged to wear an eye patch to cover the disfigurement. In fact, although he lost the sight of the eye, the eyeball was never

ANATOMICAL MODEL ONCE WRONGLY IDENTIFIED AS NELSON'S 'GLASS EYE'.

removed, and in later years that eye appeared only slightly different from the seeing eye. In August 1794, a month after his injury, Nelson wrote to his wife: *'Although the blow was so severe as to occasion a great flow of blood from my head, yet I most fortunately escaped, having only my right eye nearly deprived of sight: it was cut down, but is so far recovered, as for me to be able to distinguish light from darkness. As to all the purposes of use, it is gone; however, the blemish is nothing, not to be perceived, unless told. The pupil is nearly the size of the blue part, I don't know the name.'*[14] There is no contemporary record of Nelson ever having worn an eye patch, and indeed it would have been unnecessary, but so great is the strength of myth that Nelson is frequently portrayed today, especially in cartoons and popular souvenirs, wearing a black eye patch over the right eye, making him instantly recognizable.

PART II

CATALOGUE

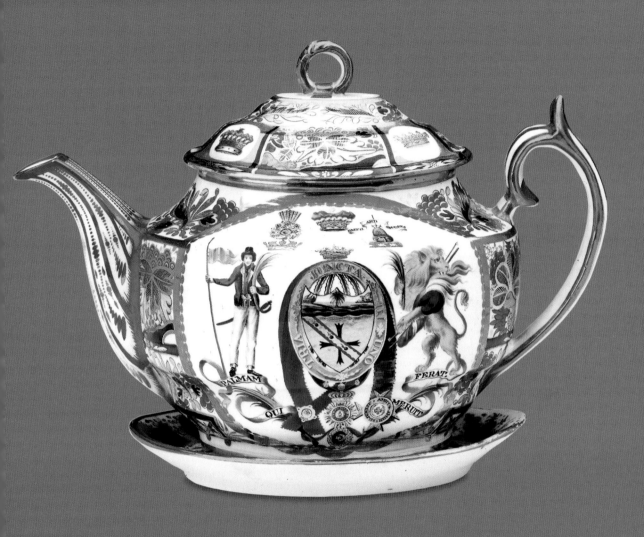

CHAMBERLAIN'S WORCESTER TEAPOT FROM THE HORATIA SERVICE.

UNIFORM AND CLOTHING

Five of Nelson's uniform coats have survived, and this clothing gives us a good idea of his height and frame, which has always been a matter for conjecture. Although there is a popular misconception that he was extremely short, his clothing and other evidence suggests he must have been about 5 feet 6 inches tall. Contemporary accounts, including that of Nelson's nephew George Matcham, describe him as being of '*middle height*', and a Royal Marine writing to his sister from the *Victory* after Trafalgar describes him as '*a man about five feet seven, very slender*'. A Dane, Mr J. A. Anderson, describing a visit to Merton on 20 August 1805, wrote in an account of his visit to England published four years later, '*Lord Nelson was of middle stature, a thin body, and apparently of delicate constitution. The lines of his face were hard, but the penetration of his eye threw a kind of light upon his countenance which tempered its severity.*' Probably the best evidence for Nelson's height is the effigy in the undercroft of Westminster Abbey, made after the funeral, which was accepted as a good likeness by Lady Hamilton. The height of the figure is slightly under 5 feet 6 inches.

William Beatty, the *Victory*'s surgeon, gives this interesting description of Nelson's appearance at sea in his *Authentic Narrative of the Death of Lord Nelson* (1807):
On several occasions he did not quit the deck during the whole night. At these times he took no pains to protect himself from the effects of wet, or the night-air; wearing only a thin great coat; and he has frequently, after having his clothes wet through with rain, refused to have them changed, saying that the
leather waistcoat which he wore over his flannel one would secure him from complaint. He seldom wore boots, and was consequently very liable to have his feet wet. When this occurred he has often been known to go down to his cabin, throw off his shoes, and walk on the carpet in his stockings for the purpose of drying the feet of them. He chose rather to adopt this uncomfortable expedient, than to give his servants the trouble of assisting him to put on fresh stockings; which, from his having only one hand, he could not conveniently effect.

Nelson's Trafalgar uniform

On 23 September 1850 William Rivers, who had been standing on deck close to Nelson and Hardy shortly before Nelson received his fatal wound, wrote from Greenwich Hospital in reply to an enquiry from Mr William Henry Robinson, a Nelson collector: '*The dress worn on that day was the same as he usually wore, a plain cocked hat with a green shade fixed to it inclining over the right eye, hat worn nearly square, white neckerchief, white marcella waistcoat, uniform Coat with four stars, white casumer Breeches & Stockings thread & silk mixed, Shoes with Buckle, he had no sword on, a glass about 2 feet long in his hand.... His Lordship never altered his dress the 3 years in the Victory, upon two occasions he put on Boots for a few hours in wet weather.*'

It is remarkable that almost every item of clothing worn by Nelson when he received his fatal wound at Trafalgar should have survived to the present day, despite originally being widely dispersed. Beatty mentions that before being placed in the large cask, or leaguer, to transport it home, Nelson's body '*after*

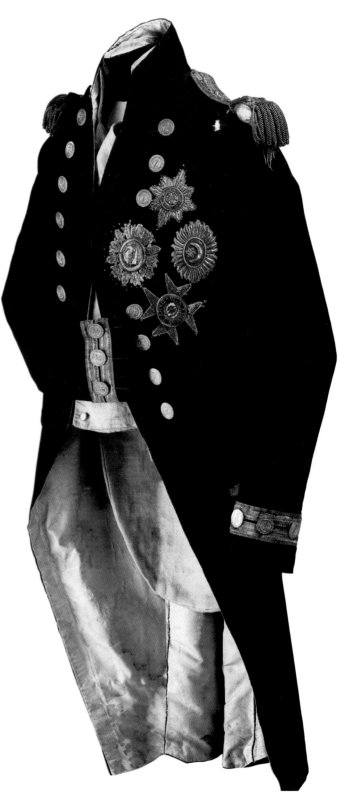

the hair had been cut off, was stripped of the clothes except the shirt, and put into it, and the cask filled with brandy'. The only items Nelson wore that day which are not now at the NMM are that shirt and his shoes. All the items bear the scars of their violent history, from the musket-ball damage on the epaulette and shoulder of the coat to the breeches, which were rapidly cut away from the wounded man by the surgeon. There are bloodstains on every garment, but Nelson was bleeding internally and not all the blood on the clothing was his own. The *Victory*'s deck and cockpit in battle was a bloody place. Beatty reports that when Nelson was hit at 1.15pm, '*He fell with his face on the deck... he had fallen on the same spot on which, a little before, his Secretary (John Scott), had breathed his last, with whose blood His Lordship's clothes were much soiled.*' In the 1980s, while the Trafalgar clothing was being conserved, analysis of the bloodstains was suggested. However, the Metropolitan Forensic Science Laboratory advised that after such a long time the results would be inconclusive and would probably only indicate that the blood was human.

The Trafalgar coat

This iconic coat is arguably the most important Nelson relic in the NMM's collection. It is the Vice-Admiral's undress uniform coat in which Nelson was mortally wounded at the Battle of Trafalgar. The damage can clearly be seen on the left shoulder where the musket ball entered, leaving a hole in the fabric and taking with it some of the gold bullion from the epaulette. (For the musket ball, see Catalogue: Wounds & Death.) The coat tails and left sleeve are stained with blood, probably not Nelson's but perhaps John Scott's or Midshipman Westphal's.

The coat, which is of the 1795–1812 RN uniform pattern, worn with epaulettes, is made of blue wool cloth with a stand-up collar, button-back lapels and white silk twill lining. The lapel buttons are by Smart, Exeter Change. The left sleeve and the top of the right sleeve are lined with black silk twill, and the right sleeve has a small black silk loop at the cuff to secure the empty sleeve to a lapel button. The sleeves have narrow round cuffs with two rows of gold distinction lace and three flag-officer's buttons.

The epaulettes, introduced as part of naval uniform for the first time in 1795, are of wide gold

lace, and are worn attached to a small uniform button on the shoulder of the coat. There would originally have been two stars on each epaulette, worked in metal thread and silver spangles, to indicate the rank of vice-admiral, but one star is now missing from the right epaulette. The undersides are covered with yellow silk.

On the left breast the embroidered stars of Nelson's four orders of chivalry, the Order of the Bath, Order of the Crescent (sewn on upside-down), Order of St Ferdinand & of Merit, and the Order of St Joachim, are sewn to the coat, overlapping the lapel (see Catalogue: Orders and Medals). It is frequently asserted that Nelson's vanity in wearing his decorations on deck during the battle led to his death. The evidence has been hotly debated over the years, but Beatty and other contemporary accounts make it clear that he always wore the embroidered orders on his uniform coats.

Sir Nicholas Harris Nicolas quotes a letter written in 1844 by Captain Sir George Westphal, a midshipman on board *Victory* who was wounded at Trafalgar: '*I am most positive that the Coat which his Lordship wore on the day the Battle was fought, was an old undress Uniform, the skirts being lined with white shalloon or linen. The four Orders that he invariably wore were embroidered on the breast of every Coat I had ever seen him wear from his first hoisting his Flag.*'

Westphal continued, '*When I was carried down wounded, I was placed by the side of his Lordship, and his Coat was rolled up, and put as a substitute for a pillow under my head, which was then bleeding very much from the wound I had received; and when the Battle was over, and an attempt made to remove the Coat, several of the bullions of the epaulette were found to be so firmly glued into my hair, by the coagulated blood from my wound, that the bullions, four or five of them, were cut off, and left in my hair, one of which I have still in my possession.*' This relic is now at Monmouth.

PROVENANCE
After Nelson's death the coat was sent to Emma Hamilton, and then came into the possession of Nelson's brother William, first Earl Nelson. In 1806 William's wife Sarah lent it rather reluctantly to Lady Hamilton, for her lifetime only. The Countess wrote to Emma on 13 February 1806: '*My Dear Friend, The*

Coat which our beloved and lamented Lord had on when He received his fatal wound, is as you know in our possession — In point of right there can be no doubt to whom this precious relick belongs, and it certainly is my Lord's most ardent wish & as well as my son's who spoke very feelingly on the subject before he left us, to have retain'd it in his possession to be kept as a Memorial in Trafalgar House as long as it can hold together — But notwithstanding all these feelings my Lord is willing, tho' done with a bleeding heart, to part with it to you, for your life provided, my dear Friend, you give us assurances it shall at some future time be restored to the Heir of the Title, to be by him preserved. Tis thought a Glass Case Hermetically sealed (the same as Miss Andreas [sic] will do hers in Westminster Abbey) will be the best mode of preserving it from the Injuries of the external air. Believe me your ever affectionate friend S Nelson. Feb 13th 1806.' (NMM/AGC/18/14)

Emma, however, released the coat to Alderman Joshua Jonathan Smith to pay off a debt, and it was from Smith's widow that the coat eventually came to the national collection. Horatia had always known where the coat was and told Sir Nicholas Harris Nicolas at their first meeting in October 1844. Nicolas determined to buy the coat for Greenwich Hospital but Mrs Smith wanted £150 for it. A dealer, Mr T. A. Evans of the Old Curiosity Shop, Hanover Square, also wanted to purchase the relic. Horatia visited Mrs Smith in December 1844 and afterwards received a letter from her: '*I perfectly agree with you, that if it should so happen that it cannot belong to the family, it should to the Nation, as the most valuable relic.... It is strange that so many persons are anxious to possess that which has remained so many years in my possession, unsought.*' (16 December 1844, NMM/NWD/9594/1)

On 26 June 1845, having personally examined the coat, and vouched for its authenticity, Nicolas sent to HRH the Prince Consort a copy of a statement he intended circulating to the press to open a public subscription to buy the coat for display alongside the Nile coat at Greenwich. By return came the reply: '*I have brought the subject before the Prince, and have received H.R.Highness's Commands to purchase these relics on his account, and it will be a pride and a pleasure to present them to Greewich Hospital.*' *ILN* of 26 July 1845 published a report and engraving of the coat and waistcoat, commenting: '*There is*

kind and generous wisdom in this act; for nothing could so help to identify the Queen's husband with the British people as such little tributes to their maritime pride.' The cheque for £150 was sent to Nicolas, who paid Mrs Smith and delivered the coat and waistcoat to Buckingham Palace. The disappointed dealer from Hanover Square produced a bitter pamphlet against Nicolas, but in July 1845 the coat was presented to Greenwich Hospital, where it was displayed until 1934. It was then transferred to the new NMM in Greenwich.

EXHIBITED with the Trafalgar waistcoat, breeches, stockings and stock.
1891: RN Exhibition, Chelsea, cat. no. 3206
1905: RUSI, Exhibition of Nelson Relics, no. 6001

BIBLIOGRAPHY [D]
Beatty, *Authentic Narrative of the Death of Nelson*.
Nicolas, 1846, Vol. VII, pp.347–352, 'Nelson's Fighting Coat'
T. A. Evans, *A Statement of the means by which the Nelson coat... was obtained by Sir Nicholas Harris Nicolas*, London, 1846
ILN, 26 July 1845
The Times, 9 July 1845

NMM, Greenwich Hospital Collection, coat UNI0024, epaulettes UNI0031 (damaged) and UNI0032

Trafalgar waistcoat

Waistcoat worn by Nelson at Trafalgar, heavily stained on the left shoulder with his blood.

The waistcoat is made of off-white cotton marcella woven in a diaper pattern. It is double-breasted with seven fabric-covered buttons on each side. There is a stand-up collar with folded-back revers, and narrow pockets on both sides of the body. The waistcoat is lined with white linen and the collar and revers are lined with marcella. The back is of white flannel with four linen tying tapes to adjust the fit.

This is a non-regulation waistcoat which Nelson wore with his uniform. He is recorded as having habitually worn a marcella waistcoat in undress.

PROVENANCE
Surrendered together with the coat to Alderman Smith by Lady Hamilton to discharge a debt, and purchased from Smith's widow in 1845.

Presented to Greenwich Hospital by Albert, the Prince Consort, together with Nelson's Trafalgar coat, in July 1845.

NMM, Greenwich Hospital Collection, UNI0065

Trafalgar breeches and stockings (see pp.100–1)

Nelson's breeches worn at the Battle of Trafalgar were cut off by the surgeon William Beatty in the cockpit of the *Victory*. The breeches and stockings are stained with blood, probably Scott's rather than Nelson's.

The breeches, of the 1795 RN uniform pattern, have a flap front, and are made of white twill woven wool with a napped finish. The back has a white linen gusset, laced with tapes passing through eyelets, to adjust the fit. The breeches are fastened by brass buttons and tightened below the knee with small gilt brass flag-officer's buttons and gold buckles. One button is missing from each leg.

The stockings are finely knitted from a cotton/wool blend thread, with a different, slightly thicker, wool used for the feet. Nelson's laundry mark, a coronet and initial 'N' in blue, with a number II below, is embroidered in cross-stitch with blue thread at the top of both sides of the stockings.

PROVENANCE
Retained by Lieutenant Lewis Rotely, Royal Marines, HMS *Victory* (d. 1861). Bequeathed to Greenwich Hospital by his daughter Jane D. Rotely in 1896. The breeches buckles were purchased at Christie's Bridport sale of 12 July 1895 and presented to Greenwich Hospital by Thomas Barratt in 1902, when they were sewn to the breeches. (NA/ADM169/219 and 304)

NMM, Greenwich Hospital Collection, UNI0021 (breeches) & UNI0067 (stockings)

Trafalgar stock

Black velvet stock worn by Nelson at the Battle of Trafalgar. Lined with white linen and fastened at the back of the neck by means of a gilt metal buckle with four prongs, which fit into four corresponding buttonholes at the other end.

Presented to Greenwich Hospital by the children of Mrs Horatia Nelson-Ward, 1881.

NMM, Greenwich Hospital Collection, UNI0066

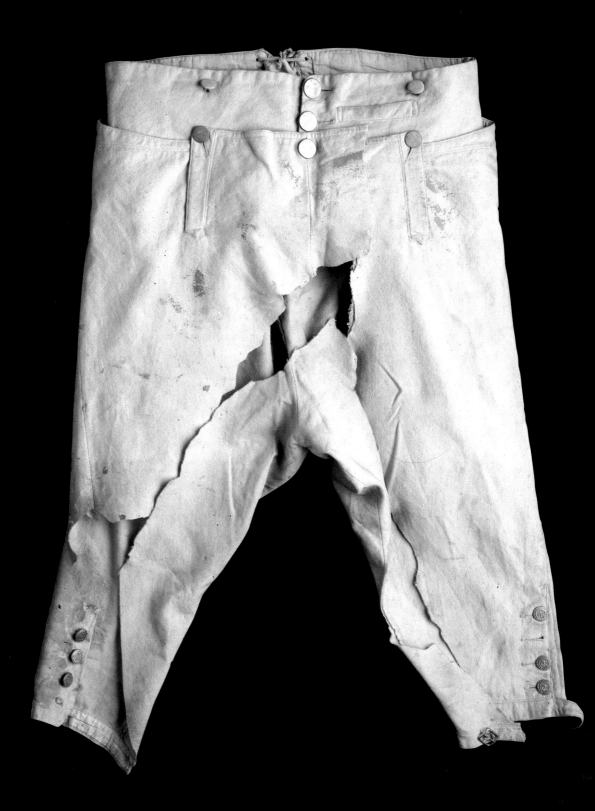

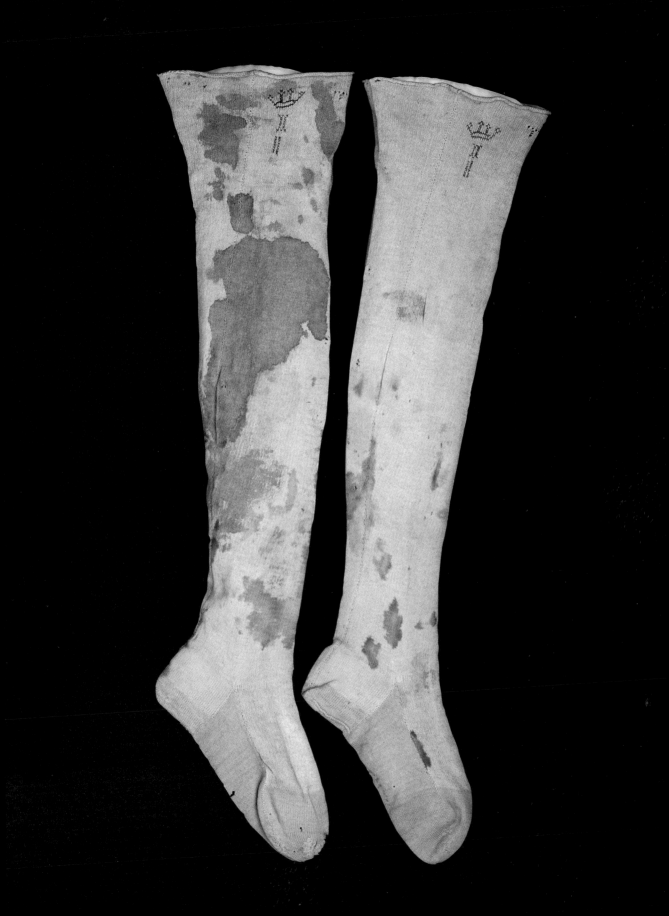

The Nile coat

Rear-admiral's undress coat worn by Lord Nelson at the Battle of the Nile, 1798.

The coat, which is of the 1795–1812 uniform pattern, is made of blue wool fabric with a white linen lining, probably a replacement, except for the collar, lined in white silk, and the right sleeve, which is unlined. There are nine gilt buttons by Firmin & Westall, Strand, on each lapel and two small buttons on the stand-up collar. The epaulettes are secured by a button and loop. There is a single row of gold lace on each cuff, denoting a rear-admiral, with three gilt buttons and dummy buttonholes, and each cuff is secured by a self-covered button and working buttonhole. The pocket flaps are lined in white and there are decorative buttonholes with three buttons under each pocket flap (one of which is missing from each side). The skirts of the coat are pleated on each side, with a vent in the centre and gilt regulation buttons at top and bottom of the pleats.

The cuff of the right sleeve has a small black silk loop used to secure the empty sleeve to the front buttons of the lapels. There are no orders sewn to this coat. The coat is well worn and has signs of old patching and moth damage, and there is a greasy mark across the shoulders left by the dressing on Nelson's pigtail.

PROVENANCE
Nelson gave the coat to the Hon. Mrs Anne Seymour Damer (1748–1828), a sculptress, when he wore it while sitting to her for a bust in 1798. She was a friend of the Hamiltons and was in Naples when Lord Nelson arrived there after the Battle of the Nile. Nicolas, in Vol. VII, pp.347–8, quotes Lord William Campbell:

The last time he sat to her, he good humouredly asked her what he could give her for the high honour which she had conferred on him, and for all the trouble which she had taken on the occasion. She answered 'one of your old Coats,' on which he replied, 'you shall immediately have one, and it shall be the one which I value most highly, – the one which I wore during the whole of the Battle of the Nile, and which I have never worn, nor even allowed

PREVIOUS PAGES: THE BREECHES CUT OFF NELSON AS HE LAY DYING (LEFT) AND NELSON'S TRAFALGAR STOCKINGS (RIGHT).

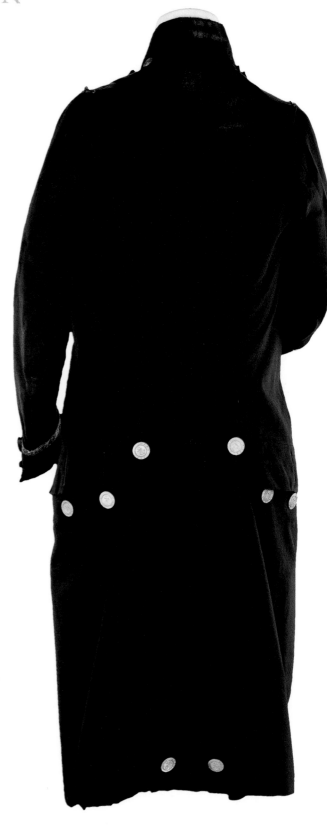

to be brushed, since, in order that my Naval as well as other friends may know, the streaks of perspiration and hair-powder which are still to be seen on it, the exertions which I made, and the anxiety which I felt, on that day to deserve the approbation of my King and Country.

The large marble bust, now in the Guildhall, London, depicts Nelson wearing the coat with the three Orders of the Bath, St Ferdinand and the Crescent, the riband of the Bath and the Naval Gold Medals for St Vincent and the Nile. After Nelson's death it was engraved by various artists. On her death in 1828 Mrs Damer left the coat to HRH the Duke of Clarence, later King William IV, together with a bronze version of the bust. He presented it to Greenwich Hospital in 1828, to be exhibited in the Painted Hall with other Nile relics.

EXHIBITED
1891: RN Exhibition, Chelsea, cat. no. 3205

BIBLIOGRAPHY
Nicolas, 1846, Vol. VII, p.348
Walker, pp. 220–2

NMM, Greenwich Hospital Collection, UNI0022

Stock, *c.*1798

Black silk stock reputed to have been worn by Nelson at the Battle of the Nile in 1798.

The stock is made of black silk ribbon, overlapped into eleven pleats, which are sewn down at each side. It is backed with white silk interlined with heavy glazed linen, and the remains of the silk ribbon ties are still visible at each end.

(Another of Nelson's silk stocks, also said to have been worn at the Battle of the Nile, was given by Nelson in Naples to Sir Edward Baines, who had served with him in the West Indies, for his daughter Pamela, who had asked for some personal relic of the battle.)

NMM, Greenwich Hospital Collection, UNI0047

Full-dress uniform coat

Vice-admiral's full-dress uniform coat of the 1795–1812 pattern, worn by Nelson.

The coat is of blue wool and lined with white silk twill, except for the right sleeve, which is unlined. A small black silk loop sewn to the edge of the right cuff was used to fasten the empty sleeve to a button.

The embroidered badges of Nelson's four orders, the Bath, the Crescent, St Ferdinand and St Joachim, are sewn to the front of the coat, with St Ferdinand over the edge of the lapel, preventing it from being buttoned. The Order of the Crescent is sewn on upside-down as on the Trafalgar coat. The coat was fastened by two hooks and eyes just inside the edge of the lapels.

The coat has full lacing on the lapels, pockets, collar, skirt and cuffs. The pocket flaps are three-pointed and edged with gold lace, which also appears as horizontal bands across the back vent of the coat. The ten buttons are by Firmin & Westall.

PROVENANCE
Belonged to Dr Horatio G. A. Wright, who attended Prince Alfred, Duke of Edinburgh, when he was wounded in Sydney in March 1868. Displayed in Sydney Museum and presented to Britain by Mrs Josephine Maude Macarthur of Sydney, New South Wales. Accepted by HRH Henry, Duke of Gloucester during his visit to Australia in March 1935, and brought to Greenwich.

NMM, UNI0023

Undress uniform coat and waistcoat

Vice-admiral's undress coat, of the 1795–1812 uniform pattern, worn by Nelson. Similar cut and style to the Trafalgar coat. The coat is made of blue cloth, and is double-breasted with nine gilt buttons by R. Bushby, St Martin's Lane, on each lapel. The coat fastens edge to edge with three hooks and eyes. There are two rows of distinction lace on each sleeve with three buttons between, and a black silk loop sewn to the inside of the right cuff.

The four embroidered stars of Nelson's orders are sewn to the left breast, but the Crescent is not sewn on upside-down as on the other uniforms.

PROVENANCE
This coat and waistcoat went to Nelson's sister Mrs Catherine Matcham after his death.

Coat and waistcoat lent by William Eyre Matcham to the 1891 Royal Naval Exhibition (cat. no. 3228) and the 1905 Exhibition of Nelson Relics at the

RUSI (cat. no. 3032). The coat, and no. 3033, a uniform waistcoat, are described as being 'one of two worn by Lord Nelson in his last service in HMS Victory, 1803-1805'.

In 1948 the coat and waistcoat were purchased for the NMM as part of the Trafalgar House Collection by Sir James Caird Bt. Displayed at RNM Portsmouth 1977–86.

NMM, UNI0026 (coat) & UNI0028 (waistcoat)

Undress uniform coat

Vice-admiral's undress coat, of the 1795–1812 naval uniform pattern. The coat is identical in cut to the Trafalgar coat and likely to be made by the same tailor. Made of blue wool fabric, the front, tails and collar lined with cream silk. The left sleeve is lined with black silk and the right is unlined. The lapels are buttoned back with nine gilt buttons by R. Bushby, St Martin's Lane, on each side, and the epaulettes are attached by gilt buttons and straps. The embroidered stars of his four orders are stitched to the left breast, the Crescent upside-down.

By tradition, this coat is said to have been laid out ready for Nelson to put on after the Battle of Trafalgar, which is unlikely as the admiral's cabin would have been cleared for action.

PROVENANCE
From the collection of Miss Frances Girdlestone, Nelson's great-great-niece. She said that after Nelson's death, his servant Tom Allen went to work for her father Henry Girdlestone. 'In return Tom Allen brought to the family this Nelson coat. It was a coat which Tom kept specially well brushed for important occasions, as Nelson was careless about his appearance.' (Sir Geoffrey Callender, Director of the NMM, reporting on Miss Girdlestone's visit to offer the coat for sale in July 1935.) Allen had actually left Nelson's service in c.1802 and was not at Trafalgar. In 1937 Sir Percy Malcolm Stewart Bt purchased it from Miss Girdlestone for the NMM.

EXHIBITED
1905: Naval, Shipping & Fisheries Exhibition, London: Relic Section, lent by Mrs Girdlestone of Lymington.

NMM, UNI0025. Currently on loan to RNM Portsmouth.

Epaulettes

Pair of vice-admiral's epaulettes, 1795 pattern, attributed to Nelson. These are almost identical to those on the Trafalgar coat, but one of the two stars on each epaulette, denoting the rank of vice-admiral, has been removed, perhaps by early souvenir hunters.

On 18 July 1795 Nelson wrote to his wife: 'I have just been ordering what I fancy is the proper epaulettes. However, I was obliged to take a young friend of mine, a soldier officer, or I might have made a bad choice. The navy lace for the strap very full and long the bullions so we shall all be bucks in our old age.'

NMM, UNI0033

Clothing on Westminster Abbey's Nelson effigy

The wax head on a lay figure, modelled for display in Westminster Abbey by Catherine Andras of Pall Mall in 1806, was based on John Hoppner's full-length portrait of 1800. A few of the clothes worn by the effigy are Nelson's own, while other items, particularly the vice-admiral's full-dress coat, were probably made specially for the display. The effigy and its clothing was fully conserved, photographed and recorded in 1992–3. Only those items now believed to be Nelson's own, the hat, shirt and stockings described below, are included here.

BIBLIOGRAPHY
Geoffrey Callender, 'The Effigy of Nelson in Westminster Abbey', Mariner's Mirror, 1941, Vol. 27, no. 4, pp.307–313
Lawrence E. Tanner, Recollections of a Westminster Antiquary, 1969
Ed. Anthony Harvey & Richard Mortimer, The Funeral Effigies of Westminster Abbey, 2003

Hat, 1801

Undress uniform cocked hat owned by Nelson, bearing the label of the hatters Lock's of 6 St James's Street, London, a firm which still exists and still owns the ledgers containing entries for Nelson's original orders. This is a plain cocked hat made of beaver fur, intended to be worn with undress, rather than with the full-dress uniform of the effigy. It has a button, loop and cockade, as well as a crescent-shaped green

silk eyeshade stitched to the front. By 1805 such a hat cost two guineas at Lock's.

This is one of two hats ordered by Nelson in August and September 1805. His head size was *seven and one-eighth, full*. It is the only surviving Nelson hat to have the green eyeshade attached. Nelson ordered his first hat with an eyeshade from Lock's on 11 February 1803, although he had first placed an order there on 11 November 1800, when he opened an account with the firm. A sketch of the *Cocked Hat Cockade and Green Shade* appeared in Mr Lock's ledger, and after 1803 Nelson had all his hats made with the shade of stiffened silk to protect the failing sight of his remaining left eye. He also ordered spare shades. Such a hat is depicted in the portrait of Nelson by Arthur Devis, 1805.

The hat is lined with cotton and leather and has a paper label reading *James Lock hatter, St James's Street, London*, and the stamp *Stamp office no 57. Hat duty. Value above twelve shillings not exceeding eighteen shillings. Two shillings.*

Nelson visited Lock's on 13 September 1805 to settle his account before leaving England for the last time, and he is thought to have worn one of Mr Lock's hats at the Battle of Trafalgar.

BIBLIOGRAPHY
Kenneth S Cliff, 'Mr Lock: Hatter to Lord Nelson's Navy 1800–05', *Trafalgar Chronicle*, 1999, pp.98–104
Kenneth S Cliff, 'Mr Lock and Nelson's eye', *Nelson Dispatch*, Vol. 6 pt 11, July 1999, pp.486–90

Westminster Abbey, London

Linen shirt

Fine linen shirt, marked on the front with Nelson's laundry mark, being his monogram and coronet embroidered in blue cross-stitch, this one with the number '24'. The shirt is made from a single length of linen, and is of full cut, with the material gathered

NELSON'S HAT FROM THE WESTMINSTER ABBEY EFFIGY, FITTED WITH A GREEN EYESHADE.

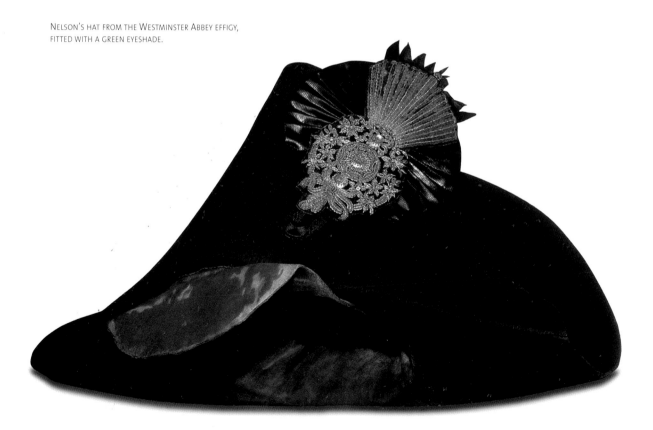

into a yoke across the shoulders. It has a high collar fastened with three Dorset buttons, and there is a frilled ruff in the front of the shirt. The sleeves have large gussets and are gathered into narrow pleats, with a cuff on the left sleeve. The short right sleeve has a tape running through the hem to pull it together over the stump. The shirt has been torn open at the back to fit it on to the effigy.

Westminster Abbey, London

Stockings

Machine-knitted white silk stockings with white clocks and a double welt at the top with a pink stripe. The stockings are marked below the welt with a coronet and initials 'HN' and the number 2, embroidered in blue silk. On 29 March 1798 Nelson wrote to his wife from Portsmouth: *'What you will be surprised to hear, with great difficulty found one pair of raw silk stockings. I suppose in some place or other I shall find my linen, for there is scarcely any in this trunk.'*

Westminster Abbey, London

Tenerife stockings

Pair of white silk knitted stockings with narrow blue vertical stripes, worn by Nelson when wounded at Tenerife in July 1797. The stockings have been extensively darned, especially on the heels.

PROVENANCE
Presented to Greenwich Hospital by Mr Brettell, nephew of Lord Nelson's steward, 1833.

NMM, Greenwich Hospital Collection, TXT0381

Hat

Cocked hat worn by Nelson at the Battle of Copenhagen, in April 1801.

It is a flag-officer's cocked hat of beaver fur, bound with lace, with a gold lace loop (missing its button) and a black-painted card cockade. The original crown has been replaced with black felt crudely stitched to the original brim.

Although the maker is not known for certain, it is likely to be by Lock's of St James's, from whom he had ordered a *'cocked hat and cockade'* on two recent occasions, in November 1800 and January 1801.

HAT WORN BY NELSON AT THE BATTLE OF COPENHAGEN.

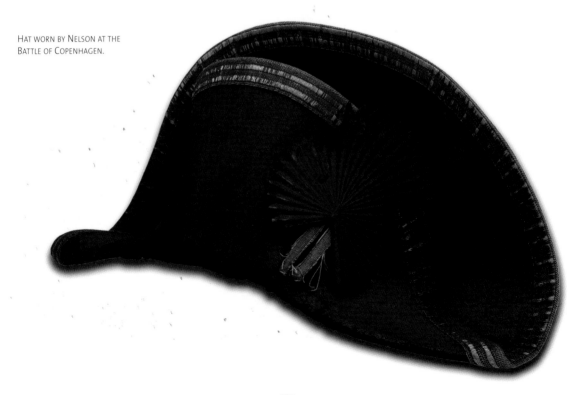

PROVENANCE

Given by Nelson in 1802 to John Salter of 35 Strand, his jeweller and sword cutler. In 1831 Salter went into partnership with his nephew J. Widdowson, and in 1835 the firm became Widdowson & Veale.

On 15 March 1846 Horatia wrote to Sir N. H. Nicolas: *'I had the pleasure of meeting you in the Strand – it was Wednesday the 2nd of Octr 1844…. Mr Veale remarked "I Sir, have a cocked hat of Lord Nelson for which I have been offered a large sum but nothing would tempt me to part with it".'* (NMM/NWD/34)

Given to the RUSM by E. C. Ball of Widdowson & Veale (Letter to RUSI 15 April 1909).

EXHIBITED

1891: RN Exhibition, Chelsea, cat. no. 3349 (lent by Messrs Widdowson & Veale)
1905: Exhibition of Nelson Relics, RUSI, cat. no. 92

NMM, UNI0058

Hat

Captain's foul-weather bicorn hat with waterproof crown said to have been worn by Nelson in his last service in the *Victory* 1803–5.

The hat is of a pattern fashionable *c*.1780, but the gold lace loop is secured by a captain's button of 1795. The original worn beaver fur has been covered with linen fabric and painted with a black oil-based paint. The cockade, shown in the illustration in the 1905 RUSI exhibition catalogue, and tassels are now missing. The hat appears rather large to have been Nelson's.

EXHIBITED

1905: Exhibition of Nelson Relics, RUSI, cat. no. 93, given by J. N. Powell

NMM, RUSI Collection, UNI0038

Hat

Plain bicorn hat presented by Nelson when his portrait was painted for the City of Norwich by William Beechey RA in 1801. The lining of the hat is signed in ink *'Given to me by Ld Nelson when I painted his portrait 1801 for the City of Norwich. W Beechey'.*

The hat, which has a small cockade and button and a hat-tax stamp inside, is by an unknown maker.

PROVENANCE

Presented by Mrs P. E. Baker.

In 1894 Canon St Vincent Beechey, a son of Sir William Beechey, wrote in a local history of Rossall when he was 88 years old: *'Before he [Nelson] went to Trafalgar he called on my father and said, "Beechey, I'm off after the French again! What shall I leave my godson?" To which my father replied "the cocked hat in which you fought the battle of the Nile". "He shall have it" he said, and it is still [1894] in the possession of my niece. How deeply it was prized after the hero's death I need not say. It was pierced by two bullets.'* St Vincent Beechey's elder brother was Nelson's godson Charles.

'He parted with it as an old and tried friend, for he had worn it in many battles.' (Quoted in W. Roberts, *Sir William Beechey RA*, 1907, pp.75-6; Walker, pp.75–6.)

EXHIBITED

1891: RN Exhibition, Chelsea, 1891, cat. no. 3009: *'Hat worn by Lord Nelson at the Battle of the Nile, and presented by him to the late Sir William Beechey R.A. Lent by Miss E M Beechey.'*

Norwich Castle Museum

Undershirt

A woollen undershirt with plain collarless neck, buttoned front, button at the left cuff, and the right arm cut short. Marked in cross stitch with 'N' and a coronet.

PROVENANCE

Descended through the line of Nelson's sister Catherine Matcham.

Private collection

Shoe buckles

Although no Nelson shoes are known today, shoe buckles said to have belonged to him are in the collections at Greenwich, Portsmouth and Monmouth.

A pair of shoe buckles with gold borders in a box from Salter's, Nelson's jeweller. Sold by Viscount

Bridport at Christie's sale of 12 July 1895, lot 189: '*A pair of shoe-buckles, with gold borders – in shagreen case.*' These sold for £15.

Pair of shoe buckles with a handwritten note from Thomas A. Evans, the antique dealer of 17 Madox Street, who had also wanted to buy the Nelson coat: '*Nelson's shoe buckles were presented to Mr H Russell the architect of 22 Palace New Road Westminster in 1839 by Sir Thomas Hardy who assured Mr Russell on presenting them to him that they were the identical pair Nelson wore when he received his death wound on the 21st of October 1805 on board the Victory at the Battle of Trafalgar. I purchased them of him in 1846. Thomas A Evans 17 Madox Street Regent Street.*'

Nelson Museum, Monmouth

Buttons

Occasionally buttons appear which are said to have been on Nelson's uniforms. All buttons worn by Nelson on his uniforms were regulation naval buttons. The coats at Greenwich all have flag-officers' buttons with a design of a fouled anchor surrounded by laurel and are by the button makers Firmin & Westall, R. Bushby or Smart.

Recently some buttons came to light with a coronet and decorative sprigged initial 'N', similar to the initial engraved on some of the drinking glasses. The buttons are of two sizes and marked on the back '*Firmin London*', the maker of the naval buttons on Nelson's Nile coat. However, the coronet is that of an earl, so the buttons may be associated with his brother William, first Earl Nelson, but certainly not with Admiral Nelson. The most likely explanation is

that they are livery buttons used on the uniform of the Earl's male servants.

The Revd William Nelson had written to Lady Nelson on 1 April 1799, advising her on the design of livery: '*With regard to the full dress livery, I cannot say that I am a competent judge, I should think a London tailor who is used to make them for the nobility who frequent St James's will immediately know from seeing the undress... the coat and waistcoat pockets and collar should be embroidered with a worsted lace composed of the colours of the livery with the cross which composes part of* [*the arms*] *worked upon it.... the buttons should have either the aigrette or San Josef crests upon them.*' Of course, we do not know if this suggestion was ever followed up, but it is possible that examples of the Nelson livery might have survived somewhere, and buttons bearing Nelson's crests may one day add to the existing confusions.

Nelson letter

Nelson's letters home frequently went into minute details about clothing and domestic arrangements. This letter to his wife on 7 April 1798 gives a flavour: *My dearest Fanny, I have looked over my linnen, and find it very different to your list in the articles as follows: 13 silk pocket Hanks: only 6 New, five Old. 13 Cambrick ditto: I have 16. 12 Cravats: I have only 11. 6 Genoa Velvet Stocks: I have only 3. You have put down 30 Huckaback Towels: I have from 1 to 10. Eleven is missing from 11 to 22, that is No. 12 and 21; therefore there is missing No. 11-22, and to 30; 10 in all. I only hope and believe they have not been sent. I do not want them.*

Nelson Museum, Monmouth, E329

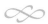

St. Helens Oct 7th 1798 Wind SW_4

My Dearest Fanny. — I have looked over my linnen
and find it very different to your list in the articles
as follows — 13 Silk Pocket Hankts only 6 New 5 Old
13 Cambrick Do I have 16 — 12 Cravats I have only
11 — 6 Ganoa Velvet Stocks I have only 3 — You
have put down 30 Huckaback Towels I have
from 1 — & 10 — Eleven is missing from 11 to 22 — that
is No 12 & 21 — therefore there is missing No 11 —
22 & to 30 — 10 in all, I only hope & believe they have
not been sent I do not want them, have you the
two Old peices of gold which my father gave
me, for I have them not, & yet I am pretty
positive I brought them home if you have
them not, they are lost, When my Print comes
out you must send one to Capt J: Mc.namara if
directed at Sr Peter Parkers he will be sure to get
it and he is very ansious about it, my health
never was better & only wishing for a fair Wind
 God Bless you Horatio Nelson

have recd only one letter, love to all —

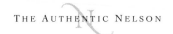

Catalogue B

ORDERS AND MEDALS

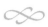

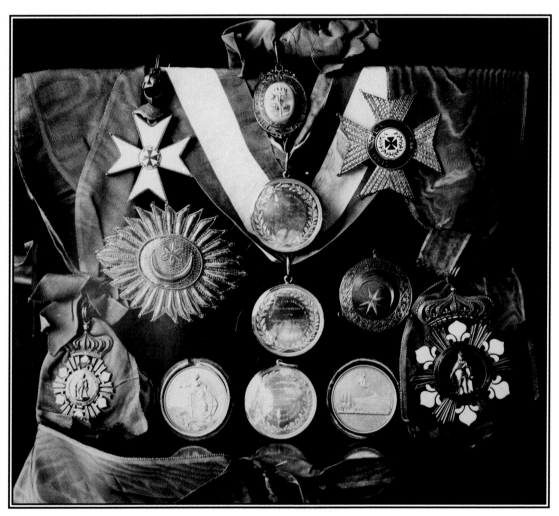

NELSON'S ORDERS AND MEDALS, PHOTOGRAPHED C.1889.

NELSON'S ORDERS OF CHIVALRY

Describing Nelson at Trafalgar, Surgeon William Beatty wrote: '*His Lordship came upon deck soon after day-light: he was dressed as usual in his Admiral's frock-coat, bearing on the left breast four stars of different orders which he always wore with his common apparel.*' (Beatty, p.12)

Nelson's services were rewarded by the granting of four orders of chivalry. After the Battle of Cape St Vincent, in 1797, he was made a Knight of the Bath. In 1799, Selim III, Sultan of Turkey, founded the Order of the Crescent, which Nelson was the first person to receive as a tribute for his victory at the Nile the previous year. Ferdinand IV, King of the Two Sicilies, made him a Knight Grand Cross of the Sicilian order of St Ferdinand and of Merit in 1800, and two years later he became a Knight Grand Commander of the German Order of St Joachim.

Mrs Melesina St George, an English widow visiting Dresden, described Nelson in her diary for 15 October 1800: '*Went by Lady Hamilton's invitation to see Lord Nelson dressed for court. On his hat he wore the large aigrette, or ensign of sovereignty given him by the Sultan of Turkey; on his breast the Order of the Bath, the Order he received as Duke of Bronte, the diamond star including the sun or crescent given him by the Sultan, three gold medals obtained by various victories... in short, Lord Nelson was a perfect constellation of stars and orders.*' However, Lady Minto, who saw him in Vienna in August 1800, wrote: '*I don't think him altered in the least. He has the same shock head and the same honest simple manners; but he is devoted to Emma... she leads him about like a keeper with a bear. She must sit with him at dinner to cut his meat, and he carries her pocket handkerchief. He is a gig from ribands, orders and stars, but he is just the same with us as ever he was.*' (Mahan, *Life of Nelson*, 1897, Vol. II, p.41)

The Jewels of Nelson's original orders were bequeathed to Earl Nelson and then descended through the Bridport family until they were sold in 1895 and displayed in Greenwich Hospital, having been purchased for the nation. Most of these were stolen from the Painted Hall in 1900, but the Collar of the Order of the Bath and the Grand Cross of the Order of St Ferdinand have survived, together with examples of Nelson's embroidered versions.

As was the custom at that time, Nelson habitually wore replica insignia of the orders, embroidered in gold and silver thread, on his uniform coats. There are surviving examples of these at Greenwich, Portsmouth, Lloyd's and in private collections, and the complete set of four can also be seen on Nelson's Trafalgar uniform coat at the NMM. These embroidered orders would become worn and tarnished, necessitating regular replacement. Monmouth has an important invoice from Messrs Barrett, Corney & Corney of 479, Strand, London, a firm of lacemen and embroiderers, detailing embroidered orders purchased by Nelson between October 1803 and August 1805. During that period Nelson bought five replacement sets of his four stars at about four guineas a set. The receipt for £21 12s, dated 7 September 1805, pasted at the bottom of the invoice, was paid by Nelson seven days before leaving England for the last time. The back of the invoice has an interesting illustration of '*Nelson's sword 3 feet long*', which had been sent for a new sword-knot to be fitted, and a sketch of his uniform cuff.

Collar of the Most Honourable Order of the Bath
Maker TL, London, 1797

Nelson was made a Knight of the Order of the Bath on 27 May 1797 for his part in Sir John Jervis's victory off Cape St Vincent on 14 February 1797. He received the insignia, including this collar, to be worn on ceremonial occasions, from George III in September 1797 while convalescing in England after the loss of his arm. The silver-gilt and enamelled chain is composed of nine imperial crowns and eight enamelled roses, thistles and shamrocks, linked together with seventeen gold knots enamelled white. The plain gold badge pendant from the collar is of the 1797–1814 pattern and has the motto of the Bath '*Tria Iuncta in Uno*'.

PROVENANCE
Normally the insignia would be returned to the sovereign after the death of the recipient, but Nelson's and Wellington's families were allowed to retain them. When Lord Bridport was appointed as GCB in 1891, he used the collar originally given to Nelson.

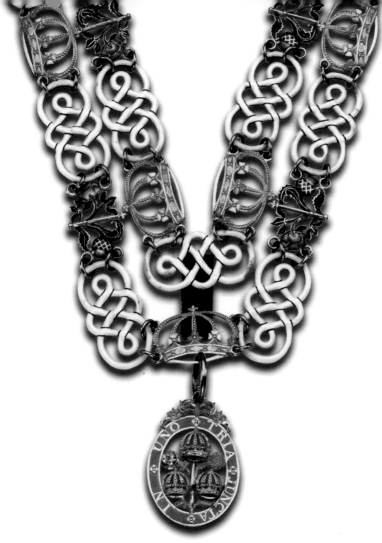

NELSON'S COLLAR OF THE
ORDER OF THE BATH.

Presented to Lloyd's in 1932 by 'a group of friends'.
(*The Times*, 27 Feb. 1932)

BIBLIOGRAPHY
J. C. Risk, *History of the Order of the Bath & its
Insignia*, 1972
Clarke & M'Arthur, Vol. II, 1809, Appendix 4, pp.
474–80, describes all four of Nelson's orders.

Loan to NMM from the Nelson Collection at Lloyd's of London,
NMM, ZBA1342

Replica Order of the Bath

Nelson wore a replica star of the Order of the Bath,
embroidered in metal wire and sequins, constantly
on his uniform coats, as instructed. These silver stars
have three gold sequin crowns in the centre
surrounded by the Bath motto '*Tria Iuncta in Uno*' on
a red ground. On the back of one star is written
'*Worn by Adl. Viscount Nelson KB on his uniform.*'

PROVENANCE
Bridport Collection.

NMM, REL0119 & REL0784

Order of St Ferdinand

Grand Cross of the Order of St Ferdinand and of
Merit, conferred on Nelson by Ferdinand IV, King of
the Two Sicilies, in 1800 to mark the restoration of
his kingdom. This order, which is on its original silk
sash, was the only one to survive the theft of the
Nelson relics from Greenwich Hospital in 1900.

The gold and enamel badge of the order depicts
St Ferdinand in regal robe and mantle, surrounded
by six bundles of golden rays and six Bourbon lilies
surmounted by a royal crown. The sash, which was
worn across the right shoulder, has faded in colour
from the original dark blue with red borders, the
colours of the royal house.

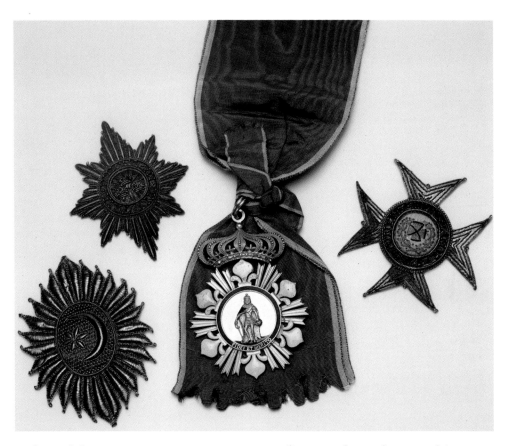

ORDER OF ST FERDINAND WITH ITS ORIGINAL RIBAND, AND EMBROIDERED ORDERS OF THE BATH, THE CRESCENT AND ST JOACHIM WORN BY NELSON ON HIS UNIFORM COATS.

PROVENANCE
Sold Christie, Manson & Woods, 12 July 1895, sale of Presentation Plate etc. of Admiral Viscount Nelson, the property of Viscount Bridport: 'Lot 182. Grand Cross of the Neapolitan Order of San Ferdinando, with riband.' Lot 181 was the Jewel of the same order, also on a riband. Both are illustrated in the catalogue, the Grand Cross being considerably larger than the Jewel. Nelson's orders and medals, Lots 176 to 185, were all sold together for £2500 to the nation, purchased by HM Government.

BIBLIOGRAPHY
Frederick A. Wieder, Order of St Ferdinand of the Two Sicilies, Numismatic Circular, Oct. 1973, pp.378–9

EXHIBITED
1891: RN Exhibition, Chelsea, cat. no. 2488, lent by General Viscount Bridport

1905: Exhibition of Nelson Relics, RUSI, loaned by the Lords Commissioners of the Admiralty from the Greenwich Collection, cat. no. 6030

NMM, Greenwich Hospital Collection, RELO783
There are also examples of the embroidered stars at RNM Portsmouth and Lloyd's.

Replica Order of the Crescent

Sultan Selim III founded the Order of the Crescent in 1799, and Nelson was the first to receive it, for his victory at the Nile.

On 6 November 1799 Nelson wrote to the Right Hon. Earl Spencer from Palermo: 'A few days ago, a gentleman from the Grand Signior came here with letters for me, and also a magnificent diamond Star, in the centre of which, on a blue enamel, is the Crescent and a Star. It is desired by the Grand Signior,

that I will wear it on my breast. I have, therefore, attached it to my coat, over the Star of the Order of the Bath.' Nelson wore a replica star of the Order constantly on his uniform coats. The silver radiant star is of oval lozenge shape, embroidered in silver thread with a star and crescent in the centre.

The Order was intended to be worn with the crescent to the left of the star, and is so depicted in most but not all Nelson portraits. However, it is sewn upside-down on the Trafalgar coat and two other of the five surviving Nelson coats, and is shown the same way in Arthur Devis's 1805 portrait of Nelson, suggesting that he may indeed have sometimes worn it incorrectly.

BIBLIOGRAPHY
Sir Bernard Burke, *Book of Orders of Knighthood & Decorations of Honour*, 1858
Edhem Eldem, *Pride and Privilege, a History of Ottoman Orders, Medals and Decorations*, 2004

NMM, Greenwich Hospital Collection, RELO120 & RELO121. Other examples are at RNM Portsmouth and Lloyd's.

Replica Order of St Joachim

In September 1801 the General Chapter of the Order of St Joachim of Leiningen decided to confer on Nelson the honour of Knight Grand Commander. This capitular, rather than state order, was instituted in 1755 by German nobles. Nelson wrote to the Rt. Hon. Henry Addington on 13 October 1801: '*I send you a letter which I have just received from Germany. What the Order of Knighthood is, I am totally ignorant of; but I can accept nothing without his Majesty's approbation.*' (Nicolas, Vol. IV, p.510. Nicolas mistakenly dismissed this order as 'apocryphal'.)

The NMM holds Nelson's bound and sealed Patent as Knight Grand Cross of the Order of St Joachim, April 1802 and Nelson's licence from George III to wear the ensign of the Order, 15 July 1802. (NMM/TRA/2)

Nelson wore a replica star of the Order constantly on his uniform coats. The design is an eight-pointed cross in silver sequins, in the centre a cross pattee and laurel wreath embroidered in green on a white silk background, and the motto '*Junxit amicus Amor 1755*' embroidered in gold wire on green velvet.

BIBLIOGRAPHY
J. C. Risk, 'The Order of St Joachim', *Journal of the Orders & Medals Research Society*, Vol. 12.4, 1973, pp.196–202
Ron Fiske, 'Nelson, Levett Hanson, and the Order of St Joachim', *Nelson Dispatch*, Vol. 7 pt 10, April 2002

NMM, Greenwich Hospital Collection, RELO122 & RELO123

HERALDRY

In addition to the various orders, there are still in existence a number of Nelson's illuminated grants of arms, city freedoms and manuscripts relating to his honours and titles. Although they fall outside the scope of this book, they are, of course, highly relevant to the heraldic and silver objects associated with Nelson. These manuscripts can be found in the collections of the NMM, College of Arms, National Archives, BL and Lloyd's. Other heraldic material, which has appeared at various times in the salerooms, may also now be in private collections.

Nelson's personal heraldry is an important aspect of his accumulation of honours following naval achievements, and he took a close personal interest in the details. His career can be traced through the changes to his coat of arms. After the Battle of Cape St Vincent in 1797 he was created a Knight of the Bath and granted a coat of arms which included the *San Josef* crest and supporters of a sailor and a lion tearing a Spanish flag. Following the Battle of the Nile of 1798, his arms were augmented by a chief to the shield which depicted a palm tree, disabled ship and ruined fort; the sailor now held a palm branch and the lion had a French flag added to the Spanish. At this time Nelson also received the *chelengk* crest and a new motto '*Palmam qui meruit ferat*' ('Let he who has earned it take the palm [reward]').

These heraldic details can prove very useful in dating and authenticating Nelson relics, although, of course, artists and craftsmen would not necessarily be aware of the correct version and the latest changes when they were depicting Nelson's arms. The *chelengk* crest, for instance, was seldom depicted correctly in painted and engraved versions. The inclusion on engraved or painted arms of a baron's, a viscount's or an earl's coronet can sometimes be critical to dating silver or porcelain. After Trafalgar, Earl Nelson received an augmentation to the arms, examples of which can be seen in the Silver section of this catalogue.

The small visiting cards used by Nelson as a viscount exist in various collections, although some may be later copies. The NMM also has a copper printing plate for these, which came from Viscount Bridport. The plain white cards are printed in copperplate script '*Viscount Nelson Duke of Bronte*'. Nelson changed his form of signature a number of times as he accumulated titles, discussing the matter with Sir Isaac Heard, Garter King of Arms, but eventually adopted '*Nelson & Bronte*' as the norm. The form of Nelson's name which appears in inscriptions on objects can be a further aid to authentication.

BIBLIOGRAPHY
Ron Fiske, 'Nelson's Arms and Hatchments', *Nelson Dispatch*, Vol. 6, 1999
David White, 'The Arms of Nelson', *Trafalgar Chronicle*, Vol. 8, 1998

MEDALS

Nelson received the flag-officer's Naval Gold Medals for the battles of Cape St Vincent and the Nile, and Davison's gold medal for the Nile. Although his medals were stolen from the Painted Hall their appearance is known from late-nineteenth-century photographs and detailed descriptions, as well as by studying the medals awarded to other naval officers for these actions. Nelson complained bitterly that his officers were not awarded similar medals for Copenhagen.

After the Nile, Alexander Davison commissioned Matthew Boulton to produce a medal to be presented to everyone who had served in the battle, the metal depending on their rank. Nelson's would have been gold, worth £10 13s 4d. The first two gold medals which Davison sent to Nelson he immediately passed on to Sir William Hamilton and Captain Hardy. Then on 23 August 1799, he wrote to Davison: '*Poor dear Miller is dead, and so will be your friend Nelson; but until death, he will wear your Medal that was intended for Miller*'.

The question of the fate of Nelson's own Davison Nile Medal is particularly complex. In September 1901 the *Connoisseur* reported that '*The gold medal given to Horatio, Lord Nelson, for the victory of the Nile, by Alexander Davison, of St James's Square, as a token of regard, fetched £180 at Messrs Debenham's in the same month. This medal was formerly in Viscount Bridport's collection of Nelson relics.*' On 20 June 1905 the sale of Nelson relics at Messrs Foster's of Pall Mall included lot 63, sold by direction of the executors of the late Joseph Williams of Waterloo near Liverpool: '*A Gold Medal, presented to Lord Nelson for the victory of the Battle of the Nile, by Alexander Davison Esq, from Viscount Bridport's sale, in gold-mounted glazed case*'. Two gold Davison medals had appeared in the catalogue of the Bridport sale of 12 July 1895, lots 174 and 175, but we cannot now be sure whether these were actually gold or bronze-gilt. They were purchased by Glendining and Spink. Other examples said to be Nelson's have also been sold, including one which was part of the Davison family collection sold in 2002. However, a number of gold Davison Nile medals are known, and it is now impossible to be sure which was Nelson's personal one.

BIBLIOGRAPHY
J. H. Mayo, 'Davison's Nile Medal', *Hamilton's Coin & Medal Despatch*, Vol. I, no. 3, 1973, pp.181–92

Catalogue C

SILVER

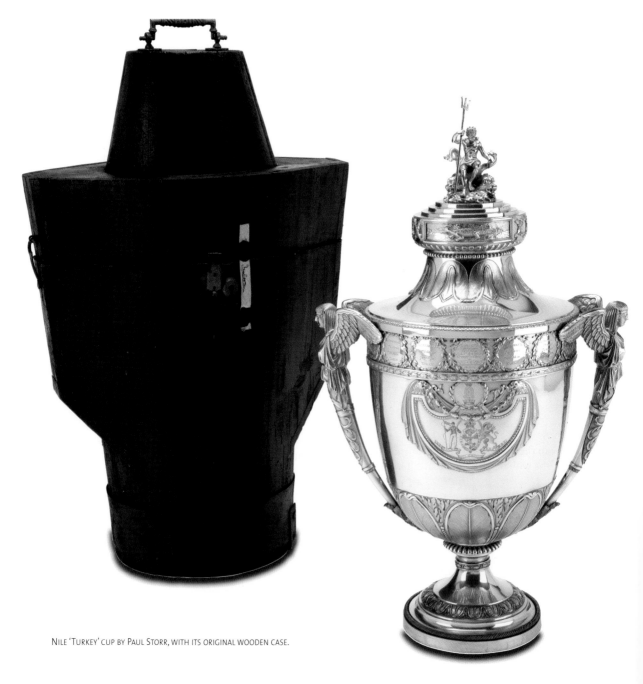

NILE 'TURKEY' CUP BY PAUL STORR, WITH ITS ORIGINAL WOODEN CASE.

PRESENTATION SILVER

Nile 'Turkey' cup
Paul Storr, London, 1799

This silver cup and cover, which Nelson always called his 'Turkey cup', is a unique piece commemorating the Battle of the Nile, 1 August 1798. On one side is Nelson's coat of arms as a baron, and on the other a presentation inscription. In reference to the Nile, the handles are formed as winged Egyptian female figures and the cover is decorated with crocodiles. The cover is surmounted by a finial in the form of Neptune with his trident and dolphins. Beneath the rim are cartouches within laurel wreaths naming the prizes captured at the Battle of the Nile.

The inscription reads:
Presented to the Right Honble. Rear Admiral Horatio, Baron Nelson of the Nile, by the Governor & Company of the Merchants trading into the Levant Seas, in commemoration of the glorious victory obtained by his Lordship at the mouth of the Nile on the 1st August 1798, on which ever memorable day by the defeat and capture of a French squadron, superior to his own he restored to his Majesty's Arms, the dominion of the Mediterranean, and to the British Merchants, the Free enjoyment of their ancient and valuable trade to Turkey.

The engraved coat of arms has Nelson's latest Nile augmentations of a palm tree, disabled ship and ruined battery in chief, as well as his new motto '*Palmam qui meruit ferat*' and the *chelengk* crest, also granted after the battle.

The original shaped wooden carrying case, bearing wax impressions of a personal Nelson seal, is still with the cup. He evidently took this piece of silver to sea with him, and mentions it in a letter to his wife sent from the *San Josef* in Torbay on 3 February 1801:
Not one thing that Mr Dods sent but is ruined, large nails drove through the mahogany table and drawers to fasten the packing cases.... Mr D has sent only 3 keys, of the small table and chest of drawers not of the wardrobe, trunk, case of the Turkey cup etc etc. By the by the trident of Neptune is bent double from ill package.

PROVENANCE
Bequeathed by Nelson to his sister Susannah Bolton and inherited by her son Thomas, second Earl Nelson, thence in the Trafalgar House collection, bought for Greenwich by Sir James Caird Bt, 1948.

EXHIBITED
1891: RN Exhibition, Chelsea, no. 1973
1905: Exhibition of Nelson Relics, RUSI, no. 3177

BIBLIOGRAPHY
N. M. Penzer, *Paul Storr 1771–1844*, pp.106-7

NMM, PLT0095

Lloyd's silver

Since 1794, the underwriters and merchants at Lloyd's Coffee House had subscribed to funds for those wounded in naval battles and the relatives of those killed. The Committee also made awards of merit to particular naval officers for their services. Following the Battle of the Nile in August 1798, the sum of £38,436 was raised, and Nelson was voted £500 by the Committee to purchase a service of silver. A second grant of £500 was made to Nelson after the Battle of Copenhagen in 1801, which he used to order additional items of silver from the goldsmiths Rundell & Bridge to supplement the Nile pieces (see Appendix 2).

It appears that the Nile silver was not delivered until April 1801. On 27 January 1801 Alexander Davison wrote to Nelson: '*Rundle and Bridge are exerting themselves to finish your plate, but it requires time, and being confined to a few hands to work upon it.*' The service became dispersed after Nelson's death, but many pieces, including ice pails, meat dishes, sauce tureens and plates, have found their way back to Lloyd's, the NMM and other museum collections.

The Lloyd's ice pails and tureens were marked during manufacture with small incised dots to match the body with the collars and liners (one to four dots). These evidently became muddled in the past, so that the matching pieces are now dispersed between collections.

BIBLIOGRAPHY
Warren R. Dawson (ed.), *The Nelson Collection at Lloyd's*, 1932
Leslie Southwick, 'The Nelson Collection at Lloyd's of London', *Trafalgar Chronicle*, 1996, pp.71–86

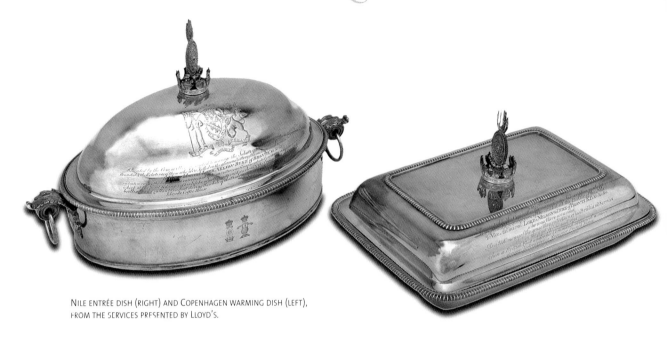

NILE ENTRÉE DISH (RIGHT) AND COPENHAGEN WARMING DISH (LEFT), FROM THE SERVICES PRESENTED BY LLOYD'S.

Entrée Dish
Paul Storr, London, 1800

Oblong covered entrée dish, part of the Nile service. The cover is engraved with Nelson's coat of arms as a baron and the Nile inscription: '*Lloyd's 1800. Presented by the Committee for managing a Subscription made for the Wounded & Relatives of the Killed at the Battle of the Nile to Vice Admiral Lord Nelson and Duke of Bronti [sic] KB &c &c &c who was there wounded as a testimony of the sense they entertain of his Brilliant Services on the first of August 1798 when a British Fleet under his Command obtained a most decisive Victory over a Superior French Force. JJ Angerstein, Chairman.*'

The lid has a detachable finial representing Nelson's *chelengk* crest issuing from a naval crown. These dishes appear in various early inventories as '*caseroles covers and aigrettes*'.

Lloyd's has another two matching entrée dishes by Paul Storr hallmarked 1800, and one is in South Africa.

PROVENANCE
Probably purchased by Lloyd's in 1910 from George Matcham, great-grandson of Nelson's sister Catherine Matcham.

Loan to NMM from the Nelson Collection at Lloyd's of London, ZBA1341

Vegetable dishes
Paul Storr, London, 1800

A pair of covered round vegetable dishes with the Nile inscription on one side of the lids and Nelson's coat of arms as a baron on the other. The covers are surmounted by *chelengk* crest finials.

PROVENANCE
Purchased at Christie's Bridport sale 12 July 1895. Bequeathed by Lady Llangattock, 1923. The Nelson Collection at Lloyd's has another with a replacement finial.

Nelson Museum, Monmouth, C21 & C22

Pair of ice pails, with fitted collars and liners
William Hall, London, 1801

Part of the silver service presented to Nelson by the Corporation of Lloyd's after the Battle of Copenhagen, 1801. A presentation inscription on one side reads:
Presented by the Committee appointed to manage the Subscription raised for the benefit of the Wounded and the Relatives of those who were killed in the glorious victory obtained off Copenhagen on the 2 of April 1801, to Vice Admiral Lord Nelson KB Duke of Bronte &c &c &c in testimony of the high sense entertained of his meritorious and

unprecedented exertions in defence of his Country, which at the peril and danger of his life, he so nobly sustained previous to the Engagement, and as a token of his brilliant and gallant Conduct during the whole of that ever memorable Action. Lloyds Coffee House. John Julius Angerstein, Chairman.

On the other side is Nelson's coat of arms as a viscount, and on the separate collar the *chelengk* and *San Josef* crests (wrongly inscribed *Vanguard*). The rims are gadrooned, the lower part of the body fluted, and there are lions mask and ring handles. Inside are separate cylindrical containers, one of them silver with a matching hallmark, and the other a silver-plated replacement.

PROVENANCE
Sold at Christie's sale of Viscount Bridport's Nelson relics, 12 July 1895, lot 162 for £370 to Thomas Barratt, collector and historian and Chairman of A. & F. Pears Ltd, who bequeathed them to Greenwich Hospital in 1915. (See *The Times*, 11 July 1915 and NA/ADM 169/435.)

NMM, Greenwich Hospital Collection, PLT0096 & PLT0097

Pair of ice pails
William Hall, London, 1801

As above set, with the Copenhagen inscription.

PROVENANCE
Purchased at Christie's Bridport sale of 12 July 1895, lot 161, for £400, by J. A. Mullens Esq. and given to the RUSI, cat. no. 101.
Purchased from the RUSM by Lloyd's from the bequest of G. J. Egerton in September 1963.

EXHIBITED
1905: RUSI Exhibition of Nelson Relics, cat. no. 101

The Nelson Collection at Lloyd's of London

Pair of ice pails
George Ashfield & Co., Sheffield, 1800

A pair of Copenhagen ice pails of a different design, with mask and ring handles, the Copenhagen inscription on one side of the body, and Nelson's coat of arms as a viscount on the other. Nelson's *chelengk* and *San Josef* crests are on the removeable collar.

PAIR OF ICE PAILS FROM THE COPENHAGEN SERVICE, NMM.

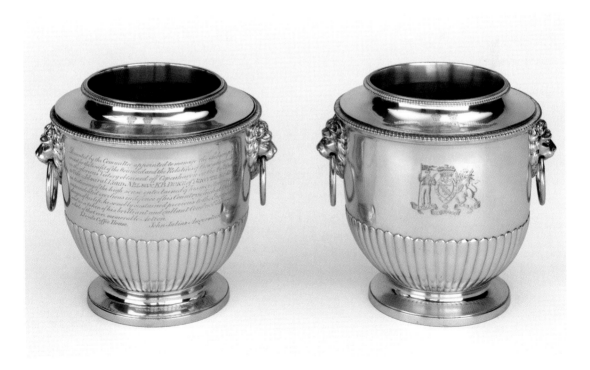

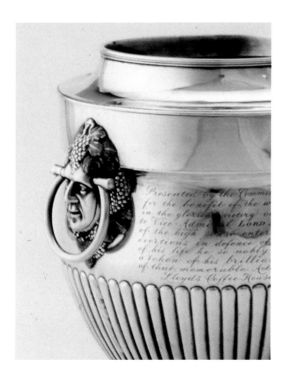

COPENHAGEN ICE PAIL WITH MASK HANDLES.

PROVENANCE
Purchased Bridport sale 12 July 1895. Bequeathed by
Lady Llangattock, 1923.

Nelson Museum, Monmouth, C41 & C42

Vegetable warming dish (see p.118)
Timothy Renou, London, 1801

Oval vegetable dish, cover and liner, part of the
Copenhagen service. The domed cover is engraved
on both sides with Nelson's coat of arms as a
viscount and also has the full Copenhagen
inscription, as above. The lid has a detachable finial
representing Nelson's *chelengk* crest issuing from a
naval crown.

The double base has slots with a division, which is
engraved on one side with the *chelengk* crest and
the other the *San Josef* crest. Both sides of the base
have Nelson's two crests surmounted by viscount's
coronets. At the ends are two cast foliate scrolled
handles with ring mounts. The liner has both crests
with viscount's coronets.

Lloyd's has another of these covered dishes.

PROVENANCE
Probably purchased by Lloyd's from George
Matcham *c.*1910.

Loan to NMM from the Nelson Collection at Lloyd's of London,
ZBA1340

Sauce tureens and covers
Daniel Pontifex, London, 1801

Five boat-shaped sauce tureens, from the eight in
Lloyd's Copenhagen service. On oblong plinths, with
angular handles, gadrooned top rim, and domed
cover with reeded loop handle. The full Copenhagen
inscription is engraved on one side, as on the ice
pails, and on the other side Nelson's coat of arms as
a viscount with the usual mottoes. The cover has the
chelengk crest on one side with a naval crown and
viscount's coronet, and on the other the *San Josef*
crest wrongly inscribed *Vanguard*.

PROVENANCE
Two pairs of Nelson sauce tureens were sold in
Christie's sale of the Viscount Bridport Collection on
12 July 1895, lots 163 and 164, for £135 and £145.

Two tureens were presented in June 1939 by
Horatia's grandsons the Revd Hugh Nelson-Ward
and the late Admiral Philip Nelson-Ward (died 1937).

One was purchased from Spink's by NMM in 1936.

One came from the collection of Miss Frances
Girdlestone, purchased by A. E. Cornewall-Walker in
November 1930. Purchased by Sir P. Malcolm-Stewart
Bt at Sotheby's sale of 30 April 1936, lot 50, via Spink
& Son and presented to the NMM. (See *The Times*
and *Morning Post*, 1 May 1936.)

NMM, Nelson-Ward Collection, PLT0099 to 0102, PLT0748

Sauce tureen and cover
Daniel Pontifex, London, 1801

Another sauce tureen from the set, with the
Copenhagen inscription.

PROVENANCE]
One of four sold at Christie's 10 July 1913 for £455 to
T. J. Barratt Esq.
Two matching sauce tureens are in a private
collection.

The Nelson Collection at Lloyd's of London

Four Salts

Robert and David Hennell, London, 1800

Boat-shaped salts, standing on oblong plinths, with gadrooned rims and gilt interiors. Engraved on one side with the *chelengk* crest and a naval crown and on the other with the *San Josef* crest. The spoons, by William Eley & William Fearn, have gilt bowls and the *San Josef* crest on the handle.

Four other salts from the set are in a private collection.

NMM, salts PLT0112 to 0115; spoons PLT0116 to 0119

Plates

Timothy Renou, London, 1801

Nine plates from the Lloyd's Copenhagen service. Gadrooned rim, engraved on the border with the complete arms of Nelson with viscount's coronet but no crests. The coat of arms is inscribed '*Tria iuncta in uno* and *Palmam qui meruit ferat*'. One has been mounted on a later foot and gilded.

Nelson's silver delivered by Rundell & Bridge in 1801 included six dozen gadrooned circular plates and eighteen soup plates.

NELSON'S SILVER COPENHAGEN SAUCE TUREENS AND PLATE, LADY NELSON'S CHAMBER CANDLESTICK, AND EARL NELSON'S HOT-WATER JUG.

PROVENANCE
Six presented by the Revd Hugh Nelson-Ward, June 1939.

The others are from the Walter and Turner collections and the Greenwich Hospital Collection (presented by Spink's, 1895, who purchased the plates sold at Christie's Bridport sale of 12 July 1895). See NA/ADM169/193.

NMM, PLT0103 to 0111

Plates

Four dinner plates by Timothy Renou, 1801, have the Copenhagen inscription engraved on the rim opposite Nelson's coat of arms. One of these was presented by Mr C. E. Heath to Mr Harry C. Cornwall prior to 1916, and presented by his widow to Lloyd's in 1936. The committee presented a specially engraved replica to Mrs Cornwall.

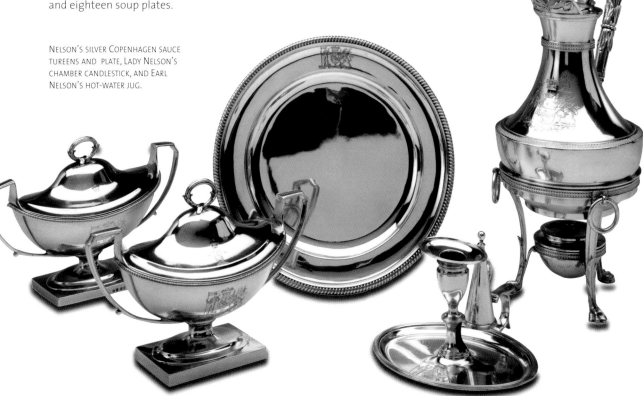

Nine other plates by Timothy Renou, 1801, have the same small Nelson coat of arms on the rim, but the backs of the plates have a later inscription, c.1910, identifying them as part of the Copenhagen set. Two of the plates were presented to Lloyd's by T. A. Miall and two by G. N. Rouse, in September 1948, one was presented by Mr D. Hargreaves in December 1954 and one loaned to Lloyd's in April 1962.

The Nelson Collection at Lloyd's of London,

Plates

In 1919 twenty-three silver plates from Nelson's Copenhagen service were presented to the Royal Navy through the Navy League. Twenty-one were distributed among RN ships then in commission, and the other two went to HM Australian Ship *Sydney* and the SS *Carmania*. By 1928, most of the plates had gone into store when the ships had been paid off, so it was decided to reallocate them all. On 17 March 1928 *The Times* reported that, as from June, the plates were to be held permanently by establishments and '*The commanding officer of any naval establishment receiving one of these plates on its permanent transfer to that establishment is to make suitable arrangements for its display and safe custody*'.

The plates were allocated to RN Gunnery School, Portsmouth (*Excellent*); RN Torpedo School, Portsmouth (*Vernon*); RN Barracks, Portsmouth (2); RN Barracks, Chatham (3); RN Barracks, Devonport (3); RN College, Greenwich (3); RN College, Dartmouth; Shotley Training establishment (*Ganges*); *Impregnable* Training Establishment; *Victory*; *St Vincent* Training Establishment; RN Submarine Depot, Gosport (*Dolphin*); RNE College, Keyham. The plate originally allocated to HMS *Lord Nelson* was to go to the Admiralty when there was no ship of that name in commission, HMAS *Sydney*'s plate would go to the New South Wales government, and SS *Carmania*'s would be allocated to the Cunard Steamship Company.

There is a useful table in *The Times* of 17 March 1928, p.9, which lists the original ship to which each plate was allocated, its location at the time of writing, and its final resting place.

Freedom box (see p.35)
Thomas Phipps & Edward Robinson II, London, 1798

The silver-mounted oak freedom box presented on 30 October 1798 to Nelson by the Corporation of Thetford in Norfolk, after the Battle of the Nile. The wooden lid of the box has an oval silver cartouche engraved with a fort, surrounded by a trophy of flags, guns, anchors and other maritime equipment. The edges are mounted in silver, engraved with leaves. There is an engraved inscription on the silver lining inside the lid: '*The Gift of the Corporation of Thetford in Norfolk To their Gallant Countryman Rear Admiral Sir Horatio Nelson KB (now Lord Nelson of the Nile) For his brilliant Services to his Country on the Glorious 1st of August, 1798*'.

The original vellum freedom document is also at Greenwich (ADM/P/2).

PROVENANCE
Sold at Christie, Manson & Woods, Bridport sale, 12 July 1895, lot 168, for £85 to Phillips of Bond Street and subsequently purchased by H. Panmure-Gordon of Mayfair, for Greenwich Hospital, 1895.

EXHIBITED
1891: RN Exhibition, Chelsea, cat. no. 1973. Lent by General Viscount Bridport.

NMM, Greenwich Hospital Collection, PLT0728

Freedom box
Peter, Ann & William Bateman, London, 1800

Silver-gilt oval freedom box, the lid engraved with the arms of Oxford surrounded by scrolling floral decoration. Attached to the box by a wax seal is the vellum document for the Freedom of Oxford, dated 22 July 1802.

PROVENANCE
Descended through Nelson's sister Catherine Matcham.

EXHIBITED
1891: RN Exhibition, Chelsea, cat. no. 1977. Lent by W. Eyre Matcham.

Private Collection

DOMESTIC SILVER

Silver-gilt cup

Engraved 'EH', and the reverse later engraved '*This cup was presented by Emma Lady Hamilton to Rear Admiral Lord Nelson The Victorious Hero of the Nile 29 Septr: 1798 Who constantly drank out of it until the Glorious tho' fatal 21st Octr 1805. It was bequeathed by his Lordship's Will to the Donor.*' The date in the inscription is Nelson's fortieth birthday.

PROVENANCE [D]
Nelson's will states: '*I likewise give and bequeath to the said Emma Lady Hamilton, the Silver Cup marked E.H. which she presented to me.*'
 Presented to the Victory Musum in 1957 by Mrs M. S. Ward, widow of Maurice Suckling Ward, descendant of Horatia.

EXHIBITED
1928: Loan Exhibition of Nelson Relics, Spink's, 1928, cat. no. 23

Royal Naval Museum, Portsmouth, 1957/61

NELSON'S CRESTED SILVER SPOONS AND FORKS.

Flatware

Many of Nelson's personal silver spoons and forks and ladles are in museums and private collections. The NMM, for example, has fifty-five pieces. There are table and dessert forks and spoons, teaspoons and salt spoons. They are of plain fiddle-pattern, by William Eley and William Fearn of London, and a few by George Smith of London, of various dates between 1796 and 1800. They are engraved with variations of Nelson's crests, the earlier ones with the *San Josef* crest, and some of the later pieces with both the *San Josef* and *chelengk* crests.

Breakfast dish
Henry Chawner, London, 1794

Covered silver dish, said to be Nelson's favourite breakfast dish and to have been with him in the *Victory* at Trafalgar. The dish is a plain flat circular vessel with reeded loop handles and a domed lid with ivory finial. The lid is engraved with Nelson's coat of arms on both sides with a viscount's coronet, which must date after May 1801.
 Sold at Christie's 17 July 1935, lot 91.

The Nelson Collection at Lloyd's of London

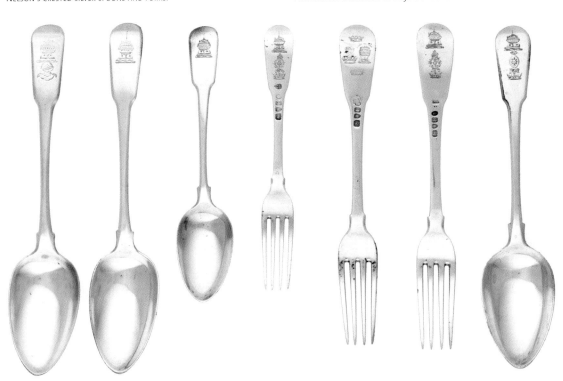

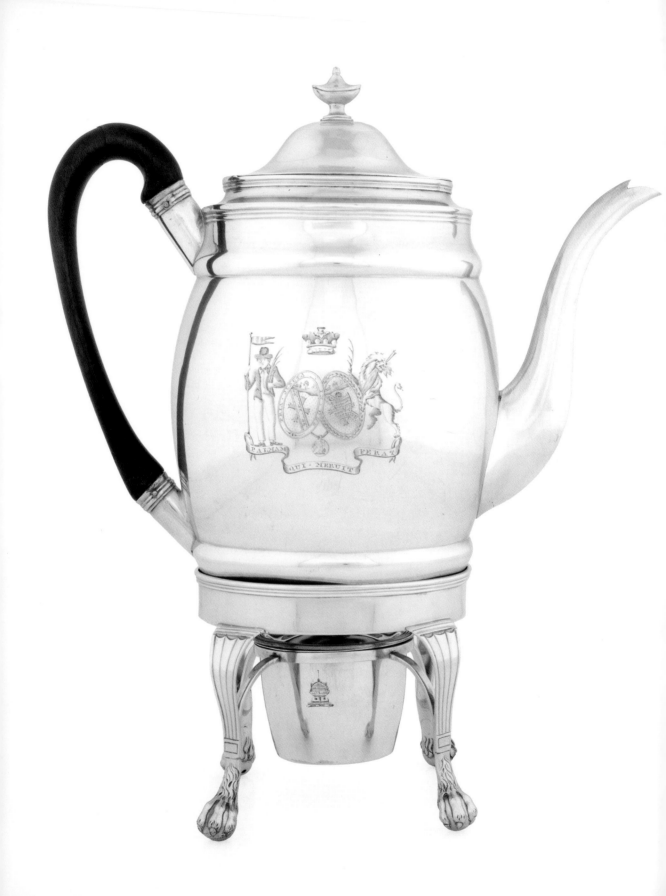

Coffee pot, spirit burner and stand
Robert & David Hennell, London, 1799

Oval coffee pot with hinged lid and wooden handle (which has been repaired), reeded edges, domed cover and an urn finial. On one side is engraved Nelson's coat of arms as a baron, and on the other side his *chelengk* and *San Josef* crests surmounted by a baron's coronet.

The stand is four-legged with ball-and-claw feet and incorporates a spirit burner. The heater has the *chelengk* crest on one side and the *San Josef* crest on the other, and the cover of the heater has two baron's coronets.

PROVENANCE
Presented to Greenwich Hospital by Robert Lionel Foster in 1928 (NA/ADM169/562).

NMM, Greenwich Hospital Collection, PLT0120

Teapot
Robert & David Hennell, London, 1799

Small barrel-shaped teapot with an initial 'N' engraved on the side.

PROVENANCE
Descended through the Catherine Matcham line.

Private collection

Chamber candlestick (see p.121)
William Bennett, London, 1798

Silver chamber candlestick on an oval stand with a separate candle socket and conical extinguisher. The stand is engraved with Nelson's coat of arms surmounted by a viscount's coronet. The shield of the arms is of a diamond form with an inescutcheon of Lady Nelson's arms and no crests. The candlestick, stand and extinguisher have reeded borders, and the candlestick has a cut-away stem, originally intended to accommodate a pair of candle-snuffers.

PROVENANCE
Said to have been presented by Nelson to his wife. Presented by Robert Lionel Foster in 1928.

NMM, PLT0121

OPPOSITE: NELSON'S COFFEE POT AND HEATER BY ROBERT & DAVID HENNELL.

Tea set and coasters

Large oval teapot by John Emes, London, 1801, with a hinged lid with a wooden knop and a scrolled wooden handle. Slender spout and engraved bands of foliage round the body. On one side 'N' with a coronet in a wreath and on the other 'B'.

PROVENANCE
Sold by Miss F. Girdlestone in 1930 to A. E. Cornewall-Walker of Reigate. Sold Sotheby's London via Spink's on 30 April 1936. Purchased by Malcolm-Stewart for the NMM together with a Sheffield plate oval teapot stand engraved with 'NB' below coronets, and an oval silver sugar bowl and helmet-shaped cream jug by William Fountain, London, 1797, with *San Josef* crests.

Purchased together with a pair of circular coasters or decanter stands by Robert & David Hennell, London, 1800, with wooden bases and central silver medallions engraved with the *chelengk* and *San Josef* crests (see p.40). Four matching pieces are in Clive Richards' collection. On 8 September 1805 Nelson paid John Salter eighteen shillings to varnish and polish six bottle stands.

See *The Times* and the *Morning Post*, 1 May 1936.

NMM, teapot PLT0125; teapot stand PLT0128; sugar bowl PLT0129; jug PLT0130; coasters PLT0135 & PLT0136

Salver
John Harris, London, 1797

Oval salver with a reeded border, standing on four feet. Engraved with Nelson's coat of arms, with mottoes, surmounted by a viscount's coronet, and *chelengk* and *San Josef* crests.

PROVENANCE
A plaque in the wooden presentation box is inscribed: '*This salver which belonged to his great uncle Horatio Viscount Nelson presented to Herbert Horatio Viscount Trafalgar by his cousin Frank Girdlestone 1879.*'

NMM, Trafalgar House Collection, PLT0127

Porringer

A plain round silver porringer, hallmarked 1750, standing on a small foot, with a close-fitting slightly domed knopped lid. Said to have been given to Nelson as a child.

PROVENANCE
This is the type of relic which might be easily dismissed, were it not that it came from a branch of the Eyre-Matcham family. Miss Joyce Horatia Eyre-Matcham, who with her sister lived and died in Kenya, had a number of Nelson relics including his rummers. On her death she left the porringer to Mr W. M. Fletcher, who presented it to the NMM in 1976.

NMM, PLT0122

Dog collar
Joseph Heriot, London, 1799

A dog collar with copperplate inscription: 'Right Honble Lord Nelson – Nileus'.

The silver collar has punched holes along the whole length top and bottom, to enable it to be stitched to a leather lining, now missing. It can be adjusted in size by three slots at one end.

Said to belong to Lord Nelson's dog Nileus, named after the Battle of the Nile.

PROVENANCE
Presented 1928 by Colonel F. W. Peacock.

EXHIBITED
1905: Loan Exhibition of Nelson Relics, RUSI, no. 3168 (lent by F. W. Peacock).

NMM, PLT0138

SILVER COLLAR OF NELSON'S DOG 'NILEUS'.

HORATIA'S SILVER

A number of pieces of silver, silver-gilt and Sheffield plate which belonged to Nelson's daughter Horatia are in public collections. They mostly fall outside the scope of this study, being at one remove from Nelson's own possessions. However, these two items are included because of Nelson's direct involvement in their ordering and purchase.

Horatia's cup
Thomas Ellerton, 1803

Small silver-gilt goblet purchased by Nelson at John Salter's in the Strand in August 1805, before he left England for the last time. The cup was a present for his daughter Horatia.

The cup is decorated with a key-pattern design and is inscribed 'Horatia'. The other side was later inscribed 'To my much loved Horatia 21st August 1805' and facsimile signature 'Nelson & Bronte'. A piece of paper with the cup has in Emma's handwriting: 'The Victor of Aboukir Copenhagen & Trafalgar &c &c &c the glorious the great & good Nelson bought this for His daughter Horatia Nelson August 30th 1805. She used it till I thought it proper for her to lay it by as a sacred relick.' (RNM84/57)

PROVENANCE
Nelson's account with John Salter, 17 August 1805: 'A silver goblet with Horatia engraved - £2-6s'.

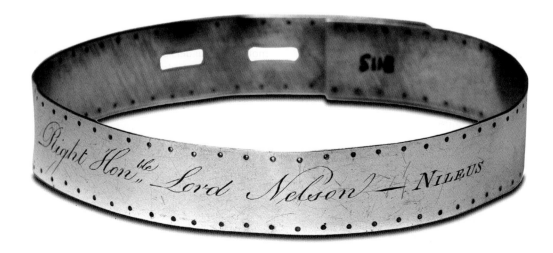

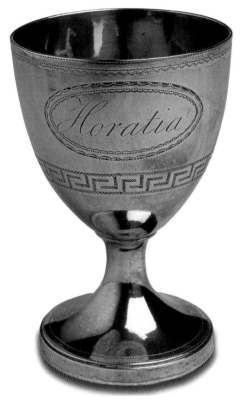

SILVER-GILT CUP GIVEN TO HORATIA BY NELSON.

In possession of Horatia and her descendants. Presented to the Victory Museum in 1957 by Mrs Maurice Ward, wife of one of Horatia's grandsons.

EXHIBITED
1891: Royal Naval Exhibition, Chelsea, cat. no. 3383S
1928: Loan Exhibition of Nelson Relics, Spink's, cat. no. 29

BIBLIOGRAPHY
Colin White, 'Emma Hamilton and the Making of the Nelson Legend', *Trafalgar Chronicle*, 1995, pp.17–19.

Royal Naval Museum, Portsmouth, 1957/60

Horatia's dessert knife
RT, Sheffield, 1801

Horatia Nelson's silver-gilt dessert knife, purchased by Nelson from John Salter, his silversmith in the Strand. The blade has a monogrammed 'H', and on the other side the inscription '*To my much loved Horatia 21 August 1805. Nelson & Bronte*' (in facsimile of his own signature).

There is also a replica of this knife copied in 1930 by Lionel Alfred Crichton of London from the original.

PROVENANCE
Given to the NMM in 1939 by Horatia's grandson, the Revd Hugh Nelson-Ward.

NMM, Nelson-Ward Collection, PLT0750 (replica PLT0751)

SILVER OWNED BY WILLIAM, FIRST EARL NELSON

The first Earl adopted as his coat of arms the Admiral's arms, with its supporters, crests and mottoes, but with the difference that the Battle of Trafalgar was recognized in the shield by a bar containing the word *Trafalgar*. The Earl's arms are easily distinguished from the Admiral's, as an earl's coronet replaced the baron's or viscount's coronet. The baron's coronet is a circlet with a row of seven or nine visible balls or 'pearls', the viscount's has a row of four balls, but the earl's coronet has a circlet with five visible lofty rays each topped with a ball and strawberry leaves between. Some examples are included for comparison.

Hot-water jug (see p.121)
Paul Storr, London, 1799

Hot-water jug engraved with the arms of William, first Earl Nelson, bearing the Trafalgar augmentation and surmounted by an earl's coronet. The *chelengk* and *San Josef* crests and Nelson's mottoes appear on the pot, the stand and the heater.

The jug has a wide body and narrow neck with a hinged lid. The pronounced lip has a cast anthemion motif on the underside, and the jug and stand are decorated with bands of basket pattern and foliage. The scrolling handle has a mask at the upper end and is insulated with a band of ivory. The central portion of the handle, which is reeded with acanthus decoration, is a later replacement (after 1829) by E. E. J. & W. Barnard. The jug has a tripod stand with three hanging rings and claw feet, and incorporates a heater.

PROVENANCE
Sold Christie's Bridport sale 12 July 1895, lot 132 for £109 to Phillips of Bond Street, and subsequently

sold to H. Panmure-Gordon, who gave it to Greenwich Hospital.

EXHIBITED
1905: Exhibition of Nelson Relics, RUSI, cat. no. 6025, loaned by Greenwich Hospital (illustrated in catalogue)

NMM, Greenwich Hospital Collection, PLT0123

Teapot
William Plummer, London 1791

Plain oval silver teapot with reeded borders, owned by William, first Earl Nelson. It is engraved with an earl's coronet, which must have been added after 1805.

The lid is hinged to the top of the teapot, and has a wooden knop. Each side is engraved with the *chelengk* and *San Josef* crests with '*Faith and Works*', surmounted by an earl's coronet. The teapot has a straight spout and a wooden handle.

PROVENANCE
Bequeathed to Greenwich Hospital by Thomas J. Barratt in 1915. Acquired by him, with other items, at Christie's Bridport sale of Nelson relics, 12 July 1895, lot 130, for £39 (NA /ADM169/435). With a matching oval teapot stand by Peter & Ann Bateman, London, 1796.

BIBLIOGRAPHY]
Descriptive Catalogue of the Painted Hall, 1922, 'An oval teapot and stand, with beaded and threaded borders'

NMM, Greenwich Hospital Collection, PLT0098 & PLT0131

Salver
Thomas Hannam & John Crouch II, London, 1805

Large oval salver with gadrooned rim, the centre engraved with Nelson's coat of arms with crests and the Trafalgar augmentation, surmounted by an earl's coronet, for William, first Earl Nelson.

PROVENANCE
Probably purchased in 1943 from William Comyns & Sons Ltd.

The Nelson Collection at Lloyd's of London

Patriotic Fund vases

The Patriotic Fund was founded at a meeting at Lloyd's Coffee House at the Royal Exchange, London, in July 1803, following the breakdown of the Peace of Amiens. The Fund set up a national subscription, strongly supported by Lloyd's members, which was used to vote money to those wounded in action, and to the dependants of those killed, and also gave awards of merit in the form of money, silver and presentation swords. Between 1804 and 1809 sixty-six Patriotic Fund silver vases went to naval and military officers in recognition of distinguished services.

Fifteen Patriotic Fund vases were awarded after the Battle of Trafalgar, in different sizes according to value. Most were valued at £100, but there was also a larger £200 vase awarded posthumously, one £300 and three magnificent £500 silver-gilt vases on additional plinths. John Flaxman, the sculptor, produced the final design for the vases, which modified John Shaw's original prize-winning design. They were supplied by the Royal Goldsmiths, Rundell, Bridge and Rundell, and made by different silversmiths. All the vases are of similar design, being based on a classical Greek urn form, and all are surmounted by a lion finial.

Since Nelson had died before receiving his reward for Trafalgar, the Patriotic Fund Committee voted two £500 vases to Nelson's family, one to his brother William, who had been created the first Earl Nelson, and one to his widow, the Viscountess Nelson. A third large £500 silver-gilt Trafalgar vase went to his second-in-command, Vice-Admiral Collingwood. The design of the two Nelson vases was more elaborate than the rest. They are of silver-gilt, rather than silver, and stand on additional plinths, making them larger and heavier than most of the other presentations. The design, though essentially the same as the smaller vases, differs in having Lord Nelson's coat of arms on one side and a long presentation inscription on the other, in English on Lady Nelson's and in Latin on the Earl's, in place of the figures of Britannia and Hercules on the smaller vases. The sides of the plinth of both vases are inscribed in recognition of Nelson's victories, and the four corners of the base are supported by mermen blowing on conch shells. Earl Nelson's vase is by Benjamin Smith, London, 1807 and Lady Nelson's by Benjamin Smith, London, 1808.

BIBLIOGRAPHY
Jim Gawler, *Britons Strike Home: A History of
Lloyd's Patriotic Fund 1803–1988*
Leslie Southwick, 'The silver vases awarded
by the Patriotic Fund', *Silver Society Journal*,
Winter 1990, pp.27–49

Earl Nelson's: NMM, Trafalgar House Collection,
PLT0094
Lady Nelson's: Royal Collection, RCIN 60425.1

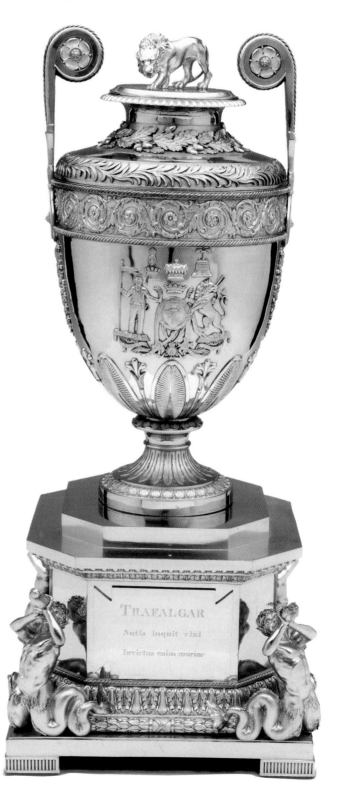

SILVER-GILT VASE PRESENTED TO
EARL NELSON AFTER TRAFALGAR.

Catalogue D

JEWELLERY, PERSONAL ACCESSORIES AND GIFTS

I have got a little box of chains & earrings & Bracelets which Mr Falconet [the French banker at Naples] writes me Mrs Falconet was so good as to chuse for you, as he says they are nicely packed I have not open'd them, but I doubt whether I can send them in the Admiralty packet. I have few opportunitys of getting any little thing for you and must trust to the taste of our friends, but my beloved Emma will take my intentions as well meant. (Nelson to Emma, 7 December 1803)

JEWELLERY

Finger rings

Fede rings exchanged by Nelson and Emma Hamilton in September 1805, before their last parting. The two gold rings have the bezel shaped as clasped hands. *Fede* rings could be worn as betrothal rings or as a token of affection; the term is said to come from *mani in fede* (hands in trust).

PROVENANCE
Nelson's ring was presented to the NMM in 1939 with the Nelson-Ward collection.

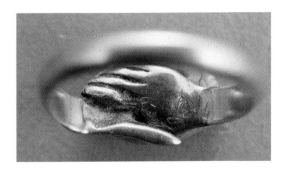

Emma's ring was given as a pair with a wedding ring to the Victory Museum, Portsmouth, in 1957 by the widow of Maurice Suckling Ward, descendant of Horatia.

EXHIBITED
Nelson's ring: 1891: RN Exhibition, Chelsea, no. 3364, *'Gold ring taken from Lord Nelson's hand after death, and sent to Horatia Nelson. Lent by Mrs H Nelson Nelson-Ward.'*
Emma's ring: 1972: Arts Council Exhibition at Kenwood, 'Lady Hamilton in Relation to the Arts of Her Time', item 87.

NMM, Nelson-Ward Collection, JEW0168
Royal Naval Museum, Portsmouth, 1957/59

Pair of rings

Another pair of rings was displayed in 1973 at the British Antique Dealer's Association International Art Treasures Exhibition in Bath Assembly Rooms. Here a dealer, Morton Lee, exhibited a pair of George III gold rings (item 268), one bearing a miniature painting of an eye, with a letter 'h' engraved on the back of the bezel, and the other an initial 'H' in gold framed in seed pearls on a background of hair, and the date '13 9bre' on the back. This pair of rings was claimed to be from a lady directly descended from Nelson. The eye is said to be that of Lady Hamilton, the hair Nelson's and the date to represent 13 September 1805, the day Nelson left Merton for the last time, when they may have exchanged rings.

However, the interpretation of the rings has been challenged on various counts. Emma's biographer Flora Fraser thinks that the inscribed date on the ring could be the Italian 13 Novabre (November).

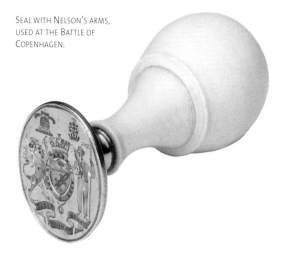

SEAL WITH NELSON'S ARMS, USED AT THE BATTLE OF COPENHAGEN.

Diana Scarisbrick, an expert on rings, thinks that the style is of an earlier period, 1785–90, and that the initial 'H' may stand for Hamilton rather than Horatio. Richard Cosway is known to have painted similar eye miniatures in the 1780s. One suggestion is that Emma retained both rings after Sir William Hamilton's death and may later have given the one with the eye to Nelson. (David W. Bain: 'A Tale of Two Rings', *Nelson Dispatch*, Vol. 4 part 1, Jan. 1991, pp.9–11)

Unknown private collection

Gold and enamel ring

A gold finger ring with a scroll-pattern shank with five small black enamel panels around the ring, on which 'NELSON' is spelled out in white.

PROVENANCE
Presented to NMM by the Duchess of Bronte, 1992. By family tradition Nelson gave the ring to Lady Hamilton, and upon her death it passed into the Bridport family.

NMM, JEW0162

Seal

Gold seal ring, *c.*1799, set with a large oval bloodstone intaglio cut with a portrait of Emma, Lady Hamilton as a Bacchante, signed by Teresa Talani, the eminent late-eighteenth-century gem engraver working in Naples. Formerly the property of Lord Nelson.

PROVENANCE
Presented to NMM by Miss Frances Girdlestone 1935.
Impressions of this seal are known on Nelson letters, including a cover addressed to Alexander Davison and signed '*Nelson*', sold at Sotheby's Davison sale of 21 October 2002 and illustrated in the sale catalogue, p.60. Letter believed to date between Nov. 1798 and Jan. 1801.

NMM, Girdlestone Collection, JEW0161

Copenhagen seal, 1800

Ivory-handled oval silver desk seal, engraved with Nelson's full coat of arms as a baron, complete with supporters and mottoes, and surmounted by a baron's coronet and the *San Josef* and *chelengk* crests. The baron's arms used by Nelson after 1798 predate his viscountcy, granted in May 1801.

Nelson is said to have used this seal on his note to the Danes proposing a ceasefire during the closing stages of the Battle of Copenhagen, 2 April 1801.

BIBLIOGRAPHY
Horatio, third Earl Nelson, *The Nelson whom Britons Love, c.*1905

NMM, Trafalgar House Collection, JEW0078

SEAL RING BY TERESA TALANI, WITH PORTRAIT OF EMMA.

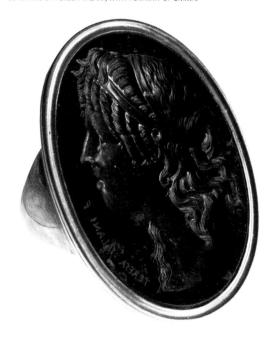

Fob seal

Gold fob seal, set with a crystal intaglio cut with Nelson's coat of arms, as used by him before the Battle of the Nile. It has the original shield of arms without the Nile augmentations, and only the *San Josef* crest. The motto underneath is the family one, '*Faith and Works*'.

NMM, JEW0079

Intaglio

Oval brown intaglio engraved with a profile portrait of Emma Lady Hamilton, her curls classically arranged in a bandeau. Intaglio signed 'РЕГА' for Filipo Rega.

Provenance
NMM has a cover sent by Nelson which bears an impression of this seal in black wax. The cover was sent to the Rt Hon. George Rose at Palace Yard and is undated, but the signature '*Nelson & Bronte*' dates it to 1801 or later (AGC/35/2).

The British Museum has a similar glass paste intaglio, also said to be Emma and with the same signature, which was presented in 1867 as having belonged to Nelson, with Nelson letters of 1801 with impressions of this seal.

Another Filipo Rega intaglio at Greenwich, descended through the Nelson-Ward family, is engraved with a profile portrait of Emma wearing long ringlets (JEW0065).

NMM, JEW0066

Fob seal

Gold fob seal set with an oval agate intaglio engraved with a baron's coronet and an initial 'N'.

This simple seal is likely to have been used by Nelson for routine correspondence (see Felix Prior, 'Nelson the Letter-Writer', *The Nelson Companion*, 1995)

NMM, Nelson-Ward Collection, JEW0091

Other personal seals

Another gold fob seal at Greenwich (JEW0090) is set with a cornelian engraved with Nelson's *chelengk* and *San Josef* crests.

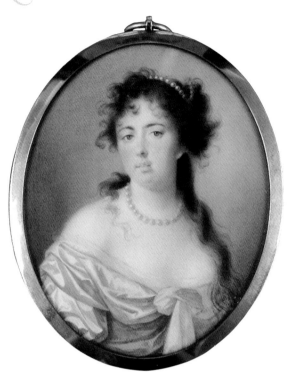

Painted miniature of Emma by Henry Bone, worn by Nelson.

Other seal impressions with minor variations of the coat of arms are known, suggesting that Nelson used a number of seals on different occasions. One such impression at Greenwich (JEW0124) has a very detailed coat of arms, with the viscount's and ducal coronets and *chelengk* and *San Josef* crests. Another (JEW0174) is similar but without the ducal coronet. Nelson is also known to have used a seal with a badge of a palm tree, double cornucopia and bird, likely to have been adopted after the Battle of the Nile.

In November 1996 Christie's sold a gold fob seal with a dolphin loop, the oval intaglio cut with Nelson's full coat of arms as a viscount.

Many fob seals with a head of Nelson or star and an initial 'N' exist and these are frequently mistaken for seals owned by Nelson, although they are almost certainly commemorative.

Miniature

Oval gold-framed miniature of Emma Hamilton by Henry Bone, after the painting by Madame le Brun. Bequeathed by Sir William Hamilton to Nelson and worn by Nelson until the time of his death. A thick

lock of Emma's auburn hair is mounted in the back of the locket.

PROVENANCE
Codicil to Sir William Hamilton's will, 16 April 1803: *'The copy of Madame Le Brunn's picture of Emma in enamel, by Bone, I give to my dearest friend Lord Nelson, Duke of Bronte, a very small token of the great regard I have for his Lordship, the most virtuous, loyal and truly brave character I ever met with. God bless him, and shame fall on those who do not say Amen.'*

28 April 1817: Sale of property of Alexander Davison, lot 830: *'An exquisite miniature of Lady Hamilton with her hair and initials at the back, worn by the Immortal Nelson at the time of his death.'*

Presented to the Victory Museum, Portsmouth in 1957 by the widow of Maurice Suckling Ward, descended from Horatia.

There is also a copy of the miniature, signed T. Fall, in the NMM.

Royal Naval Museum, Portsmouth, 46/57

Dog necklace

Necklace with a gold silhouette of a greyhound in an oval frame, the chain of flattened gold links. This is said to be a gift from Nelson to Horatia in answer to her letter saying that he had promised her a dog.

In 1844 Horatia wrote to Sir Nicholas Harris Nicolas while he was editing the Nelson letters: *'The dog here alluded to puts me in mind that Lady H had a letter addressed to me by Lord N but wh I suppose was lost in the wreck of her property & wh I have seen but have it not, in wh he says that he cd not bear that I shd have a dog as I shd perhaps love it better than Ld N but that he sent me (wh I now have) a gold chain with the medallion of a greyhound in the centre.'* (NMM/NWD/34)

There are many items said to have been given by Nelson to Emma or Horatia, some of which have a good provenance. Only a few examples can be included here, although others can be found in the Silver section of the catalogue.

NMM, Nelson-Ward Collection, JEW0369

Horatia's fob watch

Fob watch by Fréres Bordier of Switzerland, *c*.1800,

no. 61424. This is a fob watch in a gold and enamel hunter case chased with flowers and foliage and surrounded on both sides with a border of forty-two split pearls and a narrow band of blue enamel. It is likely to be the watch mentioned below.

Nelson wrote from the *Victory* on 4 January 1804, promising to send Horatia a watch: *'As I am sure that for the world you would not tell a story, it must have slipt my memory that I promised you a Watch therefore I have sent to Naples to get one and I will send it home as soon as it arrives. The Dog I never could have promised as we have no Dogs on board ship.'* (NMM/NWD/17) Having thanked Horatia for sending a lock of her hair, he adds, *'I send you a lock of my hair and a one pound note to buy a locket to put it in and I give you leave to wear it when you are dressed & behave well.'*

There are two watches in the NMM which came through the Nelson-Ward line, both with the family story that they were given to Horatia by Nelson. Neither watch has a presentation inscription, but in 1844 Horatia wrote to Sir Nicholas Harris Nicolas: *'The watch here alluded to... was for me and sent to Merton. It is a small French watch set round with pearls, a chain and seals attached – I have it now in my possession.'* (NMM/NWD/34)

NMM, Nelson-Ward Collection, JEW0241

Horatia's watch

Miniature Swiss watch in the form of an oval spherical locket with an enamelled gold case. Alternate segments of dark red over black basse-taille enamel, black and white champleve enamel in a scallop design, and black champleve enamel in an open trellis design.

NMM, Nelson-Ward Collection, JEW0242.

Trafalgar watch

His Lordship in a few minutes after this called Lieutenant Pasco, Mr Ogilvie, and some other officers, near him, and desired them to set their watches by the time of that which His Lordship wore.
(Surgeon Beatty's account of Nelson at the Battle of Trafalgar)

The pocket watch worn by Nelson at Trafalgar was later mounted in a gilt and glass carriage clock case, inscribed: *'The Chronometer of Horatio Viscount*

Nelson worn by him at the Battle of Trafalgar, placed in this case by his Niece, Charlotte Mary, Lady Bridport, to be preserved for any one of her descendents who may enter the Navy.'

This important watch of c.1787 is signed by Josiah Emery of Charing Cross, London, no. 1104. It is one of the first series having the lever escapement of the type invented by Thomas Mudge, which became the standard escapement used in the modern mechanical watch.

WATCH WORN BY NELSON AT TRAFALGAR, LATER MOUNTED AS A CARRIAGE CLOCK.

The watch is of thirty-hour duration, with fusee movement with Emery's two-plane lever escapement. Flat regulator-type enamel dial with Arabic five-minute numerals and minute circle. Subsidiary seconds dial below the centre with Roman hour numerals. The watch does not have its original case and the second hand is a replacement.

PROVENANCE
Owned by Charlotte Mary, Lady Bridport, daughter of

Nelson's brother William, first Earl Nelson. She married into the Hood family and succeeded to her uncle's and father's Sicilian Dukedom of Bronte.

Lent to the RUSM in 1930 by Mrs Percy Leveson, widow of Commander the Hon. Horatio Nelson Hood RN. Cat. no: 3582.

Loaned to NMM 1962.

EXHIBITED
1891: RN Exhibition, Chelsea, cat. no. 3001, lent by General Viscount Bridport.

Loan to NMM, from a private collector, JEW0248

Watch (see p.67)

English verge watch no. 5007, by William Plumley of London, hallmarked 1767–8 (IW for John Wright?). The pocket watch is in an eighteen-carat gold pair case, and is of thirty-hour duration, single train, gilt metal, four-pillar fusee movement with verge escapement. It has a convex white enamel dial with Arabic hour numerals and dot minute marks.

The outer case is engraved with Nelson's crest, the stern of the San Josef. The watch is complete with a key and a gold fob seal set with an oval cornelian engraved with a full-length classical female figure (JEW0026).

PROVENANCE
Purchased for £500 in 1848 by the Marchioness of Westminster from Mr N. Davis, whose wife had been a maid to the blind Mrs Maurice Nelson and had been given the watch and other items at her death. Rivers and other old officers at Greenwich Hospital were said to be satisfied that it was worn by Nelson, and John Pasco wrote on 10 Feb 1847: 'with many thanks for the gratification you have afforded me in once more feasting my eyes on an intrinsic relic of... Lord Viscount Nelson and without hesitation I pronounce it to be the identical watch worn by his Lordship at the time he received his fatal wound in the battle of Trafalgar'. (NA/ADM169/278 GH7568)

Presented to Greenwich Hospital by the Marchioness of Westminster in 1861. Illustrated in Beresford & Wilson, p.158. This was the only item stolen from the Painted Hall in 1900 to be recovered (see Chapter 4). Returned to display in the Painted Hall 30 September 1904.

NMM, Greenwich Hospital Collection, JEW0246

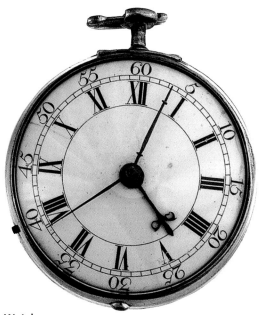

Watch
Thomas Mudge & William Dutton
Case by Peter Mounier, London, 1770–1

Pocket watch in a silver pair case, no. 878. Thirty-hour duration, Tompion-style regulator. Gilt metal cap signed 'Thos Mudge Wm Dutton London 878'. Convex white enamel dial with Roman hour numerals and Arabic five-minute markers. Thomas Mudge, one of London's most celebrated watch makers, was in partnership with William Dutton in Fleet Street, London, between 1759 and 1771.

The back of the outer case back is engraved with a large monogram 'WL', for William Locker.

PROVENANCE
Bequeathed to Nelson by Captain William Locker RN (1731–1800), Nelson's commanding officer in the *Lowestoft* in 1777. Given to the third Earl by a Girdlestone aunt. Purchased from Earl Nelson 1948.

NMM, Trafalgar House Collection, JEW0243

PERSONAL ACCESSORIES

Blue Trafalgar purse

Blue silk mesh stocking purse, the open end held by two metal pins with white glass beads at either end (one missing) and a white bead at the bottom of the purse. Closed by a carved ivory and silver collar or 'slider'.

PROVENANCE
Said to be taken from the pocket of Lord Nelson after his death at Trafalgar and retained by Captain Hardy as a memento. In the possession of the Hardy family until 1880, when it was purchased by Dr George Williamson, who later lent it, together with a yellow and silver silk purse belonging to Captain Hardy, to the RUSM.

Presented to the NMM by Dr G. C. Williamson of Guildford, through the National Art Collections Fund in 1930. (NA/ADM169/595)

EXHIBITED
1891: RN Exhibition, Chelsea, 3168. '*This purse belonged to Vice-Admiral Lord Nelson and was constantly used by him. It was removed from his dead body by Captain (afterwards Sir T M) Hardy, in the cock-pit of the Victory immediately after Nelson's death, on October 21st, 1805, and was retained by Captain Hardy as a memento. The purse at that time contained a gold guinea, which has since been lost.*'

NMM, TXT0371

PURSE CARRIED BY NELSON AT TRAFALGAR AND RETAINED BY CAPTAIN HARDY.

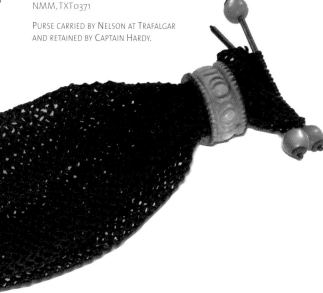

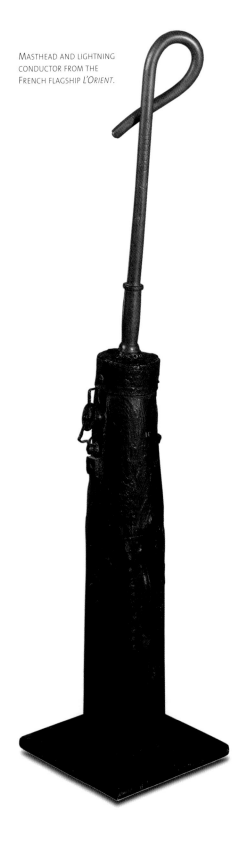

MASTHEAD AND LIGHTNING
CONDUCTOR FROM THE
FRENCH FLAGSHIP *L'ORIENT*.

Minto visited Merton in March 1802 and reported: '*Not only the rooms but the whole house, staircase and all, are covered with nothing but pictures of her and him, of all sizes and sorts and representations of his naval actions, coats of arms, pieces of plate in his honour, the flagstaff of L'Orient etc – an excess of vanity which counteracts its own purpose.*'

PROVENANCE
After Nelson's death, Emma Hamilton presented the masthead to St Katherine's Church, Milford Haven, where it remained for some forty years before being sent to London to the RUSM. A replica of the masthead is still in St Katherine's Church.

Presented by the Lords Commissioners of the Admiralty to the RUSI (no 2199). Transferred to the NMM 1963.

BIBLIOGRAPHY
Edward Fraser, *Greenwich Hospital & the Royal United Service Museum*, c.1910, p.185
Official Catalogue of the Royal United Service Museum, 1932, p.113

NMM, REL0295

Snuff box

Wooden snuff box made from the timber of *L'Orient*, said to be Nelson's.

PROVENANCE
Presented to Greenwich Hospital 1847 by H. T. Woodburn Esq.

NMM, Greenwich Hospital Collection, REL0555

Book of Common Prayer

Prayerbook c.1760–70 (title page missing) given to Nelson by Captain William Locker in 1777, and in 1799 presented by Nelson to Emma Hamilton.

Flyleaf inscribed in ink in three different hands: '*Captain Locker to Lieutenant Nelson*' (probably Locker's handwriting), '*August 13th 1777*' (Nelson's right-handed), and '*Given by Horatio Lord Nelson to Lady Hamilton Palermo 19th 1799 May 19th god protect this great & Brave man*'(Emma's handwriting).

In August 1777 Nelson was serving as Locker's second lieutenant in the *Lowestoffe*. On 19 May 1799 he sailed from Palermo to meet the French fleet and

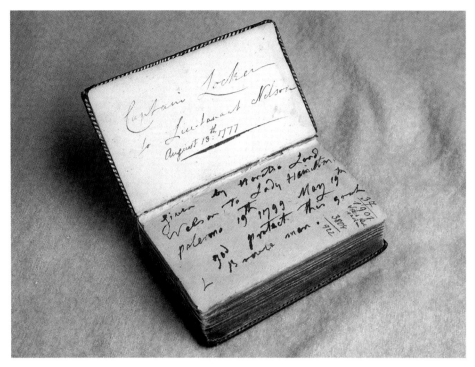

PRAYER BOOK GIVEN BY NELSON TO EMMA.

probably gave the prayerbook to Emma as a parting gift.

PROVENANCE
Purchased at Sotheby's 1991 from a private German collection.

BIBLIOGRAPHY
Colin White, 'Emma Hamilton & the Making of the Nelson Legend', *Trafalgar Chronicle*, 1995, pp.19–20

Royal Naval Museum, Portsmouth, 1991/267

Nelson's library

A number of other books once owned by Nelson, with his signature or dedications, are in libraries in Portsmouth, Greenwich and private collections. The Matcham descendants have Nelson's copies of Schomberg's *Naval Chronology*, 1802, Benjamin Moseley's *Treatise on Tropical Diseases*, 1803, and five volumes of *Asiatic Researches*, 1799, with a note to say that they were in Nelson's cabin at Trafalgar, where they received minor damage during the battle. Other evidence does suggest that a bookcase in his cabin was damaged.

Watercolour of Horatia attributed to Henry Edridge

Small framed picture of Horatia, taken to sea by Nelson in the *Victory*, and hung on his cabin bulkhead.

A note in Emma Hamilton's handwriting is on the back: '*This portrait of dear Horatia when she was two years old it was taken by dear glorious Nelson with him to sea & was with him till the fatal 21st of October which deprived her of the Best of Parents. Oh God protect her. Amen Amen.*'

Nelson wrote to Emma from the *Victory* on 1 August 1803: '*Hardy is now busy, hanging up your and Horatia's picture... I want no others to decorate my cabin. I can contemplate them and find new beauties every day, and I do not want anybody else.*' (Nicolas Vol. V, p.149) The picture of Emma referred to is Johann Schmidt's pastel now in the NMM (PAJ3940).

PROVENANCE
Presented by Mrs Maurice Suckling Ward in 1957.

Royal Naval Museum, Portsmouth, 1957/66

<p style="text-align:center;">*Catalogue E*</p>

CERAMICS, GLASS AND TABLE LINEN

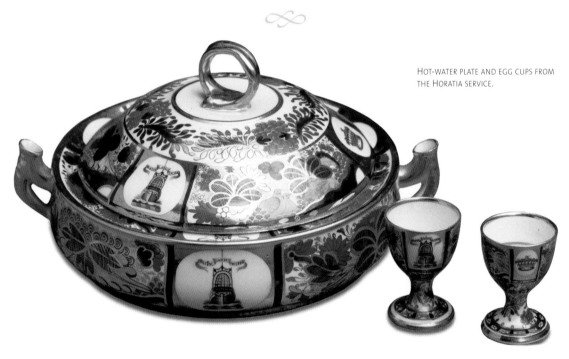

HOT-WATER PLATE AND EGG CUPS FROM THE HORATIA SERVICE.

PORCELAIN

We know that Nelson owned some fine porcelain table services and it is evident that he had an appreciation of ceramics. As well as visiting the Worcester factory to commission personal services, he purchased gifts of porcelain when visiting foreign ports. On 1 October 1798 Nelson wrote to his wife from Naples: '*I went to view the manufactory of china, magnificent. After admiring all the fine things sufficient to seduce my money from my pocket, I came to busts of all the royal family; this I immediately ordered and when I wanted to pay I was informed that the King had directed whatever I chose to be sent and free from all costs.*' (Nicolas, Vol. III, p.139) In April 1801 he purchased expensive porcelain items

from the Royal Danish China Manufactory, a '*dejeune in a case*' (personal tea set), a toilet box and an inkstand (NMM/CRK/2/37).

Inventories of Emma Hamilton's silver and china at Merton were compiled in 1813 and 1814 (see Chapter 1). Although these have never been entirely reconciled with existing Nelson porcelain, they provide an extremely good guide to the composition of the services and the contemporary names used by the family for the various patterns. The inventories list five named sets: the Nelson, the Baltic, the Horatia, the Botanical and the Hamilton's arms, of which only the first three can be identified with certainty today. Other sets were described in the inventory as the white and gold and the blue and white.

Chamberlain's of Worcester service, the 'Horatia set'

On 26 August 1802 Nelson visited the Royal Porcelain Manufactory at Worcester with Sir William and Lady Hamilton. Nelson was later described by James Plant, one of the workmen, as *'a very battered looking gentleman'*. During the visit, Nelson *'on inspection of the superb assortment of china at the shop in the High Street, honoured Messrs Chamberlain by declaring that, although possessed of the finest porcelain the Courts of Dresden and Naples could afford, he had seen none equal to the productions of their manufactory, in testimony of which, he left a very large order for china, to be decorated with his arms, insignia etc. Sir William and Lady Hamilton also favoured the proprietors with liberal purchases.'* The record of the original order for a large dinner and breakfast service is still at the Worcester Porcelain Museum (C12/166, see Appendix 3), but only the breakfast service had been completed before Nelson's death three years later. Emma Hamilton was sent the bill for £120 10s 6d on January 17, 1806 (Worcester Porcelain Museum C7/287).

This is the service described on the Merton inventory as the Horatia set. The design is a standard Worcester pattern in Old Japan style, but with the addition of Nelson's *San Josef* and *chelengk* crests, and his viscount's and ducal coronets replacing panels of fretwork in the original design. The two small green birds were part of the original Worcester design, and not, as has been suggested, a reference to the 'lovebirds' Nelson and Emma. A few plates and two teapots also include the full Nelson coat of arms in the design. Some of the most important pieces of this service are described below.

In some sale catalogues this service has been described in error as being presented to Lord Nelson by the 'Ladies of England'. Many pieces are marked with a cursive *'Chamberlain Worcester'* and the original pattern number *240*.

BIBLIOGRAPHY
R .W. Binns, *A Century of Potting in the City of Worcester*, 1865, pp.144–7
Geoffrey Godden, *Chamberlain-Worcester Porcelain 1788–1852*, 1982, pp.109–13
John Sandon, *The Dictionary of Worcester Porcelain Vol. 1, 1751-1851*, 1993, pp.243–5
Stanley Fisher, 'The Nelson Services', *Country Life*, 20 October 1955
John Sandon, 'Nelson's China', *Collector's Guide*, March 1989

Hot-water plate
Chamberlains of Worcester, *c.*1802–5

Old Japan pattern porcelain hot-water plate and cover, sometimes described as a muffin dish. The base has a double skin and hollow handles for filling with hot water. The second hot-water plate listed in the Chamberlain's order is now in the Nelson collection at Lloyds.

NMM has a number of other pieces of this service, including cups, saucers, plates and egg cups.

PROVENANCE
Descent through Nelson's daughter Horatia. Listed as the 'Horatia' service in Lady Hamilton's inventory (NMM/NWD/37). Presented to NMM by the Revd Hugh Nelson-Ward, grandson of Horatia, as part of the Nelson-Ward collection in June 1939.

NMM, Nelson-Ward Collection, AAA4541

Teapot
Chamberlain's of Worcester, *c.*1802–5

A teapot, lid and stand painted and gilt and elaborately embellished on both sides with the Admiral's coat of arms with supporters, below two coronets, the oval stand painted with a jardinière of flowers, the border with panels of flowers, a crest and two coronets. One of only two teapots in the service.

PROVENANCE [D]
Sold Christie's 12 June 2001, lot 281.

Clive Richards collection

Teapot (see p.95)

Teapot, lid and stand, similar but slightly different shape to the above.

PROVENANCE
Sold Christie's 1969. Acquired by the Museum of Worcester Porcelain in 1994 from John Cook, with contributions from the National Art Collections Fund and the Victoria & Albert Museum Purchase Grant Fund.

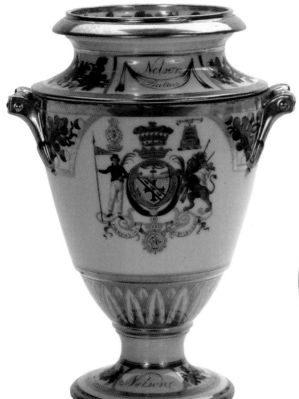

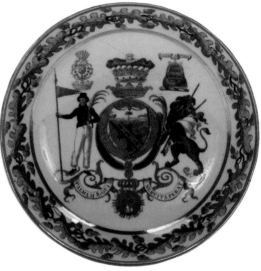

BELOW: ICE PAIL AND SAUCER FROM THE NELSON SERVICE WITH FULL COAT OF ARMS.

OPPOSITE: PLATE, CUP, SAUCER AND CREAM JUG FROM THE BALTIC SERVICE.

EXHIBITED
2003: 'Saved: 100 years of the National Art Collections Fund'.

Worcester Porcelain Museum, among other pieces of the service, has a plate with the full coat of arms, but no crests on the border, as illustrated in R. W. Binns's *Century of Potting in the City of Worcester* (1865), and there is another similar example in a private collection.

Museum of Worcester Porcelain, Worcester, M5329

Nelson arms and oak leaf service

This large porcelain service, described in the Merton inventories as the 'Nelson Service', is hand painted with an oak-leaf border, the name *Nelson*, and blue swags bearing the names and dates of his battles: 14th February for the Battle of Cape St Vincent, 1797, 1st August for the Battle of the Nile, 1798, and 2nd

April for the Battle of Copenhagen in 1801. All the plates and larger items such as the urn-shaped ice pails have Nelson's coat of arms painted in full colour, complete with supporters and his *chelengk* and *San Josef* crests, with his viscount's and Sicilian ducal coronets.

We have no record of Nelson ordering this service, although there are claims that it was presented to him in 1802 by the City of London. None of the pieces are marked, but over the years the service has been variously attributed to the Worcester and Bristol factories, which complicates tracing the service through saleroom records and exhibition catalogues. It is now accepted that the tea set is by John Rose of Coalport, and the dessert service is of hard-paste Paris porcelain, probably imported as blank porcelain for decorating in England. John May, the Kensington dealer and specialist on Nelson ceramics, believed that both sets were decorated in Thomas Baxter's London studios.

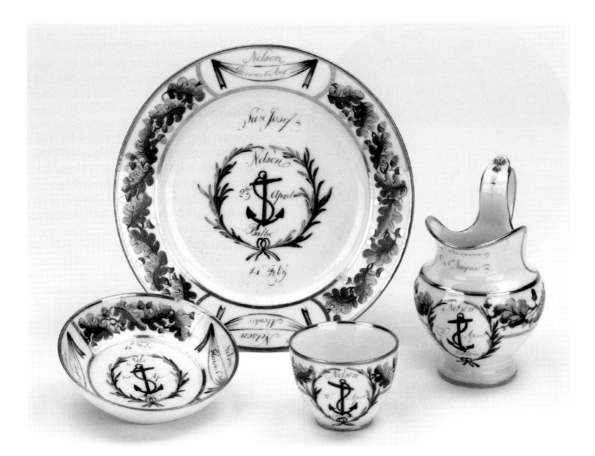

There are also many later copies of this service, which can sometimes cause confusion. Some of the copies are very close to the originals and may be by Sampson of Paris. In other cases, the shapes are quite different, and the painting of far lower quality and easily worn. In these examples the oak leaves are spiky and very unrealistic and there are errors in the inscriptions, such as 22 April instead of 2nd. The motto 'Palmam qui meruit ferat' sometimes appears as 'Palmam out meruit ferat' and 'Faith and Works' becomes 'Faith and Word' (see p.81).

NMM has pieces of this service in its collection, from the Trafalgar House, Nelson-Ward and Sutcliffe-Smith Collections (twenty-five Coalport, six Paris, including two ice pails, as well as several copies). There are other examples at the RNM Portsmouth, Monmouth, and in other museums and private collections.

NMM, AAA4547 to 4588

Baltic service

Related to the Nelson service, the Baltic set is another service of unmarked Paris porcelain which also has the oak-leaf border and the blue swags with names and dates of Nelson's battles. In the centre, instead of the Nelson arms there is a fouled anchor with laurel sprays and the words 'Nelson 2nd April Baltic'. Wilson of Hanley also produced a similar pattern in a creamware body (see p.81). There are many pieces of the Baltic service with descendants of the Matcham family, and NMM has a dessert plate, cream jug and teacup and saucer.

NMM, AAA4589 to 4592

Japan service

A dessert service of bright Japan pattern, by Barr of Worcester, unmarked, and with no distinguishing crests or coats of arms. The set includes dessert

Derby mug

Large porcelain mug with an inscription hand painted in gilt cursive script around the top band: *'Done from a Medal presented by Alexander Davison Esqr to Lord Nelson, his Officers and Men, in commemoration of the Glorious First of August 1798'.* The mug has a plain white background with gilt borders.

The mug is painted with both the obverse and reverse of Davison's Nile Medal in full colour, as on the above chocolate cups.

Two other variations of this mug are known, one sold in 1978 which had the inscription underneath rather than round the rim, and another sold in London in 1990 which had the mark of Duesbury and Kean of Derby.

NMM, AAA4737

Derby ice pails

A pair of recently discovered porcelain ice pails, decorated in gilt and full colour, painted on one side with Nelson's coat of arms as a baron, and on the other with two different panels allegorical of the Nile (see p.44–5).

These were perhaps commissioned by Alexander Davison as gifts for Nelson. There do not appear to be any records of the ordering and manufacture of these pieces, although the coats of arms suggest they were intended for Nelson's personal use. The two ice pails are of very slightly different height, and one has imperfections in the glaze inside, which may mean these particular ones were never presented.

The design of these ice pails, although hitherto unrecorded, relates to the smaller Derby porcelain pieces at Greenwich, Portsmouth and other collections, all associated with Alexander Davison, and also to a chocolate cup, cover and stand in the same Davison sale (lot 20) commemorating *'Nelson of the Nile'*, which was bought by the same collector.

The symbolic panel on one side of the chocolate cup is similar to that on one of the ice pails, but the ground is deep cobalt blue instead of gold. This is very similar to a blue and gold coffee can and saucer in the Lily McCarthy Collection at Portsmouth, and a white and gold coffee can in a private collection, which both have painted panels like that on the other ice pail.

PROVENANCE
Descent from Alexander Davison. Sold Sotheby's, 21 October 2002, lot 19 (the chocolate cup was lot 20).

Clive Richards collection

Derby cup and saucer

Porcelain cup and saucer with decoration in dark blue and gilt with foliate and vase decoration. A large circular cartouche opposite the handle is painted with the Egyptian symbolic design which appears on one of the Davison ice pails.

A chocolate cup, cover and stand at Monmouth is similar to this cup, but the ground is paler blue and the Egyptian cartouche is the same as the cartouche on the second ice pail.

RNM Portsmouth, Lily Lambert McCarthy Collection, 126/79

Chamberlain's Worcester cup and saucer

Porcelain cabinet teacup and saucer painted with a fine profile portrait of Emma Hamilton, signed *'Thomas Baxter, 1804'.* The saucer is decorated with gilded scrolling and an elaborate monogram 'N & B' and anchor. The porcelain ordered from Chamberlain's by Nelson when he visited Worcester in August 1802 included *'1 Cup and saucer with a likeness of Lady Hamilton'*, which John May believed was this one, decorated in Baxter's London studio (see Appendix 3).

We know that Thomas Baxter junior (1782–1821) visited Nelson and the Hamiltons at Merton, and the NMM has an album of sketches he made there. There is a very similar print to that on the cup reproduced in Julia Frankau's *Story of Emma Hamilton*, (1911). Although there is no proof, this could be the cup which Nelson refers to in his letter to Emma Hamilton written from the *Victory* on 27 May 1804: *'Your dear phiz – but not the least like you – on the cup, is safe; but I would not use it for the world; for, if it was broke, it would distress me very much.'* (Nicolas Vol. VII, p.36)

BIBLIOGRAPHY
John May, 'The "Emma" cup and saucer', *Trafalgar Chronicle*, 2001, pp.7–14.

Clive Richards collection

Chamberlain's Worcester beaker

Yellow-ground porcelain beaker painted with Emma Hamilton as Fame, holding a miniature of Horatio Nelson, to commemorate the Battle of the Nile. A unique piece like this is likely to have been a personal commission rather than a commemorative production intended for sale. Nelson's Worcester order included: '*1 Elegant Vase, richly ornamented with a miniature of his Lordship, supported by a figure of Fame &c.*'

PROVENANCE
Sold Law Fine Art, 21 May 2002. See *Antique Collecting*, March 2002.

Clive Richards collection

Stoneware jug

White stoneware jug (tankard) by Turner of Lane End, Staffordshire, with a brown neck and handle terminating in acanthus leaves. It has applied decoration of cherubs and vine leaves and a silver rim inscribed: '*This mug originally belonged to Lord*

Viscount Nelson was presented to Capt. MacKellar by Sir Thomas Hardy Bart.' The silver lid is engraved with Hardy's crest of a wyvern's head, and the rim is hallmarked 1805. John Mackellar (b. *c*.1768) was promoted to captain in 1798 and became a rear admiral in 1825.

PROVENANCE
Purchased by collector Cyril Walter, whose collection has been at NMM since 1935.

NMM, Walter Collection, AAA4725

'Nelson's favourite grog jug'

A well-worn jug of unmarked white stoneware, partly glazed in brown. The jug is decorated with reliefs of Venus and Cupid.

PROVENANCE
Presented to Greenwich Hospital in 1890 by the widow of George Potts MP, with a handwritten note: '*Lord Nelson's favourite jug. His "hot-grog" was made from it every night. The last he had before his death was made from it. Presented to the Nelson relic museum by the late George Potts Esq MP for Barnstable. This jug was presented to Wm. Potts Esq father of George Potts in Trafalgar Bay a day or so after the Battle in which Adml. Nelson was killed in the moment of victory 21st October 1805.*'

NMM, Greenwich Hospital Collection, AAA4724

GLASS

Rummers

Four glass rummers of slightly different size, each inscribed with a large initial 'N'. The bowl of waisted ogee shape and the base of the bowl are fluted. The collared stem stands on a circular terraced foot.

PROVENANCE
Sold in 1936 by Miss Frances Girdlestone, great-great-niece of Nelson. Sold Sotheby's 30 April 1936 and purchased for the NMM by Sir Percy Malcolm-Stewart Bt.
 Another similar rummer is at Monmouth.

NMM, Girdlestone Collection, GGG0241, GGG0242, GGG0243, GGG0244

OVERLEAF: RUMMER AND WINE GLASS WITH NELSON'S INITIAL.

Wine glasses

Four wine glasses, with waisted ogee bowl, stem and base of bowl fluted, standing on a conical foot. Large decorative initial 'N', with small engraved sprigs and stars on the strokes.

PROVENANCE
Miss Frances Girdlestone.

NMM, Girdlestone Collection, GGG0301 to 0304

Wine glasses

Six wine glasses of slightly different sizes, five inscribed with a large decorative initial 'N' with small engraved sprigs and stars on the strokes, and the sixth with an initial 'N' similar to that on the rummers. The bowl of waisted ogee shape, the stem and base of the bowl fluted, standing on a conical foot.

PROVENANCE
Miss Frances Girdlestone.

NMM, Girdlestone Collection, GGG0215, GGG0305, GGG0306, GGG0307, GGG0308, GGG0309

Decanters and glasses

The three (originally four) quart decanters are high-quality cylindrical decanters with diamond-cut glass decoration overall and two neck rings. The round glass stoppers are also of cut glass.

This shape became known as the Nelson decanter, and the type gradually gained in popularity between 1790 and 1820.

There are sixteen matching trumpet-bowled wine glasses and fifteen liqueur glasses, all of which fit with the decanters into a wooden cellaret.

PROVENANCE
Came from Trafalgar House in 1948 with the Nelson cellaret (which has silver handles hallmarked 1807, so is likely to have belonged to the first Earl Nelson rather than the Admiral. See pp.81–3).

BIBLIOGRAPHY
Andy McConnell, *The Decanter*, 2004

NMM, decanters GGG0289 to 0291

Decanters and glasses

Five cut-glass decanters engraved with initial 'N'. Six cut-glass rummers and twelve various wine and liqueur glasses, some engraved with initial 'N'.

PROVENANCE
Descended from Nelson's sister Catherine Matcham.

Private collection

Tumblers

Seven cut-glass tumblers of diamond-cut pattern.

PROVENANCE
Presented by Mrs Maurice Suckling Ward, 1957.

Royal Naval Museum, Portsmouth

Tumblers

Small diamond-cut tumbler, and a small straight-sided tumbler engraved with a small sprig pattern, with a swag and flowered cartouche containing the initial 'F'. Both tumblers reputed to have been used by Nelson on board the *Victory*.

PROVENANCE
Presented to Mr Maddock of Chester by the officers of the *Victory* after the Battle of Trafalgar, and presented by his son to Greenwich Hospital.

NMM, Greenwich Hospital Collection, GGG0300 & GGG0299

Other glass

In 1973 a cased decanter set came to light in New Orleans. The inlaid wooden box contained a set of six square-side decanters with cut-glass stoppers c.1780–90. The set is said to have been Nelson's personal property used on board the *Victory*, and to have gone to Collingwood after Trafalgar, passing down through his family until purchased by an English antique dealer, William Sydney, in c.1910. Sydney emigrated to America in the 1920s and established an antique shop in New Orleans, where he sold the decanter set, part of his private collection, in the 1940s.

A decanter and pair of glasses said to have been used by Nelson the night before Trafalgar are at the Castello Nelson in the dukedom of Bronte, on Sicily.

TABLE LINEN

All Nelson's table linen, as well as items of personal underclothing such as stockings and undershirts, appears to have been marked with a hand-sewn blue cross-stitched laundry mark, incorporating variously his coronet, initials and numbers probably indicating matching sets. Lady Nelson wrote to her husband from Bath on 17 April 1798: *'Kate and I are certain the huckaback towels were packed up, for I made her put the numbers which were at the washerwoman's down in her pocket book.'* (Naish, p.426)

Tablecloths

Four white linen damask tablecloths, two with overall patterns of sprigs with deep flower borders, one with an overall geometric flower pattern, one with stripes and small motifs. The laundry marks are slightly different on each:
1. Blue cross-stitch coronet and initial 'N' above number '12'.
2. Blue cross-stitch initials 'HN' above date '1800'.
3 & 4. Blue cross-stitch coronet and initial 'N' above number '40'.

NMM, TXT0224 to 0226, TXT0150

LINEN NAPKINS WITH NELSON'S LAUNDRY MARKS.

Tablecloth and napkins

Large white linen damask tablecloth with an overall floral motif. Two sides are selvedge and the other two sides rolled hand-stitched hems. Nelson's laundry mark of a blue cross-stitched initial 'N' and 'B' below two coronets are in one corner.

With six large white linen matching damask table napkins marked 'N24'.

PROVENANCE
Bequeathed by Mrs C. F. Joyce of Reading, 1978.

NMM, TXT0189 to 0195

Table napkins

Six white linen damask table napkins, two matching with overall sprig design and border design on three sides, being ovals consisting of continuous swag of leaves. Four are matching napkins woven with a design of flower and leaf sprays with a swag and garlanded border. All marked in blue cross-stitch with initials 'HN' above number '12'.

Another two white damask table napkins, one woven with a centre design of alternate stripes and rows of flowers with a floral border. The other a centre design and border of flowers and scrolls. The latter is marked in blue cross-stitch with a coronet and initial 'N' over the number '72'.

NMM, TXT0227 to 0232, TXT0172 to 0173

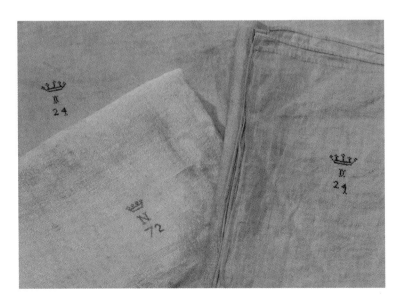

Catalogue F

SEAGOING FURNITURE

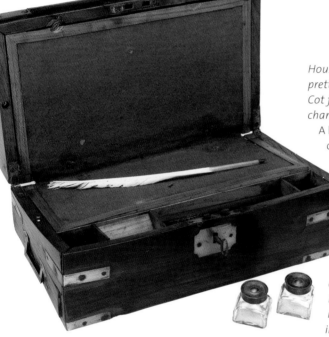

NELSON'S WRITING BOX MADE FROM *L'ORIENT*'S TIMBER.

House and come to me as it can... The Victory is a pretty state of confusion, and I have not moved my Cot from the Amperion [Amphion]. I shall take my chance I get it tomorrow.'

A letter written by Mr J. Evans on 13 January 1806 describes a visit he had made ten days earlier to the *Victory* lying in the River Medway below Chatham:

We passed some time in the cabin of Lord Nelson where we saw various packages numbered and marked with his name – We particularly observed a sofa, pictures, &c with which the apartment had been furnished and embellished. The hammock on which he lay was carefully packed up...The little table fixed to the side of the ship still remained where he passed great part of his time in writing, having at his elbow a portable compass by which the course of the ship was ascertained. His small book-case had a hole in the back of it, made by a cannon ball during the action by which the glass door was broken and some of the books scattered on the floor. (The complete letter, which also has an interesting passage on the fatal musket ball, is in *The Universal Magazine*, New Series, Vol. V, 1806, pp.43–7. Quoted by Ron Fiske in the *Nelson Dispatch*, Vol. 4, pt 1, Jan. 1991)

Nelson's writing box, *c.*1798

Brass-bound writing box, made from the timber of the French flagship *L'Orient*. A brass plaque on the lid is inscribed: '*Part of L'Orient blown up at the Battle of the Nile 1st August 1798. In Lord Nelson's possession at the time of his death 21st October 1805.*' The loud explosion of *L'Orient* clearly impressed itself on

In letters written from sea to his wife Frances and later letters to Emma, Nelson frequently referred to items of furniture and other personal possessions in his cabin. A regular complaint was that items had gone missing in transit, or had arrived damaged or incomplete. It sheds intriguing light on naval officers' arrangements at this period, and indicates Nelson's remarkable attention to details. A typical letter to Emma written from Portsmouth on 19 May 1803 reads: '*I have been examining the list of things which are coming down this evening and what comes tomorrow... My sopha & the Large chair are not on any of the lists, therefore I fear for them; my linnen I am likewise not sure of, as it was not marked Linnen. My Wine will go to the Custom*

those present, and souvenirs of the incident were gathered up. Nelson himself kept a number of other mementos of the ship, including gifts such as the top of her mainmast, a coffin and a snuff box made from her timber. This writing box or perhaps the snuff box may be the one listed in the Huntington Library manuscript (see Chapter 1).

The corners of the box are brass-bound, and there is a brass lock plate, recessed handles and a slim drawer in the base. The box opens to reveal a green baize covered writing slope, pen tray and three compartments containing two glass ink bottles with silver lids and two keys.

The box is similar in design to that depicted in T. J. Barker's later painting and engraving of Nelson at prayer in his cabin before Trafalgar.

Other larger writing boxes, also said to have been Nelson's, are at RNM Portsmouth and Monmouth.

On 15 December 1987 Sotheby's sold a quill pen said to be that used by Nelson to write his last, unfinished, letter to Emma Hamilton from the *Victory*. A note sold with it claimed: '*This pen was taken by Major Wright out of Lord Nelson's writing desk on the 2nd of Novr 1805 in the presence of Capt Hardy of the Victory, who desired him to keep it, as being the Pen with which His Lordship had written for the last time, in the morng of the action. It was lying beside an unfinished let*[ter to] *Lady Hamilton.*'

PROVENANCE [D]
Presented in 1969 by Lady Colman.

EXHIBITED
1891: RN Exhibition cat. no. 3383 1G, lent by Frederick Edward Colman Esq.

NMM, AAA3398

Nelson's cabin armchair

Mahogany armchair, upholstered in black leather with separate cushions, and finished with lines of brass studs on front rail and arms. There are two separate upholstered box cushions.

The chair was part of Nelson's cabin furniture used on board the *Victory*. The third Earl Nelson claimed that it was

Nelson's personal chair and the last chair he sat in before Trafalgar. Originally there was a black silk-covered pad on the right arm of the chair, on which Nelson could rest the stump of his arm.

The chair was extensively restored in 1977 and 1982.

PROVENANCE
On the *Victory*'s return to England, Captain Hardy gave the chair to Isabella Thompson of Portsea, whose nephew G. H. Thomson of Andover bequeathed it to the third Earl Nelson.

EXHIBITED
1891: RN Exhibition, Chelsea, cat. no. 3017. Lent by Earl Nelson.

NMM, Trafalgar House Collection, AAA3400

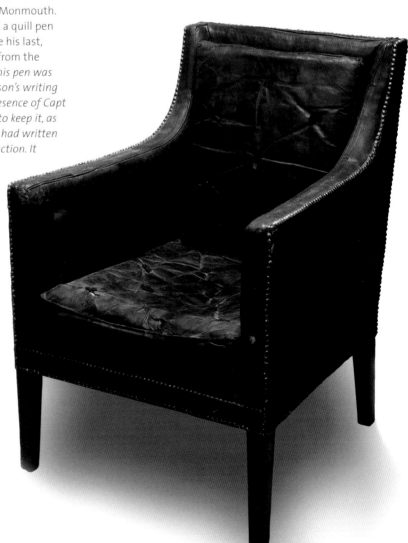

Nelson's cabin armchair

Similar to the Greenwich chair (previous entry), but with leather pockets at the sides, used by Nelson for filing papers while working.

A memoir of the Revd Alexander Scott, Nelson's chaplain and secretary, published in 1842, describes how, '*Day after day might be seen the admiral in his cabin, closely employed with his secretary over their interminable papers. They occupied two black leather armchairs, into the roomy pockets of which, Scott, weary of translating, would occasionally stuff away a score of unopened private letters, found in prize ships... These chairs, with an ottoman that belongs to them, (now treasured heirlooms in Dr Scott's family,) formed when lashed together, a couch, on which the hero often slept, those brief slumbers for which he was remarkable.*' (Alfred & Mrs Gatty, *Recollections of the Life of the Rev. A. J. Scott DD*, 1842)

PROVENANCE
Presented to HMS *Victory* in c.1963 by Richard Gatty, a descendant of the Revd Scott.

Royal Naval Museum, Portsmouth

Nelson's cabin armchair

In 1891 a RN Exhibition, Chelsea, catalogue entry (3022) read: '*Armchair from the Victory's cabin. In leather, with large pockets for dispatches. Lent by Thomas St Leger Blaauw Esq.*' The *RN Exhibition Illustrated Souvenir*, p.77, has a drawing of the chair with the caption: '*Nelson's favourite arm-chair in his state cabin on board the Victory. This seat, covered in leather, with large pockets on either side for holding dispatches, was called the 'Emma', and was the gift of Lady Hamilton to Nelson. It was purchased from the Victory at the time of Nelson's death, by Sir Francis Lafarey* [sic], *Bart, he being at that time a midshipman on board Nelson's flag-ship.*' In fact, Sir Francis Laforey was Captain of the *Spartiate* at Trafalgar.

This armchair, very similar to those at Greenwich and Portsmouth, was sold at Christie's on 23 October 1980 to J. & J. May. A plaque on the frame is inscribed with the story given in the 1891 catalogue. The same chair had previously been sold in 1920 by J. Rochelle Thomas of King Street, St James's. The advertisement in the *Connoisseur* of January 1920 offering the chair for £200 has a photograph showing that it already had the engraved brass plaque, and mentions that the chair had been in the Blaauw family until 1919, when it was purchased at the dispersal of contents of Beechland.

Private collection

Other cabin chairs

Nelson is known to have had cabin chairs made by Messrs Foxhall and Fryer, who worked for Beckford at Fonthill. Nelson wrote to Emma on 21 January 1801: '*I have not got, I assure you, scarcely a comfort about me except the two chairs which you ordered of Mr*

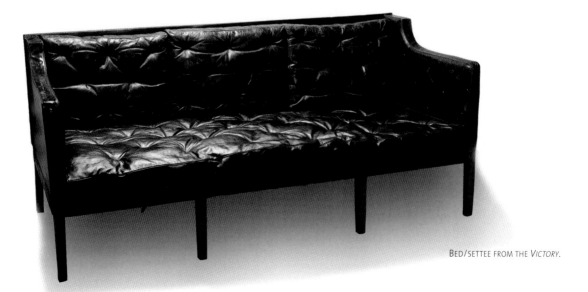

BED/SETTEE FROM THE *VICTORY*.

Foxhall.' On 13 January he had paid Messrs Foxhall & Fryer £20 (A. Morrison, *Hamilton & Nelson Papers*, Vol. II, Appendix B).

A cabin chair from the *Victory*, which came through the Revd Scott, and was left by him to his friend and neighbour Lady Tyrconnel at Kiplin, who then passed it on to Admiral Carpenter, was reported in 1949. A folding library chair with a leather cushion said to belong to Nelson was lent to the Royal Naval Exhibition in 1891 by Vice-Admiral the Hon. W. C. Carpenter.

In 1891 the Royal Naval Exhibition at Chelsea exhibited a chair lent by Messrs Norie & Wilson with an inscription: '*This was Lord Nelson's favourite chair when he was Captain of the Boreas frigate*' (cat. no. 3015). Cat. no. 3019 was an armchair from the *Victory*'s cabin, struck by a round-shot during the Battle of Trafalgar, lent by Lady Helen MacGregor of MacGregor, a Hardy descendant.

On 2 July 1971 Sotheby's sold an early-nineteenth-century mahogany library chair with caned panels, the arms with free-standing baluster supports and turned legs. On the chair was a brass plate stating that it was Lord Nelson's cabin chair on board the *Victory*. The chair came from the collection of Sir Francis Denys Bt, who died in 1922, and was accompanied by a note that Lady Hamilton had presented the chair to his grandmother.

Bed/settee

Settee upholstered in black leather, standing on eight square mahogany legs, and can be easily dismantled. There is one long box cushion for the seat and three buttoned cushions for the back. Restored and the seat recovered in 1977.

PROVENANCE [D]
Used by Nelson on board the *Victory*. Presented to Earl Nelson by the widow of Rear-Admiral Thomas Foley (1757–1833), who had served under Nelson at the Nile and Copenhagen.

NMM, Trafalgar House Collection, AAA3401

Armchair/daybed

Mahogany armchair, upholstered in black leather, piped in red. The armchair has a square back and sides, and fitted under the seat is a slide extension, which pulls out to form a bed. There are two mattress cushions and two extra box cushions, all upholstered in black leather. The castors would not have been used at sea and must be later additions.

PROVENANCE
After Trafalgar the chair was sent from the *Victory* to Nelson's sister Catherine Matcham.

EXHIBITED
1891: RN Exhibition, Chelsea, cat. no. 3261: '*Chair and bed combined, in which ViceAdmiral Lord Nelson sometimes slept when at sea. Lent by W Eyre-Matcham Esq.*'
On loan to NMM 1965–78.

Private collection, Matcham family descendants

Cabin chairs, *c.*1775

Two green-painted chairs, rush seated, with curved solid-wood back panel with rows of holes top and bottom. The stiles are square and fluted with urn-shaped finials, and the front legs similarly fluted. The green paint of one chair has been stripped to reveal pale blue paint with a painted design on the back rail.

A single chair of the same design, also described as a cabin chair from the *Victory*, formerly the property of Lord Nelson, is in Norwich Castle Museum, having been presented by the Rt Hon. Lord Stafford in 1854. The chair has an identical hole-pattern back, fluted legs and stiles with urn finials and a woven rush seat, and is also painted green. It was said to have been purchased by Nelson at Naples for use as cabin furniture in the *Foudroyant*. The layer of green paint might well have been applied at that time to protect them at sea.

Nelson's '*List of Sundries at James Dod*[d]*s, Brewer Street*' of 5 March 1801 lists among his furniture '*6 Italian painted chairs with straw seats*'. (BL Add. 34990 fo.10)

NMM, Walter Collection, AAA3440 & AAA3441

Cabin washstand

Mahogany square washstand with two hinged flaps to the lid, enclosing a fitted interior with apertures to take a wash bowl and other fittings. A swing mirror rises from the back of the cabinet secured by a decorative screw at the back. There is a hinged cupboard door and drawer in the front and brass

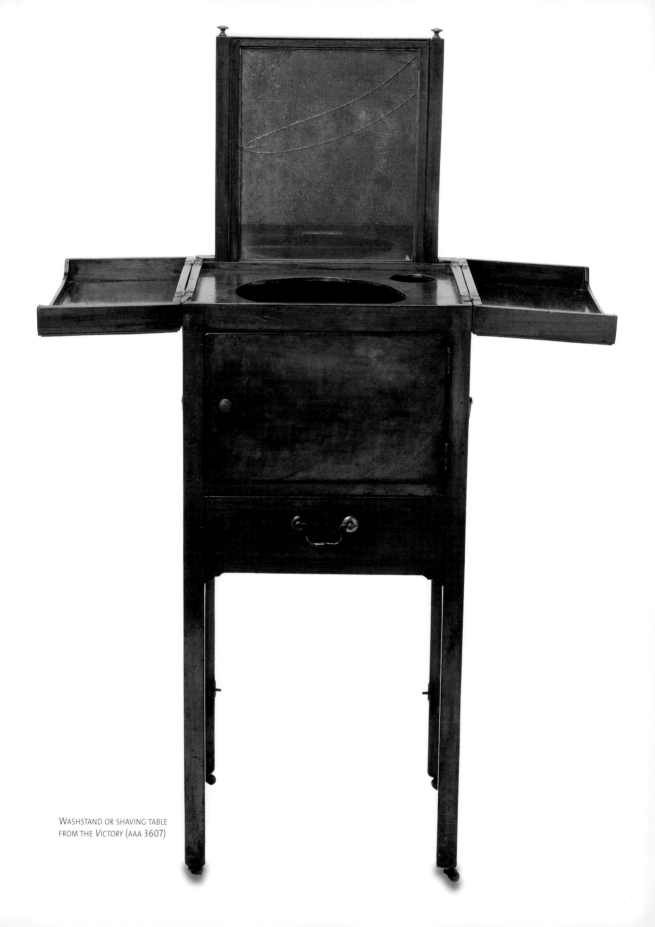

WASHSTAND OR SHAVING TABLE
FROM THE *VICTORY* (AAA 3607)

handles. The washstand stands on four square legs, now with castors. This type is described by Hepplewhite c.1782 as a 'shaving table'.

PROVENANCE
A silver plaque on the washstand is inscribed: '*Lord Nelson's cabin washstand on board the Victory. Owner J Augustine Brown Esq.*' James Brown appears on the muster lists of the *Boreas* as Nelson's clerk, 1784–7.

EXHIBITED
1891: RN Exhibition, Chelsea, cat. no. 3203: '*Mahogany washstand which belonged to Lord Nelson, and was given by him to James Brown, Purser RN., sometime his private secretary. Lent by John Augustine Brown.*' (Drawing of the open washstand in the exhibition's *Illustrated Handbook and Souvenir*, p.13.).
1905: Exhibition of Nelson Relics, RUSI, lent by J. Augustine Brown, cat. no. 3235 (with photograph showing that at this time the legs were fitted with a solid stretcher in one piece). The 1932 RUSM catalogue has it as cat. no. 5235, deposited by John Brown Esq. Passed to NMM in 1962.

Private lender to NMM, AAA3607

Cabin washstand

Mahogany-enclosed square washstand with canted corners, with two hinged flaps to lid, enclosing a fitted interior with apertures to take a wash bowl and other fittings. The washstand has its original brass handles, and stands on four plain square legs, now with castors. There is a rising mirror, cupboard and drawers, and a pull-out slop-container at the bottom.

The washstand is of a similar design to AAA3607 above.

PROVENANCE
Came from the *Victory* after Trafalgar, to Nelson's sister Catherine Matcham.

EXHIBITED
1891: RN Exhibition, Chelsea, cat. no. 3230, lent by W. Eyre Matcham.
On loan to NMM 1965–78.

Private collection, Matcham family descendants

Victory's furniture

A set of mahogany furniture consisting of an extending dining table on ten turned legs, from Nelson's dining cabin on board the *Victory*, a matching sideboard with pedestal ends and a falldown front to house the six extra table leaves, and an octagonal cellarette, with lion's-mask and ring handles, which fits under the sideboard. The dining table is a pattern called 'The Imperial', patented by Richard Gillow in 1800.

PROVENANCE
After Trafalgar the *Victory* returned to Rosia Bay, Gibraltar, to refit. While the fore-cabin was serving as a mortuary chapel for Nelson's body, the furniture was removed and put ashore. It appears to have been sold, possibly by Nelson's steward Chevalier, and purchased by Admiral Henry Warre, who left it in the care of his cousin John Hatt Noble, President and Treasurer of the British Association at Oporto, Portugal. Admiral Warre died in 1826 and the furniture became John Noble's property. He left it to his son Charles Hatt Noble, who in 1862 retired from Oporto. At the sale of his effects the suite was purchased by D. M. Feuerheerd, whose grandson, L. M. Feuerheerd, had the furniture shipped back to England from Oporto on board the SS *Cressado* in May 1928. On arrival it was exhibited at the Geffrye Museum in London, then on 16 October Mr Feuerheerd lent the furniture for display on board the *Victory*.

The suite was sold at Christie's on 25 June 1930, lot 63, and purchased by Joseph H. Jacobs, who presented it to the *Victory*. After the sale, *The Times*

DINING TABLE, SIDEBOARD AND CELLARETTE ON BOARD THE *VICTORY*.

for 23 July 1930 reported that the set was to be on view at Albert Amor's Galleries in St James's Street, London the next week.

Royal Naval Museum, Portsmouth

Bureau

Tambour-top bureau opening to reveal a writing surface with pigeonholes above. The double doors in front open to show ten half-width drawers with brass knobs. A label on a brass plaque fitted to the top is inscribed: 'This bureau belonged to Nelson and was in the Victory at Trafalgar.'

The interior fittings of the top section were altered during restoration in 1940, and there is now a different arrangement of small side drawers and pigeonholes. Miss Girdlestone's executor wrote: 'I am afraid that the pigeon-holes have already been destroyed. It was simply a self-contained fitting with two cheeks and slid in onto the front of the bureau.'

PROVENANCE
Bequeathed to NMM in 1936 by Miss Frances Girdlestone, who firmly believed that this bureau was in Nelson's sleeping cabin and he had used it when writing his last prayer aboard the Victory. It was the only Nelson item she would not part with in her lifetime.

NMM, Girdlestone Collection, AAA3263

Folding bed

Patent folding bed by Morgan & Sanders of Catherine Street, London, with a brass plaque stating that it was used by Nelson. Morgan & Sanders specialized in patent and portable furniture, and are known to have supplied Nelson, 'for whose seat at Merton they were executing a considerable order at the moment when the memorable battle of Trafalgar deprived his country of one of her most brilliant ornaments. As a tribute of respect to the victorious hero, the proprietors were induced to give their manufactory the name of Trafalgar-House.' (Ackermann's Repository of Arts, 1809, Vol. II, p.123)

PROVENANCE
1891: RN Exhibition, Chelsea, cat. no. 3151, lent by Arthur Rigg.
Sold Christie's 28 Jan. 1896: 'The following Nelson Relics, which were exhibited at the Royal United Service Institution, were formerly the property of Lady Hamilton, and purchased with her house at Richmond, by Alderman J J Smith, from whose son they passed to the present owner. 25: Lord Nelson's bedstead from the Victory. A mahogany bedstead, folding in three divisions. On dwarf turned legs, and with cover. Morgan and Sanders patent.'

HMS Victory

Portable toilet mirror c.1800

Plain mahogany-framed mirror, with rounded corners at the top and a bracket support at the back.

PROVENANCE
A handwritten note on the back reads: 'This glass was purchased by one Whapshare of Salisbury at the sale of Earl Wm's effects in 1835. It was sold as having been used by the Admiral at sea, and was brought back into the family of the aforesaid Whapshare for 25/- in February 1861 by me. Trafalgar. Nelson.'

NMM, Trafalgar House Collection, AAA3201

Cot hangings

In his cabin at sea, Nelson would sleep in a hanging cot, a more sophisticated version of a hammock, which could swing with the ship's movement. Three panels from the original hangings of the cot have survived in glazed frames as displayed in the Painted Hall at Greenwich.

The hangings are of straw-coloured figured silk, embroidered in coloured silks with sprigs of flowers. The embroidery is by tradition said to have been the work of Emma Hamilton, but it appears to be too professional. The eyelet holes through which the lacing of the cot ran are visible. A replica of Nelson's cot with copies of the embroidered panels is now displayed on board HMS Victory.

PROVENANCE
Presented to Greenwich Hospital by George Moffat Esq. in 1877.

EXHIBITED
1891: RN Exhibition, Chelsea, cat. no. 3204
1905: RUSI Exhibition of Nelson Relics, cat. no. 6032.
Descriptive Catalogue of the Painted Hall of Greenwich Hospital, 1922, p.58.

NMM, TXT0115, TXT0353, TXT0354

Catalogue G

WEAPONS AND SHIPBOARD EQUIPMENT

SWORDS

His Lordship did not wear his sword in the Battle of Trafalgar: it had been taken from the place where it hung up in his cabin, and was laid ready on his table; but it is supposed he forgot to call for it. This was the only action in which he ever appeared without a sword. (William Beatty, Authentic Narrative of the Death of Nelson, 1807)

Nelson's uniform sword is at Monmouth, but most of the other swords he is said to have used are now considered to be of dubious authenticity.

The fine City of London's jewelled sword presented to Nelson after the Battle of the Nile still survives and was the City's response to Nelson for his gift to the Lord Mayor of the French Admiral's sword captured at the battle. Other authentic Nelson-related swords are the trophy weapons he captured in battle, and a sword he presented to Captain Cockburn.

For detailed discussion on the swords associated with Nelson see:

W. E. May and P. G. W. Annis, *Swords for Sea Service*, 1970

H. T. A. Bosanquet, *The Naval Officer's Sword*, 1955

H. T. A. Bosanquet, *Naval & Other Swords in the Nelson Museum, Monmouth*, 1949

Nelson's uniform sword

Naval officer's regulation sword of 1805 pattern, with a stirrup hilt, lion's-head pommel and a straight blade six inches shorter than normal, to enable Nelson to draw it with his left hand. Nelson is said to have ordered such a sword from Salters of the Strand. The top locket of the scabbard, which would originally have had the sword cutler's name on, is

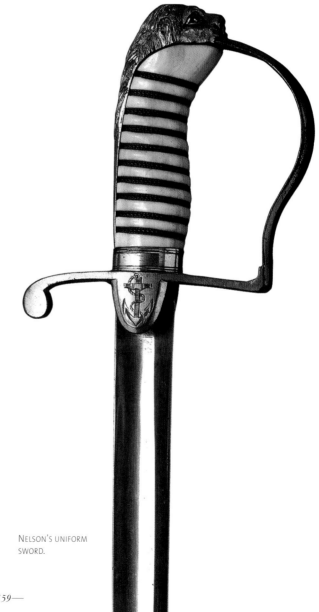

NELSON'S UNIFORM SWORD.

now missing. This is thought to be one of two swords in Nelson's cabin at Trafalgar, although he wore neither in the battle. The second sword, last heard of in the mid-nineteenth century in Henry Robinson's Nelson Museum, evidently had an oval side-ring hilt, as indicated by the sketch on the reverse of Barrett, Corney & Corney's invoice of 1805, but this sword has now disappeared.

PROVENANCE
The uniform sword, which has frequently been referred to as 'Nelson's fighting sword', is presumed to have been delivered to Lady Hamilton with Nelson's other personal property after his death. The goods detailed in the 1814 bill of sale to Alderman Smith (NMM/PHB/P/23) were not sold during Emma's lifetime, but remained crated up with Smith at Richmond until 1831. In May 1831 Mrs Smith sent the cases to an agent named Newman at Southwark to be delivered to John Kinsey, a former employee of the Alderman. After the Alderman's death in 1844, Mrs Smith sold almost everything, but Kinsey appears to have retained the sword.

The Monmouth Museum acquired with this sword a framed print of a sword said to be the same weapon, showing the top locket, complete with Salter's name engraved, as it was when Kinsey advertised the sword for sale on 16 September 1847. Not succeeding in selling it, he subsequently pawned it. The sword was rescued by an innkeeper at Bushey, Herts, from whose widow Mr E. B. Treharne of Bushey purchased it. Treharne's widow subsequently sold it at an auction of Sotheby, Wilkinson & Hodge, New Bond Street, on 22 December 1919, together with John Kinsey's affidavit of 16 Feb 1847, stating that in June 1830 he had been ordered to repack the six crates of Nelson property, which included this sword. Purchased by Lady Llangattock in 1919. (See Bosanquet, *Naval & Other Swords in the Nelson Museum, Monmouth*, pp.6–8; Annis & May, *Swords for Sea Service*, pp.100–102.)

Nelson Museum, Monmouth, 390

Winthuysen's sword (captured)

Hanger with mother-of-pearl hilt, surrendered to Nelson by the Spanish admiral Don Francisco Xavier Winthuysen of the *San Josef* at the Battle of Cape St Vincent in 1797.

The sword is of scimitar type, with a shagreen scabbard. Nelson presented the sword to the City of Norwich, writing on 26 February 1797 to Mr Windham, MP for Norwich, '*Admiral Sir John Jervis having done me the honour of insisting on my keeping possession of it, I know no place where it would give me or my family more pleasure to have it kept, than in the capital city of the county in which I had the honour to be born.*' (Nicolas, vol. II, p.257)

This sword, shown with its original chain knuckle guard, which has since disappeared, is portrayed leaning against a gun in William Beechey's full-length portrait of Nelson, painted 1800–1, in St Andrew's Hall, Norwich.

Norwich Castle Museum

Spanish small-sword (captured)

Spanish small-sword, said to have been taken by Nelson on 3 July 1797 when he commanded the inshore squadron off Cadiz in a boat attack on Spanish gunboats. The sword is of the type worn by Spanish naval officers in the eighteenth century. The hilt has a brass guard, an oval pommel, a smooth brass grip and an oval shell. The black shark-skin scabbard has two brass lockets with rings and chape.

PROVENANCE
Family tradition says that this was the sword used by Don Miguel Tyrason, captured by Nelson and given to his wife Frances. She left it to her goddaughter Ann Thomas, who in turn left it to her brother Charles Marques Thomas. Thomas's widow Jane gave it to her nephew, and it descended through the Seddon family. Colonel R. N. Seddon lent the small-sword to the RUSM (3103) together with another sword with an eagle-head pommel (3104) said to have been taken by Nelson from a French commander.

NMM, loan from private collection, WPN1229

French Admiral's small-sword (captured)

Sword surrendered to Nelson at the Battle of the Nile by the French Rear-Admiral Blanquet du Chayla, of the *Franklin*. Nelson presented this sword to the Lord Mayor of London in 1798.

The sword is a French flag officer's épée with a

helmet pommel grip bound with wire and a copper-plated brass hand guard. The blade is inscribed '*Vigilancie*' and '*Vivre libre ou mourir pour la nation la loi & le* [roi]'. The last word was erased after the execution of Louis XVI in January 1793. The blade, which is broken at the tip, is engraved with a French cockerel and Bellona, goddess of War.

Museum of London, MOL7790

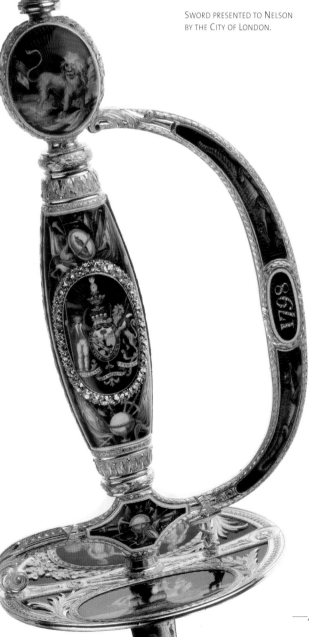

SWORD PRESENTED TO NELSON BY THE CITY OF LONDON.

City of London presentation sword

Hilt by James Morisset, London, 1798
Sword by Robert Makepeace, London

Jewelled and enamelled sword of honour presented by the Corporation of London to Lord Nelson on 10 November 1800, with the Freedom of the City of London, in recognition of the victory of the Battle of the Nile in 1798. (See *Gentleman's Magazine*, November 1800, p.1100.)

The gold hilt is set with diamonds and the shell is inscribed: '*Anderson Mayor. A common council holden in the Chamber of the Guildhall of the City of London on Tuesday the 16th Day of October 1798 resolved unanimously that a Sword to the Value of Two Hundred Guineas be presented to Rear Admiral Lord Nelson of the Nile by this Court A testimony of the High Esteem they entertain of his Public Services and of the eminent advantages he has rendered his Country. Rix.*' (William Rix was the Town Clerk in 1799.)

Nelson wrote to Sir William Anderson on 31 January 1799: '*I am truly sensible of your politeness, in desiring me to say what particular devices I should wish on the Sword which is to be presented to me by the City of London, but I beg to leave that to the better judgment of my Fellow-Citizens.*'

PROVENANCE
The City cash accounts for 1799 list the payment of £210 to Robert Makepeace '*in full of his Bill for a rich chased gold sword with painted enamelled Medallions and Ornamented with Brilliants voted by this Court. To be presented to Rear Admiral Lord Nelson of the Nile. The triangular blade is damascened with anchors. The sword hilt is decorated with a series of translucent blue enamelled plaques, those on the grip show the coats of arms of the City of London and of Lord Nelson encircled by facetted diamonds, set in a silver background. The centre of the guard is studded with silver set facetted diamonds which read "1798" and "Nile" and are flanked by enamelled crocodiles representing the Nile.*'

In his will dated 10 May 1803 Nelson made specific mention of this sword: '*Also I give and bequeath to my sister Catherine Matcham, the sword presented to me by the City of London.*' On 23 November 1805 George Matcham, Nelson's nephew, noted in his

journal: *'Papa and Mama came about 6. Heard concerning the Will... to Mama the Sword given to him by the City of London.'*

The sword was lent to the RUSI in October 1901 by George Henry Eyre-Matcham. He withdrew it and sold it in 1928 to Lord Wakefield, who presented it to the City of London. A miniature gold anchor from the hilt remained in the possession of the Matcham descendants.

EXHIBITED
1928: Loan exhibition of Nelson Relics, Spink's, cat. no. 82, lent by George Eyre-Matcham.

Museum of London, MOL11952

Cockburn presentation sword

Small-sword by Richard Clarke and Son, London, with a silver-gilt hilt hall-marked 1797, the oval shell chased with a naval trophy. Inscribed *'Presented by Commodore Nelson to Capt. Geo. Cockburn, of His Majesty's Ship La Minerve, in commemoration of two gallant actions fought on the 19th and 20th Dec., 1796.'* Nelson wrote to Earl St Vincent on 18 September 1797: *'After George Cockburn's gallant action with the Sabina, I directed a gold-hilted sword to be made for him, which I had hoped to present to him myself in the most public and handsome manner; but as Providence has decreed otherwise, I must beg of you to present it for me.'* (Nicolas, vol. II, p.446)

On 7 May 1799 Nelson paid Richard Clarke £114 11s 3d for a gold sword.(See Nelson's accounts with Messrs March and Creed 1792–1802 in Morrison, *Hamilton & Nelson Papers*, 1894, Appendix B.)

Many years later Sir George Cockburn (1772–1853) was painted by Sir William Beechey as a vice-admiral, wearing this sword (BHC2618).

PROVENANCE
Left by Cockburn in trust to his widow. It passed to his daughter and afterwards to the holder of the baronetcy, which ended in 1880.

Sold at Christie's, 19 July 1905, lot 26. The sword was bought by another branch of the Cockburn family and presented by the mother of Lieutenant George Cockburn Yorke RN in 1948.

NMM, WPN1167

PISTOLS

The codicil to Sir William Hamilton's will, 16 April 1803, stated: *'All my firearms I bequeath to my nephew Charles Greville, except two guns that are at Merton, and which I bequeath to Ld. Nelson.'* We do not know which guns these are, and although a number of pistols are said to have belonged to Nelson, most of these cannot be authenticated.

The 1891 RN Exhibition at Chelsea included no. 3213, *'Pair of carved and silver-mounted pistols, formerly the property of Lord Nelson. Lent by Francis Smith Esq'* and no. 3270, *'Pair of pistols which were presented to Lord Nelson by Captain Thomas Masterman Hardy, June 18th, 1801. Lent by Mrs Blaikie.'*

NAVIGATION INSTRUMENTS

Also I give and bequeath to my late Captain and worthy friend Captain Hardy, all my Telescopes and Sea Glasses, and one hundred pounds in money, to be paid three months after my death. (Nelson's will, dated 10 May 1803.)

We know that Nelson used telescopes by Dollond, one of the leading scientific instrument makers of the period. A letter written by Nelson on 11 September 1805, shortly before he left England for the last time, reads: *'Lord Nelson has not received his glasses from Mr Dollond. Lord N things all leave London to Morrow, therefore if not sent to the Hotel Lord N begs Mr Dollond will send them immediately to Portsmouth.'* (Monmouth, E179)

Nelson's gift

Telescope by Dollond of London, given by Nelson to his godson Horatio Nelson Atkinson. The barrel is of red-painted wood, with a brass draw, lens cap and shutter over the eye-piece. The focal length is 44 1/4in.

PROVENANCE
On a paper label on the telescope: *'This telescope was given by [Nelson] to his Godson Horatio Nelson the son of Thomas Atkinson who served him faithfully as master of the flagship at Teneriffe, Copenhagen and Trafalgar. Lieut. William George Atkinson son of Horatio Nelson Atkinson presented it to me. March 5th 1886. Nelson.'*

Exhibited
1891: RN Exhibition, Chelsea, cat. no. '3111: Telescope
left by Nelson to his godson, Horatio Nelson Atkinson.
Unfortunately re-covered by Dolland [sic]. Lent by
Earl Nelson.'

NMM, Trafalgar House Collection, TOA0104

Exhibited telescopes

A. M. Broadley & R. G. Bartelot in *Three Dorset
Captains at Trafalgar*, 1906, pp.152–3, quote the
terms of Nelson's will relating to his telescopes and
identifies two: *'The shorter of these telescopes,
employed by Nelson at Trafalgar, now belongs to
Lady Helen MacGregor, the widow of Hardy's
grandson. The longer, used by Nelson prior to the loss
of his arm, was given in 1837 to his nephew by
marriage, Lord Frederick FitzRoy.'*

Exhibited
1891: RN Exhibition, cat. no. 3110: *'Lord Nelson's spy
glass. Lent by Lady Helen MacGregor of MacGregor.'*
This telescope is still in the possession of the Hardy
descendants, and is said to be the one used by
Nelson at Trafalgar. The family story is that Hardy's
widow said the telescope was in Nelson's hand
when he fell at Trafalgar.
1891: RN Exhibition, cat. no. 3347: *'Lord Nelson's
telescope, given to Lord Frederick Fitzroy by the
latter's uncle, Admiral Sir T M Hardy, Nelson's Flag
Captain at Trafalgar. Lent by Lord Frederick Fitzroy.'*
Lord Fitzroy's descendants still own a mahogany-
cased telescope signed *'Berge, London late Ramsden'*
which must date between 1800 and 1819. This is
reputedly Nelson's telescope, given to Lord Fitzroy by
Hardy in 1837.
1891: RN Exhibition, cat. no. 3113: *'Nelson's telescope,
given to Captain Otway after Copenhagen, Lent by
the Right Hon. Sir A J Otway Bart.'*
1891: RN Exhibition, cat. no. 3114: *'Small telescope used
by Lord Nelson at the battle of Trafalgar. The
telescope was the property of one of the Lieutenants
of the Victory, and was lent by him to Lord Nelson as
being handy for use by a one-armed man. The owner
gave it, as a memento of Lord Nelson, to Commissary
General Sweetland at Gibraltar, when the Fleet went
there immediately after the battle, and was by him
given to his son, the present owner. Lent by Edward M
Sweetland.'*
1891: RN Exhibition, cat. no. 3310: *'Telescope formerly
belonging to Lord Nelson, inscribed "This belonged
to Lord Viscount Nelson, 21st October 1805. Captain
Fremantle RN, 21st October 1805" Lent by Lord
Cottesloe.'*

Barometer

Marine stick barometer *c.*1800, said to have been
given by Nelson to Admiral Cockburn. Mahogany
case with a silvered brass scale and a thermometer
fitted to the inside of the barometer door. On board
ship it would have been hung from brass gimbals.

Provenance
Admiral Cockburn gave the barometer to Dr
Alexander Nisbet. There is a manuscript note
recording the presentation in 1843 of *'a small token'*
to Alexander Nisbet by Admiral Cockburn, although
the note did not specify what that was. It was
donated to NMM in 1950 by Sir Lewis Casson, who
inherited it from an aunt who was a Nisbet.

NMM, NAV0779

Barometer

Marine stick barometer by Matthew Berge of
London, *c.*1805, said to have been presented by
Nelson to Sir George Montagu GCB. It has a
mahogany case, is fitted with a gimballed
suspension so that it remains upright on board ship,
and has a thermometer set below the brass
barometer scale. The maker Berge was in business in
London 1800–19 and was previously foreman to
Ramsden, one of the leading instrument makers of
the eighteenth century.

Provenance
Bequeathed to NMM by a direct descendant, James
Drogo Montagu CBE in 1958.

NMM, NAV0786

Catalogue H

NELSON'S WOUNDS AND DEATH

Life mask

The first item in this category might seem to be misplaced, but it is included in this section because this well-known representation of Nelson was until recent years believed to be a death mask. Three versions of the mask are known, but there is no contemporary reference to a mask being taken after Nelson's death. It is now thought almost certain that this is a cast of Nelson's face taken during his lifetime. It is recorded on an 1805 engraving by P. W. Tomkins that when Nelson was in Vienna in the

Autumn of 1800, he permitted a cast of his face to be taken by the sculptor Franz Thaller. It is therefore likely that the life masks are related to the marble bust completed by Thaller and Ranson in 1801. Nelson does not appear to have mentioned undergoing this process, but Sir William Beechey, the artist, referred to one occasion when Nelson's face was being cast for a bust and '*he pursed up his chin and screwed up his features when the Plaister was poured on it*'. (Birmingham Assay Office)

The life mask still has its matrix in two sections, also at Greenwich. The mask shows the hair, added by modelling, parted in the centre, and has the eyes open. There are two other examples of this mask in existence. The mask at Portsmouth shows the eyes closed, and another example in a private collection has them open.

PROVENANCE
The early history is uncertain. The mask is said to have been made for Nelson's sister Mrs Catherine Matcham by Dr Beatty after Nelson's death, but this is now discredited. It is then supposed to have passed to her son-in-law, Captain Blanckley, whose first wife was Miss Harriet Matcham, a niece of Admiral Nelson. He married secondly Miss Naylor, who gave it to Charles Tasker, whose son J. C. Tasker loaned it to the RN Exhibition in 1891. It was subsequently sold to the Revd Hugh Nelson-Ward, who gave it to the NMM in June 1939. The third Earl Nelson did not believe in any of the 'death masks' and disputed the Matcham story.

EXHIBITED
1891: RN Exhibition, Chelsea, no. 3164, lent by J. C. Tasker.

1928: Loan collection of Nelson Relics, Spink's, no. 86, lent by Revd Hugh Nelson-Ward.

BIBLIOGRAPHY
Michael Nash, ed., *The Nelson Masks, Proceedings of the Symposium on the Nelson Masks*, 1993
Richard Walker, 'Nelson's Masks – Life or Death', *Mariner's Mirror*, Nov. 1980, pp.319–27
Richard Walker, *The Nelson Portraits*, pp.107–12, 232–3.

NMM, Nelson-Ward Collection, SCU0106

Portsmouth mask

See the entry for SCU0106 above. The Portsmouth mask has the eyes open, and the seam lines are very plainly visible.

PROVENANCE
Purchased as an authentic death mask by HM Queen Mary from an antique shop in the Isle of Wight in 1924 and presented by her to the Victory Museum at Portsmouth.

Royal Naval Museum, Portsmouth

Tourniquet

Petit-type tourniquet, believed to have been used when Nelson's right arm was amputated at Tenerife on 25 July 1797. The screw tightens a linen strop fastened around the limb to restrict the flow of blood during the operation.

Nelson was wounded in the arm by a musket ball while stepping out of the boat to land on the beach during the attack on the mole at Santa Cruz. He was rowed out to his ship the *Theseus*, where he was attended by the ship's surgeon Thomas Eshelby and his assistant Louis Remonier. Eshelby's fee was £36 and his assistant Remonier's was 24 guineas. Eshelby's journal entry reads: '*Compound fracture of the right arm by musket ball passing through a little above the elbow, an artery divided. The arm was immediately amputated and opium afterwards given.*' Nelson suffered phantom pains in his arm throughout his life following the amputation.

The medical journal of the *Theseus*, May 1797 to May 1798, is in the National Archives, and Dr Eshelby's records leave no doubt that he, assisted by Remonier, a French royalist refugee serving in the Royal Navy, was responsible for the amputation. The rival claim of another surgeon to have amputated Nelson's arm has already been examined in Chapter 5.

Science Museum, Wellcome Collection, on loan to NMM, ZBA2220

Combined knife and fork

Nelson used this combined knife and fork and other similar ones after the loss of his right arm at Santa Cruz on 25 July 1797. An inventory of Nelson's silver made in January 1801 lists '*1 silver fork & steel knife in case*' and '*steel & silver knife & fork in case*'. (NMM/BRP/14)

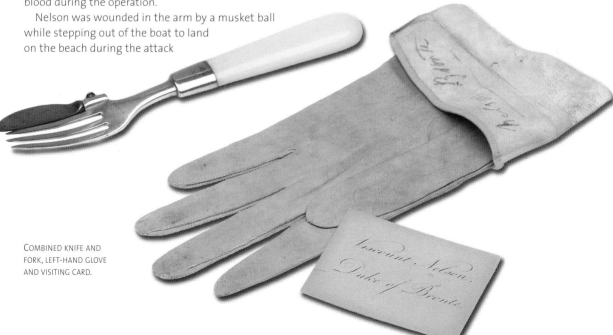

COMBINED KNIFE AND FORK, LEFT-HAND GLOVE AND VISITING CARD.

This example is a silver three-pronged fork with a separate steel blade attached by a screw alongside the prongs. The unmarked silver head is mounted in an ivory handle and is engraved on the back with a ducal coronet and initials 'NB'. It has a shaped silk-lined red leather case.

PROVENANCE
Captain Hardy is said to have given it to a friend, the grandfather of Colonel Henning of Frome House, Dorchester in c.1820, from whose family it was purchased in 1945. In 1905 Lady Wilson of Frome House lent it to the Nelson & Trafalgar Exhibition at Dorset County Museum.

Two other combined knife and fork sets belonging to Nelson are also known.
1. Lloyd's collection: ex RUSM no. 2068: '*Combined gold knife and fork, with steel edge. It was always used by Lord Nelson, after the loss of his right arm at Santa Cruz on 24th July 1797. It was presented to him by Countess Spencer, wife of Earl Spencer, First Lord of the Admiralty. At the sale of Lord Bridport's effects in 1895 it was purchased by Mr J A Mullens. Given by J A Mullens Esq.*' (1932 RUSM catalogue.) This one does not have a bone handle, and the back is engraved with an initial 'N' surmounted by a baron's coronet. Sold at Christie's Bridport sale 12 July 1895, lot 173 for £260 (illustrated in catalogue). Purchased by Lloyd's from the RUSM from a bequest by G. J. Egerton in September 1962.
2. Private collection: previously loaned to RUSM, no. 3037: '*Combined knife and fork, used by Lord Nelson after the loss of his right arm. He had also a gold one for special occasions.*' (1932 RUSM catalogue.)

EXHIBITED
1891: RN Exhibition, Chelsea. No. 1925: '*Combined gold knife and fork, used by Admiral Lord Nelson. Lent by General Viscount Bridport, Duke of Bronte KCB.*' No. 1931: '*Combined knife and fork with coronets and initials N and B, used by Lord Nelson after the loss of his right arm. Lent by Miss G A Edwards.*' No. 1961: '*Well-worn knife and fork for one hand, formerly belonged to Admiral Nelson. Lent by W Eyre Matcham Esq.*'
1905: RUSI Exhibition of Nelson Relics. No. 3213: '*A combined knife and fork, for use with one hand. It was formerly the property of Lord Nelson. It was given in 1843 to Mr Hay, Admiralty Chemist, 64 High Street, Portsmouth, by Captain R Saumarez, RN. The*

present owner came into possession of it in March, 1859 (Lent by C Moorshead Esq.)'

NMM, RELO115

Two left-hand gloves

Fine kid-leather gloves, left hand only. The seams are hand stitched and a separate cuff stitched to the glove. One glove has the inscription '*Nelson Bronte*' written in ink inside the cuff, said to be in Lady Hamilton's hand.

PROVENANCE
Purchased by NMM from Viscount Bridport 1978 (previously loaned). From the same collection came Lord Nelson's ivory and wood glove stretcher, RELO151.

NMM, Bridport Collection, TXT0380 (inscribed), TXT0375

Fatal musket ball

The lead ball which killed Nelson is mounted in a gold, silver and crystal locket.

Nelson's death at the Battle of Trafalgar was recorded in great detail by William Beatty, the *Victory*'s surgeon. Towards the end of the action Nelson was wounded by a musket ball, believed to have been fired from the mizzen-top of *La Redoutable*, which entered his left shoulder. He was carried to the *Victory*'s cockpit, where he died, every stage and word he spoke being noted and described by the surgeon in his *Authentic Narrative of the Death of Lord Nelson* (1807).

Beatty also records the autopsy which he carried out on 11 December 1805, after the arrival of Nelson's body at Spithead: '*It was at this time that the fatal ball was discovered; it had passed through the spine, and lodged in the muscles of the back, towards the right side, and a little below the shoulder-blade. A very considerable portion of the gold lace, pad, and lining of the epaulette, with a piece of the coat, was found attached to the ball; the lace of the epaulette was as firmly so, as if it had been inserted into the metal while in a state of fusion.*'

The artist William Devis, then on board *Victory*, drew the spherical musket ball with the portion of epaulette as it appeared when it was extracted from the body. Devis's drawing of the ball and his subsequent drawing of the locket were included as engravings in Beatty's published narrative of 1807.

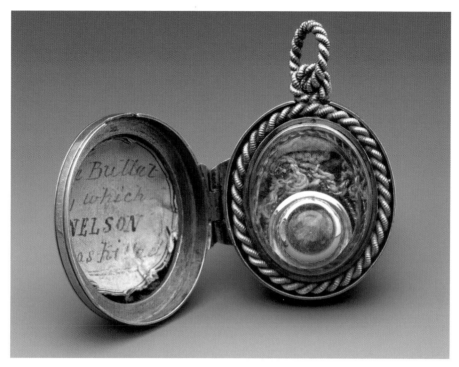

THE MUSKET BALL THAT KILLED NELSON, MOUNTED IN A LOCKET.

PROVENANCE

Sir Thomas Hardy had the ball set in a crystal locket, framed in gold rope-twist and contained in a silver outer case, which he presented to Beatty. Beatty's descendants presented the locket containing the musket ball to Queen Victoria, and ever since it has remained in the Royal Collection at Windsor Castle, only occasionally being lent for public display. See John Munday, 'The Nelson Relics' in *The Nelson Companion*, 1995, pp.68–9.

EXHIBITED

1891: RN Exhibition, Chelsea, cat. no. 3319. Lent by HM the Queen.
1995: Nelson Gallery, NMM.
2005: *Nelson & Napoléon* exhibition, NMM.

Royal Collection, H. M. The Queen

Nelson's pigtail

In the Nelsonic period sailors often wore their back hair long and bound as a queue or pigtail, dressed, with tar as a pomade. Nelson wore his own hair in this manner, and was depicted in contemporary paintings, sculptures, plaques and medallions with a long queue tied with a ribbon. Nelson's pigtail still survives, having been cut off after his death at Trafalgar. It is of sandy-coloured hair, bound with a black ribbon, which is tied in a bow.

William Beatty, the *Victory*'s surgeon who attended Nelson's death, recorded Nelson's words in his *Authentic Narrative of the Death of Lord Nelson* (1807): '*I am a dead man, Hardy, I am going fast: it will be all over with me soon. Come nearer to me. Pray let my dear Lady Hamilton have my hair, and all other things belonging to me.*'

Beatty goes on to record that after Nelson died, the pigtail was cut off before the body was placed in a large cask of brandy for preservation. After the *Victory*'s arrival in England, Hardy delivered the hair to Emma Hamilton as Nelson had requested. A number of other small locks of Nelson's hair were given to relations, close friends and mourners, some of the hair being mounted in rings and lockets. A few specifically claim to be from this pigtail and others are doubtless fakes. From the time of Nelson's

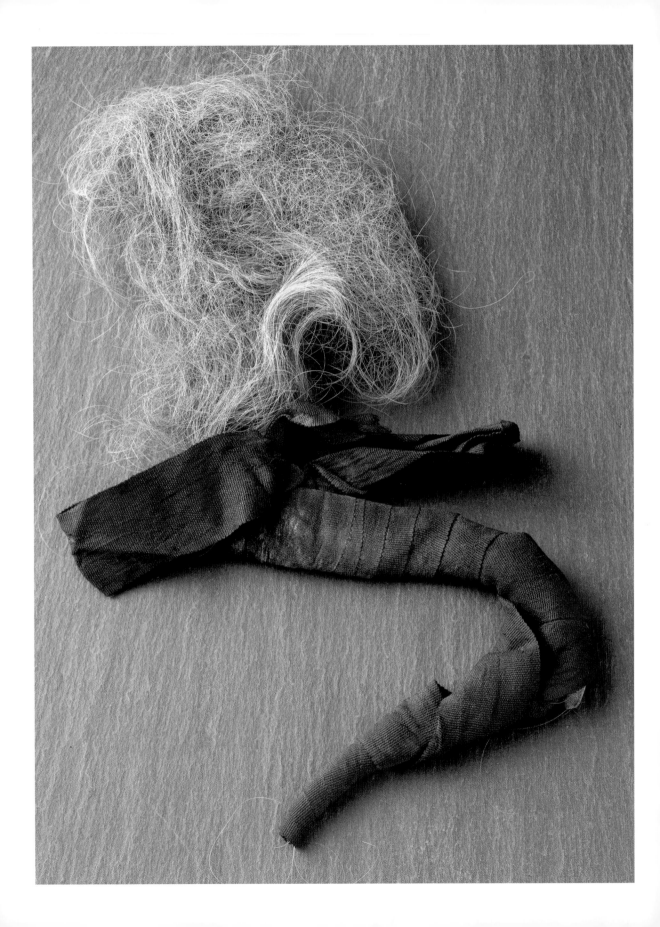

death locks of his hair were in great demand. Midshipman Richard Bulkeley, who had been in the cockpit while Nelson lay dying, wrote to Captain Thomas Bertie from the *Victory* on 12 December 1805: '*I regret extremely not to be able to send as much hair as I could wish, owing to my having sent away a greater part of it; but I trust you will find sufficient for a ring.*' (*Naval Chronicle*, quoted in Colin White, 'The Immortal Memory' in *The Nelson Companion*, 1995, p.17)

PROVENANCE
Admiral Hardy delivered the hair to Emma Hamilton, after whose death it passed to her daughter Horatia. It was presented to Greenwich Hospital by the children of Mrs Horatia Nelson-Ward, after her death in 1881, in accordance with her wish that it should be given to the nation. (NA/ADM/169/114)

EXHIBITED
1891: RN Exhibition, Chelsea, no. 3207
1905: RUSI Exhibition of Nelson Relics, no. 6003

NMM, Greenwich Hospital Collection, REL0116

Nelson's hair

In a letter to the Hon. George Rose of December 1805, Emma Hamilton enclosed a lock of hair folded in a paper, the watermark of which matches that of the letter. In her own handwriting she has labelled the paper 'Nelson's hair'. The enclosed lock of hair is tied at one end with white cotton, and is composed of a thick cluster of fine wispy light brown hairs, a shade darker than that of the pigtail. The letter accompanying the lock of hair is of particular interest as it also refers to the pigtail ('the other'), which by that time was in Emma's possession: '*I send you the enclosed which He sent to Horatia & I found today for I have not had Courage to open the other which Hardy brought me but next week I shall and as she will have part of it this I give to you as one whom he loved and respected.*'

George Rose had been a friend of Nelson, and was a man of political influence. This letter is part of a series sent by Emma in which she asks him to help promote her case for obtaining a government pension for herself and an allowance for Horatia.

OPPOSITE: NELSON'S HAIR, WORN IN A PIGTAIL, CUT OFF AFTER HIS DEATH.

PROVENANCE
Purchased by NMM at Sotheby's, January 1956.

NMM, Mss. No. LBK/50 Letter B

Nelson's hair

Glass-topped silver display box inscribed '*The hair of Admiral Viscount Nelson Duke of Bronte*', containing four separate pieces of sandy hair, one quite silky, the others more matted.

PROVENANCE
Purchased 1978 from the Rt Hon. Viscount Bridport (previously on loan).

NMM, Bridport Collection, REL0148

Bullion and hair

A short length of silver-gilt bullion from Nelson's Trafalgar uniform epaulette, with fair hairs entwined. Framed, with a handwritten paper: '*Lord Nelson's hair and the bullion cut from his epaulette by the fatal ball. From Capt. Williams 15 May 1843.*'

PROVENANCE
Presented to Lieutenant William Rivers by Captain Williams, son of Admiral Sir Thomas Williams (1762–1841). Sold in 1905 at Foster's Gallery to Mr Montagu (see *ILN* below), but was still in the Rivers family in 1939 when it was purchased via Spink's by the NMM together with other items.

BIBLIOGRAPHY
ILN, 1 July 1905, p.21: '*Nelson relics under the hammer: the Rivers Collection at Foster's Gallery. The collection of Nelson relics from which these examples were taken was made by Lieut. William Rivers, who was Nelson's aide-de-camp at Trafalgar. £125 was given by Mr Montagu for a lock of the Admiral's hair and the bullion cut from his epaulette by the French musket-ball.*'

NMM, REL0118

Nelson's hair

Lock of Nelson's hair tied with a blue ribbon. Mounted in a glazed gilt-framed locket together with a small piece of paper signed 'Nelson'.

PROVENANCE
Trafalgar House Collection. The signature is believed

to be from a letter written to his wife after losing his arm at Santa Cruz, Tenerife, in 1797, claimed to be the first letter with his left hand. It belonged to the Countess and was purchased from her granddaughter.

The hair is said to be part of the pigtail, and given by Nelson's niece Miss Bolton of Barnham, according to Earl Nelson in 1904.

Illustrated in third Earl Nelson's *The Nelson whom Britons Love*, c.1905.

NMM, Trafalgar House Collection, REL0117

NELSON'S FUNERAL

Funeral barge

Carvel-built boat of 35ft length and 6 ft 1in beam. Charles II's state barge, *c.1670*, decorated with a black velvet canopy, was used to convey Nelson's coffin in the grand river procession of City Livery Company barges from Greenwich to Westminster on 8 January 1806 on the way to the Admiralty, the day before his funeral at St Paul's Cathedral. Later displayed on the upper deck of HMS *Victory*.

Royal Naval Museum, Portsmouth, 1984-218

Figurehead from funeral carriage

This is part of the elaborate funeral carriage on which Nelson's body was conveyed in procession on 9 January 1806 from Whitehall, where it had rested overnight, to St Paul's Cathedral for the entombment. (See Nicolas, vol. VII, pp.399–418 for a detailed description of the funeral.) The funeral carriage was designed in the form of a ship, and this painted wooden figurehead depicts a winged figure symbolizing 'Victory' holding a laurel wreath in her outstretched right arm and a palm branch in her left. Her white classical robe is knotted around her waist, leaving her arms, breasts and feet bare. The figure has sometimes been described as that of 'Fame' (see below), but Fame's attribute is usually a trumpet.

With the figurehead are two tin gilt capital letters 'A' which originally formed part of Nelson's motto '*Palmam qui meruit ferat*' on the funeral carriage.

EXHIBITED
After Nelson's funeral the carriage was displayed for public viewing in the Painted Hall at Greenwich Hospital '*to perpetuate the memory of the deceased*' as the Admiralty instructed. The carriage was allowed to disintegrate, and Joseph Allen recorded in a footnote to his *Life of Nelson* (1853) that it was broken up and decayed '*about 1826*'. The Old Sailor (pseudonym of Matthew Henry Barker) wrote in *Tough Yarns* in 1835: '*Even the car that carried his body to its last moorings has been broken up as useless lumber, though I did hear that a gemman offered two thousand guineas for it. Some parts are down in the store rooms, and some has been burnt for fire-wood.*'
1928: Loan Exhibition of Nelson Relics at Spink's, London, item 2 & 124. Lent by the Revd Elphinstone Rivers.

PROVENANCE
This was part of a collection of Nelson relics (including Nelson's Nile medal, hair and bullion from his epaulette, silver shoe buckle and the Union Flag which covered the coffin), owned by Lieutenant William Rivers (1788–1856), Nelson's aide-de-camp at Trafalgar and later Lieutenant and Adjutant of Greenwich Hospital. Spink's catalogue records that when the funeral carriage was dismantled by order of the Admiralty, the figurehead and two capital letters 'A' came into Rivers's possession while he was an official at the Hospital. According to the *ILN*, his descendants the Revd Elphinstone Rivers and Mr

LEFT: METAL LETTERS FROM THE FUNERAL CARRIAGE.
OPPOSITE: FIGUREHEAD FROM NELSON'S FUNERAL CARRIAGE.

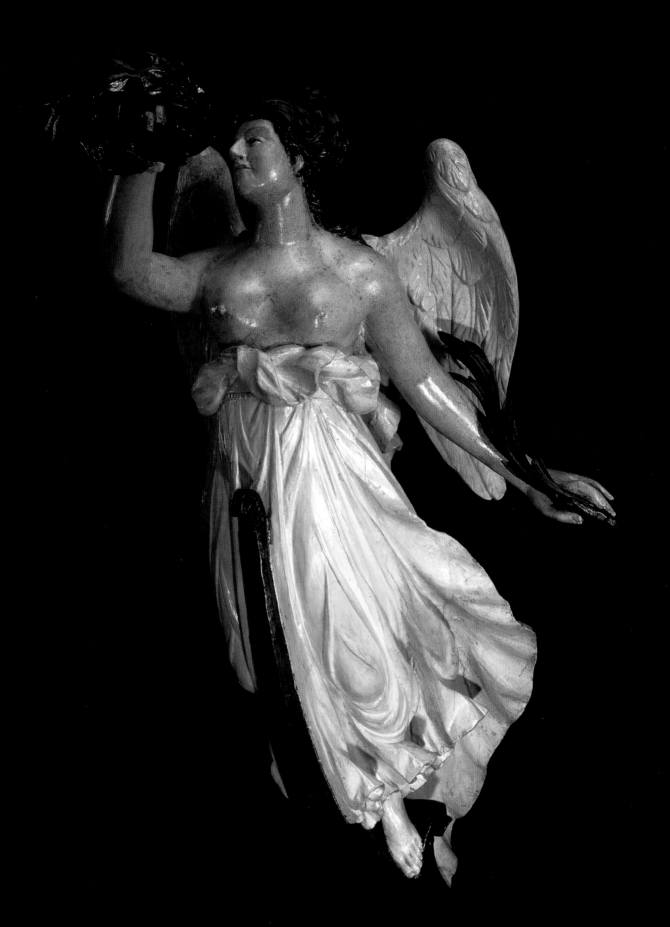

Stanley Rivers sold the collection by auction at Foster's Gallery in 1905, the figurehead fetching 20 guineas, but it still seems to have been in the family's possession in 1928. Purchased via Spink's, 1938.

BIBLIOGRAPHY
Naval Chronicle, Vol. XV, 1806, for a description of the funeral carriage, *'designed by and executed under the direction of the Rev. Mr M'Quin... its head towards the horses was ornamented with a figure of Fame'.*
ILN, 1 July 1905

NMM, FHD0093 & REL0177

ABOVE: NELSON'S FUNERAL HATCHMENT FROM THE FUNERAL CARRIAGE.

Funeral hatchment

Silk panel bearing Nelson's funeral hatchment on a black and white background, part of his funeral-carriage embellishments. One of six hand-painted heraldic silk panels on the sides of Nelson's funeral carriage.

The escutcheon depicts Nelson's marital arms surmounted by a viscount's coronet, on a black and white background. Nelson's arms are in an oval shield on the dexter side, surrounded by the motto of the Order of the Bath, and on the sinister side, his arms impale those of Woolward. Lady Frances Nelson was the daughter of William Woolward, Senior Judge on the island of Nevis, but they did not have their own coat of arms, until by patent of Sir

Isaac Heard, Garter King of Arms, dated 20 December 1805, arms were granted as *'barry of six azure and argent three stags' heads caboshed or on a chief erminois a Talbot passant sable between two pheons gules'*. (Coll. Arm Grants 23 250)

PROVENANCE
Sold Spink & Son Ltd, 18 March 1997, lot 134. Said to have been the property of the Revd Dr Scott, chaplain of the *Victory* at Trafalgar. The arms were found in Australia. The vendor's forebear Dr Charles Davies (d. 1888), a collector, acquired the hatchment before emigrating to Australia in February 1840.

Sold again by Dreweatt Neate Fine Art Auctioneers, Berkshire, 23 October 2002, lot. No. 18.

Unknown private collection

Funeral drape

Semi-circular section of the black velvet drape decorating the lower side of Nelson's funeral carriage, with gold metal lettering 'Trafalgar'.

PROVENANCE
Given to the Shipwrecked Sailors Home by Captain Rivers RN in 1861. This suggests it is from the same source as the other figurehead fragments.

Great Yarmouth Museums

Canopy fragment

Small fragment of crimson damask material with an acanthus-leaf pattern, said to be from the canopy that covered Lord Nelson's coffin at his funeral. It may be part of the red pall thrown over the coffin when it was received on the bier at St Paul's, as described in John Fairburn's edition of *The Funeral of Admiral Lord Nelson* (1806).

PROVENANCE
Given by Miss Douglas, daughter of Admiral Douglas, to Austen Chamberlain, who gave it to Greenwich Hospital.

A larger fragment of identical material in a private collection has the same story.

NMM, Greenwich Hospital Collection, TXT0376

Laurel wreath

Portion of a painted copper artificial-laurel wreath, which was placed on Nelson's coffin in the barge conveying his body from Greenwich to Whitehall on 8 January 1806.

PROVENANCE
Donated to the RUSM, Whitehall, together with Nelson's foul-weather cocked hat, by Mr J. N. Powell.

EXHIBITED
1905: Exhibition of Nelson Relics, RUSI, cat. no. 94, with illustration.

Private collection. On loan to NMM 1995-2005, ZBA1355

Memorial rings

Memorial rings were distributed by the executors William, Earl Nelson and J. Haslewood, for Nelson's close friends and relatives to wear at the funeral. The gold rings had an enamelled bezel decorated with a viscount's and a duke's coronet with the initials 'N' and 'B', for Nelson and Bronte, and *Trafalgar*, all on a black enamel ground. The hoop of the ring is inscribed with Nelson's motto *'Palmam qui meruit ferat'*. The rings were made by John Salter of the Strand, London, Nelson's jeweller, and presented in a red morocco case lined with silk, with the maker's label inside. George Matcham, Nelson's young nephew, wrote in his journal for 1805: *'NB On*

NELSON MEMORIAL RINGS AND BROOCH WITH HIS HAIR.

Tuesday 25th [November] *Colonel Coehoon came down from London.... Brought down my Mourning ring. Very handsome.'* Then on 7 January, *'Went to Mr Salters about the mourning swords.'*

Lord Nelson's executors distributed the rings to at least fifty-eight recipients, including thirty-one of his relations. Several of the rings were lent to the 1891 RN Exhibition, Chelsea, and the names of the lenders provide a useful reference source. Memorial rings were also lent to the 1905 Nelson Centenary Exhibition at the RUSI and to the 1928 Nelson Relics Exhibition at Spink's. The whereabouts of at least twenty-eight of the rings are known today; several of them are in private hands, in seven cases with descendants of the recipients. Of those in public collections, four are at Greenwich, one at the British Museum, one at the Victoria & Albert Museum, two at the RNM Portsmouth, one at Lloyd's, one at Birmingham Museum and one at the Castle Museum, Norwich. However, two or possibly three were lost in the Monmouth Museum robbery of 1953. The ring presented to the Revd Dr Scott, Nelson's chaplain, passed to his daughter Mrs Gatty and her descendants the Scott-Gattys, but was lost in an air raid on Exeter in World War II.

BIBLIOGRAPHY
BM/Add. Mss no. 34988. Lists the 58 recipients of rings sent out by Earl Nelson, including Thomas Bolton.
Notes & Queries 11th Series, Vol. XII, 6 Nov. 1915, pp.361–2. Reprints the above list.
George A. Goulty, 'Nelson's Memorial Rings', *Genealogist's Magazine*, June 1990, provides a detailed account of his research into the history, sale, exhibition and present locations of these rings.

Thomas Bolton's ring

One of four Nelson memorial rings in the NMM. (The others were John Franklin's, one from the Nelson-Ward Collection, and one from the Walter Collection.)

The inside of the ring is inscribed: *'Lost to his Country 21 Octr 1805. Aged 47.'* Although the ring resembles the usual Nelson memorial rings, the bezel is hinged on one side and opens to reveal plaited hair under the glass. Others are known, and the RNM Portsmouth has a similar ring containing hair among its examples.

PROVENANCE
Worn at the funeral by Thomas Bolton, Nelson's nephew and later second Earl Nelson. Family tradition says that he lost the ring the day after the funeral, and that it was found by the gardener forty years later.

Purchased by the NMM in 1948 from the Trafalgar House Collection.

NMM, Trafalgar House Collection, JEW0167

Memorial ring

Gold and enamel memorial ring as above, but without the hair inside the bezel. The hoop is inscribed *'Palmam qui meruit ferat'*.

PROVENANCE
Nelson-Ward Collection.

EXHIBITED
1891: RN Exhibition, Chelsea, cat. no. 3370: *'Memorial ring of Lord Nelson lent by Mrs H Nelson Nelson-Ward.'*

NMM, Nelson-Ward Collection, JEW0166

Franklin's ring

Gold and enamel memorial ring, a variation of the usual form. The bezel is made in one piece with the hoop, and the whole decorated with black enamel. The bezel has initials 'N' and 'B', below coronets, surrounded by the legend *'Gloriously fell on 21st October 1805'* and inscribed around the hoop *'In the action with the combined fleets of France and Spain.'* There is no inscription inside.

PROVENANCE
Originally the ring of John Franklin (1786–1847), later Sir John, Arctic explorer, who served in the *Bellerophon* as a signal midshipman at Trafalgar and attended Nelson's funeral, although his name does not appear on the list of rings distributed by the executors.

Descended through the Franklin family until 1932, when it was bequeathed to Greenwich by Mrs Edith Jane Burton. Franklin's widow had left the ring to Mrs Burton's brother.

EXHIBITED
1891: RN Exhibition, Chelsea, cat. no. 19A. Lent by Mrs F. L. Franklin of Grantham.

NMM, JEW0163

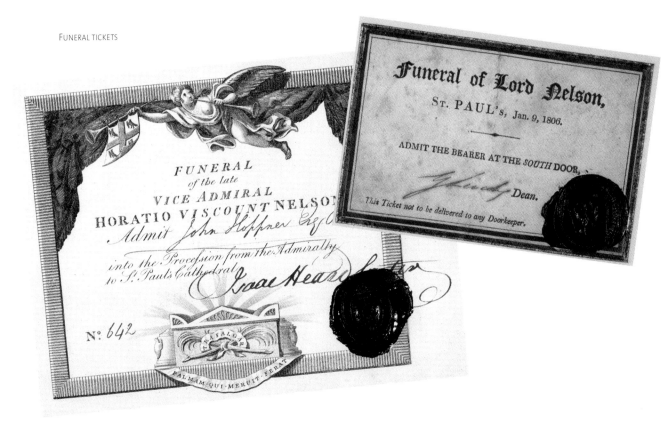

Funeral tickets

Two types of funeral tickets were printed for the occasion. The larger of the two was the ticket for the procession. The smaller was for admittance to St Paul's Cathedral for the interment. Both types of ticket were signed and sealed with black wax to prevent forgery. Because so many tickets were issued, they still appear in the salerooms from time to time, and examples are to be found in the collections of many museums. The Revd Dr Scott's ticket to the procession was sold in April 1995.

A typical example of each type of ticket is described below.

Procession ticket

Numbered ticket for Nelson's funeral procession, issued to the artist John Hoppner (1758–1810), who had painted Nelson's full-length portrait 1800–1. The ticket depicts Fame with her two trumpets and a tomb with crossed palm branches. There is a black wax seal impression of Sir Isaac Heard, Garter King

of Arms, and the ticket is printed: '*Funeral of the late Vice Admiral Horatio Viscount Nelson. Admit into the procession from the Admiralty to St Paul's Cathedral.*' The name and number of the ticket is written in ink: '*John Hoppner Esq. RA; No 642*' as well as the signature of Isaac Heard.

'Trafalgar' and Nelson's motto '*Palmam qui meruit ferat*' appear on the tomb.

NMM, REL0788

St Paul's Cathedral ticket

A small white card, black-bordered and printed in black with: '*Funeral of Lord Nelson. St Paul's, Jan. 9, 1806. Admit the bearer, at the South Door. G Lincoln* [signed in ink] *Dean. This ticket not to be delivered to any Doorkeeper.*'

Other tickets included more specific locations in the cathedral, such as the galleries under the dome or the galleries in the great nave. Signed by hand and sealed with a black wax seal.

The tickets for St Paul's were evidently difficult to

obtain. Nelson's nephew George Matcham reported in his journal that Sir Charles Malet 'wanted a ticket for St Paul's, but Papa could not procure him one'.

John Fairburn, in his *Funeral of Lord Nelson* (1806), wrote: '*The dawn had scarcely appeared, when every avenue to it [St Paul's] was crowded with those who had tickets of admission to the interior of the church, as well as those who were only curious to see them on their way thither.*'

NMM, REL0143

BELOW: SPANISH ENSIGN THAT WAS DISPLAYED AT NELSON'S FUNERAL IN ST PAUL'S AND AN AQUATINT AFTER A. C. PUGIN (OPPOSITE).

Victory's ensign

Framed section of wool bunting from the ensign torn by sailors of the *Victory* who had carried their ship's flags in procession during Nelson's funeral. The fragment includes part of the red, white and blue hand-sewn sections from the canton of the ensign.

The *Naval Chronicle* of 1806 reported: '*The Comptroller, Treasurer and Steward of his Lordship's household then broke their staves, and gave the pieces to Garter, who threw them into the grave, in which all the flags of the Victory, furled up by the sailors were deposited – These brave fellows, however, desirous of retaining some memorials of their great*

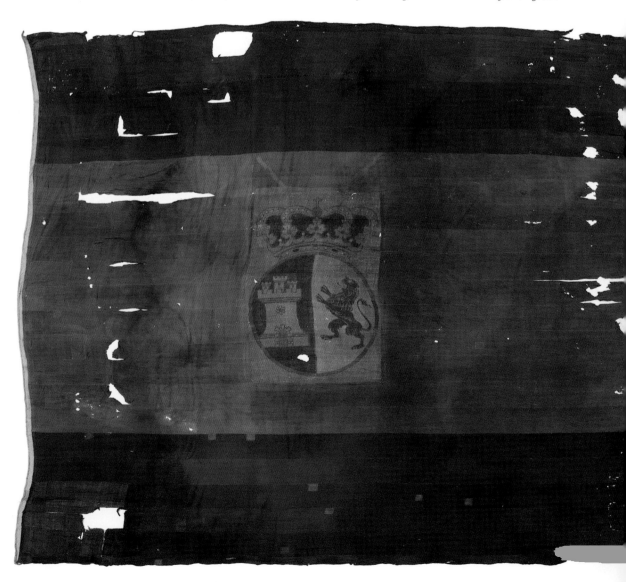

and favourite Commander, had torn off a
considerable part of the largest flag, of which most
of them obtained a portion.'

Small fragments of material said to be from this same flag continue to appear from time to time in the salerooms. Some clearly do not match the weave of the pieces believed to be authentic, but others appear to have a reasonable provenance and provide a match with the fabric of the original. On 28 September 2004, lot 117 at Bonhams in London, two 10cm-long strips of blue and white cloth from the *Victory*'s ensign, part of the Enys collection of manuscripts, sold to a collector for £47,800.

NMM, AAA0924

Royal standard

Only surviving quarter of the silk Georgian royal standard that draped the leaguer in which Nelson's body was conveyed to England in the *Victory*. This is the third quarter of the standard, painted with the harp of Ireland with the 'winged lady' design.

PROVENANCE
One of the Nelson relics in the possession of the Girdlestone family. Taken to South Africa by Nelson Girdlestone (1826–1912), first cousin of the third Earl Nelson, and after his death passed to his daughter Mrs Armine Atherstone, who presented it to the Royal Naval College at Greenwich in 1927. Repaired by the Victoria & Albert Museum and displayed in the Nelson Room of the Royal Naval Museum at Greenwich.

NMM, AAA0949

Spanish ensign

Very large Spanish naval ensign captured from the Spanish warship *San Ildefonso* at Trafalgar. The flag was hung in St Paul's Cathedral during Nelson's funeral service. The design of three horizontal red, yellow, red stripes with the arms of Castile and Leon was in use after 1785.

PROVENANCE
Presented to the Royal Naval Museum, Greenwich, by the Dean and Chapter of St Paul's in 1907.

NMM, Greenwich Hospital Collection, AAA0567

This is the last will and testament of me Horatio Viscount Nelson of the Nile and of Burnham Thorpe in the county of Norfolk and united kingdom of Great Britain and Ireland and Duke of Bronte in the kingdom of Farther Sicily First in the event that I shall die in England I direct my executors hereinafter named (unless His Majesty shall signify it to be his pleasure or that my body shall be interred elsewhere) to cause my body to be interred in the parish church of Burnham Thorpe in the county of Norfolk aforesaid near the remains of my deceased father and mother and in as private a manner as may be And I direct that the sum of one hundred pounds shall be divided amongst the poor of the several parishes of Burnham Thorpe (aforesaid) Sutton and Norton all in the county of Norfolk that is to say one third part thereof to the poor of each of the said parishes the same to be distributed at the discretion of the respective curates or officiating ministers of those parishes and in such manner and in such proportions and to such objects as they respectively shall think fit And I give and bequeath to Emma Lady Hamilton widow of the right honourable Sir William Hamilton knight of the most honourable order of the Bath my diamond star as a token of my friendship and regard I likewise give and bequeath to the said Emma Lady Hamilton the silver cup marked E.H. which she presented to me I give and bequeath to my brother the reverend William Nelson doctor in divinity the gold box presented to me by the city of London Also I give and bequeath to the said William Nelson the gold sword presented to me by the captains who fought with me at the battle of the Nile Also I give and bequeath to my sister Catherine Matcham the sword presented to me by the city of London Also I give and bequeath to my sister Susannah Bolton the silver cup presented to me by the Turkey Company Also I give and bequeath to Alexander Davison of St. James's Square in the county of Middlesex esquire My Turkish Gun Scymetar & Canteen Also I give and bequeath to my late captain and worthy friend Captain Hardy all my telescopes and sea glasses and One

Nelson & Bronte

Horatio Nelson
Wm. Haslewood Jun.
Henry Fletcher

(1)

APPENDIX 1

EXTRACTS FROM LORD NELSON'S WILL DATED 10 MAY 1803

NB Only those passages which include references to objects owned by Nelson appear below.[1]

… And I give and bequeath to Emma Lady Hamilton, widow of the Right Honourable Sir William Hamilton, Knight of the Most Honourable Order of the Bath, my Diamond Star, as a token of my friendship and regard; I likewise give and bequeath to the said Emma Lady Hamilton the Silver Cup marked E. H., which she presented to me. I give and bequeath to my brother the Reverend William Nelson, Doctor in Divinity, the Gold Box presented to me by the City of London. Also I give and bequeath to the said William Nelson the Gold Sword presented to me by the Captains who fought with me at the Battle of the Nile. Also I give and bequeath to my sister Catherine Matcham, the sword presented to me by the City of London. Also I give and bequeath to my sister Susannah Bolton, the Silver Cup presented to me by the Turkey Company. Also I give and bequeath to Alexander Davison, of St. James's-square, in the County of Middlesex, Esquire, my Turkish Gun, Scymetar & Canteen. Also I give and bequeath to my late Captain and worthy friend Captain Hardy, all my Telescopes and Sea Glasses, and one hundred pounds in money, to be paid three months after my death. And I give and bequeath the sum of one hundred pounds to each of my executors, hereinafter named, to be paid or retained at the end of three months from my death. And I give and bequeath to my before-named brother, William Nelson, and William Haslewood, of Craven-street, in the Strand, in the County of Middlesex, Esquire, all the residue and remainder of my goods, chattels, and personal estate, whatsoever, and wheresoever, (except the household goods and furniture, wines, plate, china, linen, pictures and prints, which shall be in my house at Merton, at my decease, and also except my diamond sword and jewels, hereinafter bequeathed, and also except any other articles which I do, or shall, or may by this my Will, or by any Codicil or Codicils hereto, otherwise bequeath and dispose of).

… And I give and bequeath the diamond-hilted Sword given to me by His said Sicilian Majesty, the diamond Aigrette presented to me by the Grand Signior, my Collar of the Order of the Bath, Medals of the Order of St Ferdinand and Insignia of other Orders, to the said William Nelson and William Haslewood, in trust that the same may be held as or in the nature of heirlooms as far as the rules of law and equity will permit, and belong to and be taken and enjoyed by the person or persons respectively, who under or by virtue of the limitations contained in this my Will, shall for the time being be entitled to the possession of my real estates in the Kingdom of Farther Sicily, or the lands and hereditaments to be purchased and taken in exchange in lieu thereof under the provisions hereinbefore contained.

…And I give and bequeath all the household furniture, implements of household, wines, plate, china, linen, pictures, and prints, which shall be in and about my house at Merton at my decease, and not otherwise disposed of by this my Will, or any Codicil or Codicils which I may hereafter make, to the said Emma Lady Hamilton for her own use and benefit.

… Signed, sealed, published, and declared by the Right Honorable Horatio Viscount Nelson and Duke of Bronte, as and for his last Will and Testament.

1 The full text of Nelson's will was published in Sir Nicholas Harris Nicolas, *The Dispatches and Letters of Lord Nelson*, vol VII, 1846, pp.ccxxi–ccxxxiii. The original will is in the National Archives at Kew, and there is a signed duplicate in the NMM, Greenwich (BRP/19).

APPENDIX 2

LLOYD'S PRESENTATION SILVER

Inventory of sundry Plate belonging to the
Right Honble Lord Viscount Nelson furnished
by Rundell & Bridge November 1800.[1]

10 oval dishes	Weight 703oz	7 dwt
4 round do.	119	19
4 oblong do.	230	4
4 deep Cassarole	136	16
4 Comport & Covers	254	
1 Tureen & Cover to match	128	6
8 Sauce Boats to suit	170	12
8 Salts to do.	35	16
2 Oval Vegetable dishes	178	8
4 polishd Ice pails	307	
1 Tureen Ladle	6	6
8 Sauce Ladles to weight	15	3
8 Sauce Ladles	3	1
6 doz Pad plates	1287	19
18 Soup Plates	363	19

This manuscript in the Nelson papers at the British Museum acquired in 1896 lists the presentation plate presented by Lloyd's, but appears to have been dated incorrectly. According to the number of items listed, it is almost certain that this manuscript relates to both the Nile and the Copenhagen awards, and therefore could not have been drawn up in 1800 as the title states. It also gives Nelson the title of Viscount, which was not conferred on him until May 1801, after the Battle of Copenhagen. The Nile plate was not delivered to Nelson until April 1801.

On 24 January 1801 Nelson wrote to Alexander Davison: '*My plate from Rundell and Bridge is not arrived.*'[2] On 14 February he followed this up with: '*I shall take my plate with me; sink or swim it goes with me.*'[3] It didn't. However, on 22 April, Davison was able to write to Nelson from London: '*Your plate at Rundell's is finished and a complete case making to contain the whole.*'[4]

1 British Museum Add. Mss. 34,990, fo. 7. Transcribed in *The Nelson Collection at Lloyd's*, ed. Warren R. Dawson, 1932, pp.4-5.
2 Nicolas, Vol. VII, p.cxcix
3 Ibid. p.cci
4 Pettigrew, *Memoirs of the Life of Vice Admiral Lord Viscount Nelson*, 1849, Vol. II, p.43

APPENDIX 3

CHAMBERLAIN'S WORCESTER PORCELAIN SERVICE

Nelson's order made during his visit to Chamberlain's Worcester factory on 26 August 1802, taken from the factory books, has been transcribed below. The items listed include a breakfast, dessert and dinner service, but only the breakfast service was completed in his lifetime. It is thought that the two vases and the cup and saucer at the end of the list may be items known to be in private collections, but the descriptions are insufficiently detailed to identify them for certain. On 17 January 1806, a few days after Nelson's funeral, Emma was sent the bill for the breakfast service plus four 10-inch dishes and one 12-inch dish at a total cost of £120 10s 6d.

The Right Hon. Lord Nelson, Duke of Bronte No. 23, Piccadilly, opposite the Green Park

No 240 With the Arms of several orders confer'd

12 Large breakfast cups and saucers
12 Small ditto
12 Coffees and saucers
2 Slop basons
4 B & B plates [bread & butter]
2 Water ditto and covers
2 Sugar Boxes
2 Teapots and stands
2 Milks
12 Cake plates 2nd [size]
5 Small dishes
6 Egg cups
6 Drainers
2 Butter tubs
2 Beehives [for honey]
6 Chocolates [cups] *2 handles, covers and stands*

1 Complete Dinner Service
1 Complete Desert with Ice pails &c &c.
1 Elegant Vase, richly ornamented with a miniature of his Lordship, supported by a figure of Fame &c.
1 ditto, with a likeness of Lady Hamilton.
1 Cup & saucer, ditto.

Written down the side of the order is:
'1 ink stand 31/6
1 breakfast cup & saucer 21/-
240 sent with Mrs Duncan'

After the visit to the factory, the party went to the Town Hall, where Nelson was presented with the freedom of the City *'in a richly ornamented vase made by Messrs. Chamberlain'*. Unfortunately neither the appearance nor the present whereabouts of this vase are known.

NOTES

Chapter 1

1 NMM/BRP/14

2 BL/Add.34990 fo.15

3 Alfred Morrison, *Autograph Letters: Hamilton & Nelson Papers*, 1894, Vol. II, Appendix B

4 *Naval Chronicle*, Vol. III, April 1800, 'Biographical Memoir of the Rt Hon. Lord Nelson of the Nile', pp.187–8. (A version of the list of 'Presents received for my services in the Mediterranean' compiled by Nelson. See J. S. Clarke & J. M'Arthur, 1809, Vol. II, p.480, Appendix 5.)

5 Quoted in Richard Walker, *The Nelson Portraits*, 1998, p.128

6 *Naval Chronicle*, Vol. XIV, 1805, pp.474–5

7 *Memoir of the Life and Services of Sir J. Theophilus Lee*, published for the author, 1836, p.175

8 Full description in N. H. Nicolas, *Dispatches & Letters of Lord Nelson*, Vol. III, pp.88–9

9 Part of lot 23 in Sotheby's Davison sale of 21 October 2002

10 BL/Add.34990 fo.10

11 *Autobiography of Miss Cornelia Knight, Lady Companion to the Princess Charlotte of Wales*, 1861

12 BL/ Add.34990 fo.10

13 Charles Heath, *Proud Days for Monmouth: Descriptive account of the Kymin Pavilion, and Lord Nelson's Visit to Monmouth*, 1808, reprinted in facsimile 2002. The captured sword was actually Admiral Blanquet's.

14 M. Eyre Matcham, *The Nelsons of Burnham Thorpe*, 1911, p.201

15 See transcription of relevant passages of Nelson's will in Appendix 1

16 'List of Medals &c belonging to Lord Nelson', Huntington Library, California, HM34232

17 NMM/LBK/50B; see Catalogue section: Wounds & Death

18 BL/Add.34992 fo.52

19 Unpublished diary of Lionel Goldsmid, quoted in Paul Emden, *Jews of Britain*, 1943

20 Quoted in the catalogue of the Loan Exhibition of Nelson Relics at Spink's, 1928. In 1806 the fatal ball was in the possession of William Beatty.

21 Morrison, Vol. II, p.277

22 NMM/NWD/5 and NWD/37

23 *Bill of Sale. Assignment in Trust absolutely to sell – Lady Hamilton to Alderman J.J. Smith*, NMM Phillips Collection, PHB/P/23

24 Letter from Mrs S. F. Cadogan, 2 April 1815, quoted in Winifred Gerin, *Horatia Nelson*, 1970, p.213

25 NMM/TRA/22

26 NMM/NWD/34

27 NMM/TRA/26

28 NA/ADM169/114

29 NMM/NWD/32

30 NMM/37 MS. 1254. Transcribed in George Naish, 1958, *Nelson's Letters to his Wife*, p.616

31 *The Windsor Magazine*, October 1904, p.516

32 *The Windsor Magazine*, October 1903, pp.527–32

33 C. Beresford & H. W. Wilson, *Nelson & His Times*, 1897–8

34 M. Eyre Matcham, *The Nelsons of Burnham Thorpe*, 1911

35 NMM, Callender correspondence, Girdlestone, 1935

36 See Chapter 4 (Thefts)

37 BL/SC1517, Davison sale catalogue, 21 April 1817

Chapter 2

1 *A Catalogue of the Elegant Household furniture… the property of a Lady of Distinction*, 1813–14, NMM/PBB7683

2 Thomas Joseph Pettigrew's *Memoirs of the Life of Vice-Admiral Lord Viscount Nelson* was published in 1849.

3 This and some of the other catalogues mentioned in this chapter are with the Nelson-Ward manuscripts in NMM/NWD/32.

4 *Country Life*, 11 April 1952, p.1093

5 NA/ADM169/189

6 *The Illustrated London News*, 1 July 1905, p21

7 See Westphal's account of how he acquired this, quoted in the catalogue entry for the Trafalgar coat.

8 *The Times*, 1 May 1936, and *The Morning Post*, 1 May 1936

9 *The Times*, 5 November 1937

10 Christie's, 17 November 1965, lot 74

11 Sotheby's, *Sale of European Ceramics,* 30 January 1979, lot 122

12 Sotheby's, Sale of 22–23 February 1988, lot 686

13 Martyn Downer, *Nelson's Purse,* p.329

14 Earl Nelson, 'Nelson Relics and Relic Hunters', *The Windsor Magazine,* Vol. XX, Oct 1904, p.513

Chapter 3

1 Lily Lambert McCarthy & John Lea, *Remembering Nelson,* 1995

2 *Descriptive catalogue of portraits of naval commanders… and relics exhibited in the Painted Hall,* editions published in 1887, 1900, 1906, 1912, 1922

3 See Chapter 4

4 Edward Fraser, *Greenwich Royal Hospital & the Royal United Service Museum, c.*1910

5 See drawings of Nelson relics in the *Daily Graphic,* 20 October 1900

6 See Huw Lewis-Jones, 'Displaying Nelson: Navalism and the Exhibition of 1891', *Trafalgar Chronicle,* 2004, and Cynthia Fansler Behrman, *Victorian Myths of the Sea,* 1977

7 See Major L. Edye's review in the *RUSI Journal,* 1892, pp.555–575, and John Munday 'The Nelson Relics' in White ed., *The Nelson Companion,* pp.59–79

8 See *ILN,* 5 May 1928; *The Times,* 30 April and 11 & 12 May 1928; *Country Life,* 19 May 1928; *Nautical Magazine,* 1928, p.210

9 See Appendix 3

10 See Chapter 4

Chapter 4

1 Molyneux's report 10 December 1900. NA/ADM169/278. Quoted in full in Anthony Cross's account of the theft, *Trafalgar Chronicle,* 2003, pp.92-110

2 *The Times,* 11 December 1900, p.11

3 NA/ADM169/278

4 *The Times,* 12 December 1900, p.6

5 NA/ADM169/188, and May & Annis,1970, *Swords for Sea Service,* pp.55–56

6 *The Times,* 4 July 1904, p.7

7 *The Times,* 6 July 1904, p.12

8 *The Times,* 11 July 1904, p.2

9 *The Times,* 18 July 1904, p.15

10 *The Times,* 17 September, p.3

11 NA/ADM169/278

12 Anthony Cross will report more fully on William Carter's later story in the *Trafalgar Chronicle,* 2005. I am grateful for his generous sharing of research materials.

13 NA/ADM/169/926, which also has a useful resume of the William Carter story.

14 Charles Arrow, *Rogues and Others,* 1926, pp.131–136, reprinted in *Nelson Dispatch,* Vol. 7, pt 8, October 2001, pp.544-8

15 *The Times,* 16 May 1831, p.6

16 Edham Eldem, *Pride and Privilege: A History of Ottoman Orders, Medals & Decorations,* 2004, pp.16–31

17 Nicolas, *Dispatches & Letters,* Vol. IV, p.81

18 See Richard Walker, pp.278–82

19 NMM/PAD3990

20 Catalogue of the Exhibition of Nelson Relics, May to October 1905, RUSI, p.24, no. 3041

21 Catalogue of the loan exhibition of Nelson Relics, Professor Geoffrey Callender, 1928, p.38. no. 112

22 Society for Nautical Research, Annual Report, 1929, pp.37–44 and *The Times,* 8 Nov. 1929

23 *The Times,* 12 June 1951, p.4

24 *Country Life,* 24 August 1951

25 *ILN* 16 June 1951, p.992, and 23 June 1951, p.1037

26 Hansard, House of Lords, 26 June 1951

27 *Independent Magazine* 12 February 1994, pp.32–6

28 'The Underworld', BBC1, shown on 16 February 1994

29 See obituary in the *Independent,* 10 June 1997 and 14 June 1997

30 *The Times,* 13 September, 1865, p.9, col. 6

31 *Official Catalogue of the Royal Naval Exhibition,* 1891, p.330, no. 3098

32 George Nelson Godwin, *A History of the Nelson Guineas,* 1902

33 *The Times,* 11 November 1953, p.8

34 NA/ADM1/400/N246

35 Thomas Joseph Pettigrew, *Memoirs of the Life of V.A.Lord Viscount Nelson,* 1849, Vol. I, p.390; May & Annis, *Swords for Sea Service,* p.108-9

36 Illustrated in Beresford & Wilson, p.104

37 *The Times,* 4 December 1953, p.8

38 *The Times,* 30 March 1954, p.2

39 *The Times,* 8 July 1954, p.4

40 *The Times,* 5 April 1954, p.2

41 *The Times,* 15 April 1954, p.5

Chapter 5

1 *Royal Naval Exhibition: The Illustrated Handbook and Souvenir*, Pall Mall Gazette 'Extra' No. 56, June 1891, p.11

2 *The Times*, 22 May 1891, p.13

3 Ralph Edwards, *Shorter Dictionary of English Furniture*, 1964, p.114, and Andy McConnell, *The Decanter*, 2004, p.197

4 Illustrated in the *United Service Gazette Trafalgar Centenary Number*, 1905, p.46

5 NA/ADM169/354

6 *Naval Chronicle*, Vol. XIV, 1805, p.471

7 H. T. A. Bosanquet RN, *Naval & Other Swords in the Nelson Museum, Monmouth*, 1949. Unpublished manuscript, which can be consulted at the Nelson Museum, Monmouth, and the National Maritime Museum, Greenwich.

8 John Gore, *Nelson's Hardy and his Wife*, 1935, footnote p.4; May & Annis, *Swords for Sea Service*, p.107

9 Harold T. Wilkins, *Captain Kidd and his Skeleton Island*, 1935, pp.316–39

10 See *Antiques Trade Gazette*, 4 November 2000, and Sim Comfort, 'Let the Buyer Beware', in *Nelson Dispatch*, Vol. 7, Jan. 2002, pp.587–94

11 Capt H. T. A. Bosanquet RN, 'Lord Nelson & The Loss of his Arm' in *Mariner's Mirror*, Vol. 38, 1952, pp.184–94

12 Medical Journal of HMS *Theseus*, May 1797–May 1798, National Archives

13 Ed. C. Lloyd, *The Keith Papers*, Vol. II, 1950, p.168

14 Nicolas, Vol. I, p.480

15 Beatty, p.82

16 Matcham, *Nelsons of Burnham Thorpe*, p.213

17 Nicolas, Vol. IV, p.279. Thomas Trotter was Physician of the Fleet.

18 Naish, p.430

BIBLIOGRAPHY

The standard works on Nelson can be found listed in Leonard W. Cowie's *Lord Nelson 1758–1805: A Bibliography* (1990). A number of important Nelson titles have been published since then, and others commemorating the bicentenary of Trafalgar and Nelson's death are at present in the process of publication. Below are listed some of the works which are especially relevant to the theme of the present book. Other specific references have been included in the chapter endnotes and within entries in the catalogue section of this book.

Beatty, Sir William, *The Authentic Narrative of the Death of Lord Nelson*, 1807

Beresford, Lord Charles, and Wilson, H. W., *Nelson and his Times*, n.d., 1897–8

Binns, R. W., *A Century of Potting in the City of Worcester*, 1865

Bosanquet, H. T. A., Capt. RN, *Naval & Other Swords in the Nelson Museum, Monmouth*, 1949

Bosanquet, H. T. A., Capt. RN, *The Naval Officer's Sword*, 1955

Clarke, James Stanier & M'Arthur, John, *The Life of Admiral Lord Nelson KB from his Lordship's Manuscripts*, 2 vols, 1809

Dawson, Warren R., *The Nelson Collection at Lloyd's*, 1932

Downer, Martyn, *Nelson's Purse*, 2004

Eldem, Edhem, *Pride and Privilege: A History of Ottoman Orders, Medals and Decorations*, Istanbul, 2004

Fairburn, John, *The Funeral of Admiral Lord Nelson*, 1806

Fraser, Edward, *Greenwich Royal Hospital & the Royal United Service Museum*, n.d., c.1910

Fraser, Flora, *Beloved Emma, the Life of Emma, Lady Hamilton*, 1986

[Gatty, Alfred and Mrs]: *Recollections of the Life of the Rev. A J Scott, Lord Nelson's chaplain*, 1842, reprinted 2003

Gerin, Winifred, *Horatia Nelson*, 1970

Harrison, James, *Life of the Rt. Hon. Horatio Lord Viscount Nelson of the Nile*, 1806

Harvey, Anthony & Mortimer, Richard, eds, *The Funeral Effigies of Westminster Abbey*, 2003

Hibbert, Christopher, *Nelson: A Personal History*, 1994

Laughton, Sir John Knox, *The Nelson Memorial: Nelson & his Companions in Arms*, 1896

McCarthy, Lily Lambert & Lea, John, *Remembering Nelson*, 1995

Mackenzie, Robert, *The Trafalgar Roll*, 1913, reprinted 1969 & 2004

Marriott, Leo, *What's Left of Nelson*, 1995

Matcham, M. Eyre, *The Nelsons of Burnham Thorpe*, 1911

May, W. E., Capt. RN & Annis, P. G. W., *Swords for Sea Service*, NMM, 1970

Merwe, Pieter van der, ed., *Nelson, An Illustrated History*, NMM, 1995

Morrison, Alfred, *The Collection of Autograph Letters & Historical documents: The Hamilton & Nelson Papers*, 2 vols, 1893–4

Naish, George P. B., *Nelson's Letters to his Wife and other documents 1785–1831*, 1958

Nelson, Horatio, third Earl, *The Nelson whom Britons Love*, n.d., c.1905

Nicolas, Sir Nicholas Harris, ed., *The Dispatches and Letters of Vice Admiral Lord Viscount Nelson*, 7 vols, London, 1844–6, reprinted 1997

Oman, Carola, *Nelson*, 1947

Pettigrew, Thomas J., *Memoirs of the Life of Vice Admiral Lord Nelson*, 1849

Pocock, Tom, *Horatio Nelson*, 1987

Pugh, P. D. Gordon, *Naval Ceramics*, 1971

Pugh, P. D. Gordon, *Nelson and his Surgeons*, 1968

Sichel, Walter, *Life & Letters of Emma Hamilton*, 1905

Sugden, John, *Nelson, A Dream of Glory*, 2004

Vincent, Edgar, *Nelson, Love & Fame*, 2003

Walker, Richard, *The Nelson Portraits*, 1998

White, Colin, ed., *The Nelson Companion*, 1997

White, Colin, *The Nelson Encyclopedia*, 2002

White, Colin, *Nelson: The New Letters*, 2005

Exhibition & museum catalogues

Official catalogue of the Royal Naval Exhibition, Chelsea, 1891; also *Illustrated Souvenir*, and *Illustrated Handbook and Souvenir*

Naval and Military Exhibition, Crystal Palace, 1901

Naval & Military Exhibition, Portsmouth, 1902

Catalogue of the Exhibition of Nelson Relics, Royal United Service Institution, 1905

Naval-Shipping and Fisheries Exhibition, Earl's Court, 1905

Descriptive Catalogue of the Portraits of Naval Commanders…relics etc exhibited in the Painted Hall of Greenwich Hospital, 1887, 1900, 1906, 1912, 1922

Loan Exhibition of Nelson Relics in aid of the 'Save the Victory' Fund, Spink's, 1928

Official Catalogue of the Royal United Service Museum, 1932

Nelson & Napoléon: Catalogue of the National Maritime Museum's bicentenary exhibition, 2005

Sotheby's and Christie's sale catalogues

Journals & periodicals

The Naval Chronicle

The Gentleman's Magazine

The Times

The Illustrated London News

Country Life

The Mariner's Mirror (Journal of the Society for Nautical Research)

The Nelson Dispatch (Journal of the Nelson Society)

The Trafalgar Chronicle (Journal of the 1805 Club)

Journal of the Orders & Medals Research Society.

Silver Society Journal

Windsor Magazine, October 1903 (W. H. Hosking: 'The Nelson Room at Trafalgar') & October 1904 (Horatio, third Earl Nelson: 'Nelson Relics and Relic Hunters')

Pearson's Magazine, Nelson Centenary Number, October 1905

United Service Gazette Trafalgar Centenary Number, 1905

NELSON CHRONOLOGY

1758 29 September, Horatio Nelson born at Burnham Thorpe, Norfolk.

1767 26 December, death of mother Catherine Nelson.

1771 1 March first goes to sea as midshipman in the *Raisonnable*.
 August, to West Indies in a merchant ship.

1773 With *Carcass* to the Arctic, then sails to the East Indies with the *Seahorse*.

1775 Invalided home with malaria.
 War of American Independence.

1777 April, passes examination for lieutenant. With the *Lowestoffe* to the West Indies.

1778 September, lieutenant of the *Bristol*.
 December, commander of the *Badger*. brig

1779 June, promoted to post captain, in command of the *Hinchinbroke*.

1780 Nicaraguan expedition, invalided home and convalesces in Bath.

1781 August, appointed to command the *Albemarle*.

1782 April, North American station, Quebec, New York and West Indies.

1783 End of War of American Independence. Visits Boulogne.

1784 Appointed to command the *Boreas*. Sails to West Indies.

1786 ADC to Prince William Henry.

1787 12 March, marries Frances Nisbet at Nevis, West Indies. Lives ashore on
 half pay at Burnham Thorpe for five years.

1793 February, French Revolutionary War begins. Appointed to command the
 Agamemnon in the Mediterranean.
 September, first meets Sir William and Lady Hamilton at Naples.

1794 Corsican campaign. 12 July, right eye injured at siege of Calvi.

1795 14 March, Adm. Hotham's action. *Agamemnon* in action with the *Ça Ira*
 off Genoa.
 August, appointed commodore.

1796 June, joins the *Captain*, December, joins *La Minerve*.

1797 14 February, **BATTLE OF CAPE ST. VINCENT**, in the *Captain*.
 20 February, promoted to Rear-Admiral of the Blue
 17 March, created Knight of the Bath (27 May, notified in *London Gazette*)
 24 May, in the *Theseus*, commanding inshore squadron off Cadiz.
 24 July, attack on Santa Cruz, Tenerife. Right arm injured and amputated.
 August returns to England to recover in Bath and London.

1798 29 March, hoists flag in the *Vanguard* and commands squadron in the
 Mediterranean.
 1 August, **BATTLE OF THE NILE**, French fleet vanquished in Aboukir Bay.
 Recovers from head wound in Naples.
 6 November, created Baron Nelson of the Nile.
 13 December, receives *chelengk* from Sultan of Turkey.
 Evacuates Neapolitan royal family to Palermo.

1799 14 February, promoted to Rear-Admiral of the Red.
 Relationship begins with Emma Hamilton.

8 June, transfers flag to *Foudroyant*.

August, created Duke of Bronte by King of Naples

November, receives Order of the Crescent from Sultan of Turkey.

1800 May, receives Order of St Ferdinand.

July, returns to England via Vienna, Prague, Dresden and Hamburg.

6 November, lands in Yarmouth, then to London.

1801 1 January, promoted to Vice-Admiral of the Blue.

January, separates from wife.

Hoists his flag in the *San Josef*, in command of the Channel Fleet.

End of January, Emma Hamilton gives birth to his daughter Horatia.

12 March, sails in *St George* to Baltic with Admiral Sir Hyde Parker.

2 April, **BATTLE OF COPENHAGEN**, in *Elephant*.

22 May, created Viscount Nelson of the Nile and Burnham Thorpe.

July, returns to England, September buys Merton Place.

1802 April, receives Order of St Joachim.

25 March, Peace of Amiens.

26 April, death of father, Revd Edmund Nelson.

July to August, West Country tour with the Hamiltons.

1803 6 April, death of Sir William Hamilton.

16 May, Napoleonic War begins.

18 May, hoists flag in the *Victory*, as C-in-C Mediterranean.

1804 23 April, promoted to Vice-Admiral of the White, blockading the French in Toulon.

14 December, Spain declares war on Britain.

1805 April to July chases Villeneuve's French fleet to the West Indies and back.

18 August arrives in England. On leave at Merton.

14 September, rejoins the *Victory* and takes command of the fleet off Cadiz.

21 October, **BATTLE OF TRAFALGAR** and death of Nelson.

6 November, the news reaches England.

4 December, the *Victory* arrives at Portsmouth with Nelson's body.

11 December, Dr Beatty carries out autopsy.

1806 8 January, funeral procession on the River Thames.

9 January, state funeral in St Paul's Cathedral.

1809 Clarke and M'Arthur's *Life of Admiral Lord Nelson* published.

1815 15 January, death of Emma Hamilton.

1835 Death of William, first Earl Nelson.

1843 Completion of Nelson's Column and statue in Trafalgar Square.

1844 First volume of Nicolas's *Dispatches and Letters of Lord Nelson* published.

1845 Nelson's Trafalgar coat presented to Greenwich Hospital.

1881 Death of Nelson's daughter Horatia.

1891 Royal Naval Exhibition, Chelsea.

1895 July, Christie's sales of Nelson relics owned by Viscount Bridport.

1905 Trafalgar centenary celebrations and exhibitions.

INDEX

PICTURE ACKNOWLEDGEMENTS

National Maritime Museum, Greenwich

Images from the collection of the National Maritime Museum, Greenwich are listed below with their reproduction numbers. These may be ordered by writing to: Picture Library, National Maritime Museum, Greenwich SE10 9NF or online at www.nmm.ac.uk. All images copyright © National Maritime Museum, London

Pages: *2* PU4003; *11* PZ8788; *20–1* F4100; *24* C1184; *26* F4102; *29 (left)* E8764, *(right)* D4423 ; *33* F4101-2; *35* F4094-1; *36* F4101-3; *37 (top)* F4101-4; *37 (bottom)* F4101-5; *40* D7632; *49* PW4369; *55* F4091-2; *61* C1183; *67* F4096; *69* 3969; *72* D9469-84; *81* F4098; *83* F4104-1; *85* F4089; *88* F4105; *97* B9701-2; *100* 4468-1; *101* F2163.2; *102* F2148.3; *106* D7649-2; *110* C1182; *112* F3671; *113* D7569; *116* F4087; *118* F3832; *119* F4099; *121* D4626; *123* F4095; *124* F4088; *126* C3399; *129* D7636; *130* D5575-1; *131 (top)* D5828; *131 (bottom)* E9036; *134* E2053; *135 (top)* E1860; *135 (bottom)* F3701; *138* D4721; *140* D5950; *142 (left)* D0852.2, *(right)* D0852-1; *143* F4097; *144* D0852-29; *145* D5528; *147* E5799;

148–9 F4106-1; *151* F4107-1; *152* F3672; *153* D7555; *154* D7556; *156* F4121; *164* D6591-5; *165* D7379; *168* D3210; *170* D7567; *171* D5510; *173* D7389; *175* D7393A & B; *176–7* F4077.1; *177* B2019; *178* F4092

Illustrations are reproduced by kind permission of the following:

Copyright © Dean & Chapter of Westminster: *page 105*

© Dreweatt Neate Fine Art: *page 172*

© Museum of London: *page 161*

Nelson Museum, Monmouth: *pages 75, 91, 109, 120, 159*

Royal Collection © 2005 Her Majesty Queen Elizabeth II: *page 167*

Royal Naval Museum, Portsmouth: *pages 13, 127, 152, 159, 157*

Sotheby's Picture Library: *pages 44–5, 46*

Wilkins Collection, Greenwich: *page 65*

Worcester Porcelain Museum, Worcester: *page 95*